FOLLOWING THE
BARN QUILT TRAIL

FOLLOWING
THE BARN
QUILT TRAIL

Suzi Parron

Foreword by
Donna Sue Groves

SWALLOW PRESS

Athens, Ohio

Swallow Press

An imprint of Ohio University Press, Athens, Ohio 45701

ohioswallow.com

© 2016 by Ohio University Press

To obtain permission to quote, reprint, or otherwise reproduce or distribute material from Swallow Press / Ohio University Press publications, please contact rights and permissions department at (740) 593-1154 or (740) 593-4536 (fax).

Printed in the United States of America

Swallow Press / Ohio University Press books are printed on acid-free paper ∞ ™

25 24 23 22 21 20 19 18 17 16 5 4 3 2 1

Library of Congress Cataloging-in-Publication Data

Names: Parron, Suzi, author. | Groves, Donna Sue, writer of foreword.
Title: Following the barn quilt trail / Suzi Parron ; Foreword by Donna Sue Groves.
Description: Athens, Ohio : Swallow Press, 2016. | Includes bibliographical references and index.
Identifiers: LCCN 2015044696| ISBN 9780804011693 (pb : alk. paper) | ISBN 9780804040693 (pdf)
Subjects: LCSH: Barns—United States—Pictorial works. | Barns—Canada—Pictorial works. | Parron, Suzi—Travel—United States. | Parron, Suzi—Travel—Canada. | Outdoor art—United States—Themes, motives. | Outdoor art—Canada—Themes, motives. | Culture and tourism—United States—Pictorial works. | Culture and tourism—Canada—Pictorial works.
Classification: LCC NA8230 .P365 2016 | DDC 725/.372—dc23
LC record available at http://lccn.loc.gov/2015044696

In memory of Maxine Groves, in whose honor her daughter, Donna Sue, began the quilt trail. She inspired so many through her wisdom, her quilting artistry, and a life well lived.

contents

contents

foreword

Everyone has a story, including me. Stories make us laugh and cry. They evoke memories and help us form emotional connections. Stories teach us about life, about ourselves, and about others.

Little did I think that a large part of my story would intertwine with the lives and stories of thousands of other folks across the United States and Canada.

In order to tell my story we have to go back sixty-plus years. I grew up in West Virginia. My mother and father were the first generation to move to the city away from the farm. As a family—my dad, mother, brother, and I would visit my grandparents most weekends.

My brother, Michael Blaine, was five years younger and a general pest to me. Riding side by side in a car for any length of time caused us to squabble. Those were the days of no cell phones, handheld games, or DVDs. It was impossible for us to play the typical license-plate game because all we saw were West Virginia plates. To keep us occupied Mother created a game counting barns. If it was a certain kind of barn, you got two points; if it was another type of barn, you got three points; if it had advertising on it, you got a bonus of five points if you could read the ad. Barns like "Chew Mail Pouch," or "See Rock City," or "RC Cola" were five points. Red barns were two points and white barns minus two points.

The game helped us not to fidget and poke at one another. It was an opportunity to practice our math and reading. The game sparked family discussions regarding farming practices such as the style or the function of barns. My dad loved photography and sometimes we stopped to take a picture of a barn. I was thrilled if we saw a farmer and I could ask him questions. Memories of those trips are some of my happiest!

It wasn't unusual for me to spend a weekend or a summer visit with my grandparents. I remember that my first toys, or "pretties," as Grandma Green called them, were empty spools, pieces of fabric, string, and a tin full of buttons. Both my grandmothers quilted and I was captivated with the process—from the piecing to the quilting. I particularly loved the pattern names such as "Robbing Peter to Pay Paul," "Pickle Dish," "Broken Dishes," or "Grandmother's Flower Garden." Discovering that the fabric remnants were someone's dress, shirt, or pajamas sent my imagination soaring. They pieced and quilted and I asked questions. I begged

for stories, particularly the ones about the bygone days or what it was like when they were little girls.

Eventually my path took my mother and me to Adams County, Ohio. In the spring of 1989 Mother and I bought a small non-working farm that had a barn on it.

I finally had my own barn. Ours was a tobacco barn. One day while we were admiring it, I mentioned to my mother that I thought the barn was plain and needed something to brighten it up. I said it needed color; I halfheartedly said a big quilt square would look nice and promised her that I'd paint one for her someday. That 1989 "someday" promise took fourteen years to come to fruition.

During the 1990s I started working for the Ohio Arts Council and traveled throughout the Ohio River Valley and Appalachian Ohio counties meeting artists and members of art organizations. While working for OAC, I learned the value of using the arts to build a sense of community, particularly through creating large public murals. I also realized that the majority of communities held annual quilt shows and everyone seemed to have a quilt story or a quilt to show me. Pondering what I had learned, my promise to my mother lingered in my mind.

On my numerous OAC road trips, I, naturally, watched for barns just as I did as a child. It was during those road trips that an idea started to formulate that led to my "aha" moment. Most rural communities did not have large, blank, store walls or a floodwall for murals, but they did have barns. To me the barn walls looked like empty palettes waiting to be decorated. Why not make use of those barn walls specifically for a community project decorating them with quilt squares?

As the years passed my friends asked if I still planned to paint my mother's quilt square. December 2000 was a turning point when those same friends offered to help me paint the quilt square that I had promised her. I mentioned my "aha" idea. I suggested, if we were going to paint one quilt square, why not paint several and invite tourists to travel a trail using quilt squares? I believed that a dedicated trail would lead to increased economic opportunities for us and highlight Adams County, Ohio, as a place to visit.

Enthusiastically my friends said yes and we formed the first committee. We rolled up our sleeves and started to plan. In a few months the original quilt-trail model was birthed. The Ohio Star was our first quilt square and was unveiled October 2001, during the Lewis Mountain Herb Fair. We dedicated it to my mother and my Appalachian mountain heritage. It wasn't until three years later that I finally fulfilled my promise to Mother when we hung her Snail's Trail square, painted by Geoff Schenkel.

Once Adams County dedicated our trail we had other counties and states that wanted to duplicate the model. We decided to pay-it-forward and share the model with anyone that asked. We happily passed along our how-to information with them. But, we did ask for a couple things in exchange. First, we asked that they remember where, who, and why it started; second, we asked that they share the

model with others, along with the lessons they learned. As each community passed along what they learned, I felt the model would strengthen as it traveled to new communities.

For the past fifteen years I've found purpose and delight working with communities as they planned, developed, and implemented quilt trails across the United States. But my journey for the last ten years has been one of debilitating illness. Continuing to act as a mentor, consultant, cheerleader, and the go-to person for new trails has kept my mind occupied and depression at bay. The work has given me the impetus and desire to live. Even as my health continues to deteriorate, the ever-growing community of quilt-trail participants embraces me with friendship, love, prayers, and, above all, hope. They have cooked for me, driven me to appointments, and held my hand. They've dug deep into their pockets, and their generosity has helped pay for my living expenses and my ever-growing medical costs.

Daily, I am reminded that I am part of a greater community that is bound together by a magical quilting thread. That floating thread has allowed me to virtually travel from my home. By the use of social media, letters, pictures, emails, and telephone calls, I feel like I have actually visited almost all the quilt trails across America and Canada!

I've learned from their stories that we are not so different from one another: in important ways, we are much more alike. Although I did find a couple of differences —our last names may vary and the scenery around us may be mountainous or flat— I learned that we all want and desire the same things. Our fears are no different.

I've learned that we are a kinder, gentler nation, person-by-person and neighbor-by-neighbor, than the evening news would have us believe. I've heard childhood stories telling of growing up in rural America—how a quilt or barn played a role in so many lives. I've been told how working with others to create a trail transformed these lives and gave them new purpose—even giving some a will to live. I lived for those stories; stories were and continue to be my lifeline to the outside world!

Over the years I had numerous inquiries from individuals wanting to write a book about my story and the ever-growing phenomenon of quilt trails. I struggled giving any of them the green light until I spoke with Suzi Parron. When Suzi and I first chatted I immediately knew she was the right person to tell our story. Her enthusiasm and willingness to travel impressed and excited me. Suzi had an eye for detail and accuracy. With my blessing and the support of Ohio University Press and our editor Gillian Berchowitz, Suzi and Gracie hit the road running and never looked back. As she traveled the back roads of America, Suzi met Glen Smith, a fellow kayaker who would become her best friend and an enthusiastic road-trip partner. Eventually their friendship turned to love. Now Suzi's, Glen's, and Gracie's stories are forever entwined with mine because of the American Quilt Trail.

In closing, I send a heartfelt thanks to Suzi for helping to define and save the memories that we share.

No matter where you live—I may not have been there in person to travel your trail but I am always with you in spirit. Please remember that I love you and call you friend. You have given Nina Maxine Green Groves, my mother, and me happiness and joy beyond words. We both thank you!

Here's to two little kids sitting in the backseat of a car counting barns and quilt squares on a family trip.

Donna Sue Groves

acknowledgments

I would like to thank Donna Sue Groves for trusting me with her story and opening the door to what has become not just a research and writing topic but a way of life for me. I treasure you as a sister; we will always be family.

Many thanks to all of the quilt trail committee members who coordinated my visits and spent their days touring the countryside with me. Your expertise and thoughtful planning were invaluable. So many of you have become friends whom we look forward to visiting for years to come.

Special thanks to those who opened their homes to us along the way or provided a place for Ruby to park. We could not have made this journey without your generosity.

To each of the barn quilt owners I met along the way, I appreciate so much your willingness to share your quilt trail stories. I hope you find that I did them justice.

Thank you to Gillian Berchowitz, director of Ohio University Press, for your continued support. Nancy Basmajian, your enthusiasm and kind words were much appreciated. Beth Pratt, our collaboration during the design process greatly enriched my experience. Thanks to Sally Welch, for the excellent work bringing all of the pieces together. And thank you to Chiquita Babb; your diligence in editing and skill in design resulted in a beautiful book.

Finally, I am grateful beyond measure to my best friend and husband, Glen, who made possible the two years of travel that it took to write this book. You not only supported me in my dream and cheered me on but also worked incredibly hard to make all of this easier for me. Your love and generosity amaze me every day; I could not ask for a better partner in life's journey. I am truly "The Happiest Girl in the Whole USA."

introduction

I stumbled across my first barn quilt in 2008, while on a cross-country camping trip from my home in Stone Mountain, Georgia, to Yellowstone National Park. For decades, I had wanted to make the trip west, but the imagined journey had always included a traveling partner, preferably a husband. Some women judge men by how much money they earn or whether they would make good fathers. Instead I asked myself, *Would you go to Yellowstone with him?* Unfortunately, the few for whom the answer was *yes* had not become lasting fixtures in my life, and I neared the age of fifty as a single woman. By then making the journey was more important than being part of a shared experience, and my mostly Labrador mutt, Gracie, became my companion for the two-week trip.

Other than an aversion to children, who were deterred from entering our campsite by her impressive bark, Gracie was game for anything. Being the sole human on the journey meant that I got to dictate our schedule of activities, though I did have to apologize occasionally: "You're going to have to wait in the car," when stopping into a store for groceries. Of course, I always left the air conditioner running, and Gracie held up her end by looking menacing enough that no one tried to drive away with her. The photo album that chronicled the trip could be called, "Gracie Goes West," with shots of Gracie swimming in a Kentucky lake; Gracie tracking prairie dogs; Gracie chasing a tumbleweed; Gracie on top of a picnic table to avoid campfire smoke; and of course, Gracie at Yellowstone.

Solo travel has never been lonely for me. My gregarious nature has led to many shared experiences with strangers: comparing notes as to sites seen and worth seeing, lingering until I care to depart, shifting plans to accommodate temporary friendships. When I spotted my first barn quilt, a brightly colored Flying Geese quilt block hanging on a barn in Cadiz, Kentucky, I was glad that no companion's urge to reach our destination on time overrode my desire to stop and inquire. Barn owner Belenda Holland not only told me about her barn quilt but also shared her knowledge of the quilt trail in the area and its role in recognizing the quilting art of generations of farm women. The hour that we spent talking, that chance encounter, ignited my desire to know more, to talk to as many barn owners as I could, to discover the stories behind all of those quilt blocks. My need to know eventually led to quilt trail founder Donna Sue Groves in Adams County, Ohio.

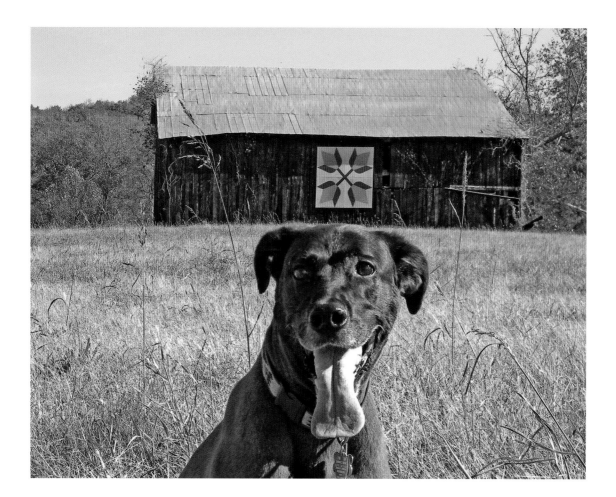

Gracie on the quilt trail

Over the course of several weeks, Donna Sue shared her story and provided me with all of the information she had compiled and contacts she had made. Armed with just enough knowledge to compel me to do so, I spent two years traveling the country, from New York to Colorado, Texas to Wisconsin, gathering the stories of those quilts. I practiced the art of careful listening as I was escorted through barns and learned of their construction and of the ancestors who had built them. I was welcomed into farmhouses where I heard stories of the quilters whose work was captured in paint and of the precious loved ones memorialized there. Some quilt blocks belonged to folks who either no longer farmed, or never had, but their stories were just as profound and worth sharing.

My faithful companion, Gracie, traveled the quilt trail with me much of the time, minding her manners in the backseat when a local quilt trail committee member rode along and learning the hard way to avoid the hooves of the horses and cows we met along the way. My considerable library of barn quilt photos included quite a number of "Gracie with a quilt block" shots, and each takes me back to a moment of our journey.

In 2010, with both my travels and my manuscript complete, a void opened up where barn quilt chasing had been. I took up kayaking, the quintessential solo sport

that combined a Florida girl's love of water with a practice that mirrors my preferred mode of travel. In my own boat, I can paddle along chatting and joking with others, or choose to break off and make my way at a quiet distance. On a weeklong adventure in June 2011, I met Glen Smith, a software developer who set his own work hours; for him that meant beginning early in the morning and kayaking on his own most afternoons. As a high-school teacher on summer break I was free to spend every day on the water, and having a partner with whom to share the work of boat transport led to weeks of carefree enjoyment on the Chattahoochee River.

Glen was quiet and shy, with a silvery gray braid that hung to the middle of his back, the opposite of what I considered my type. My certainty that we would never be an item allowed an easy friendship to develop. Our conversations happened in snippets, in shared observations when we brought our kayaks close enough for us to speak. Glen patiently coached me as I approached each riffle in the water and rescued me without complaint when I capsized despite his best efforts. I grew braver and stronger under Glen's strong and steady guidance. My kayaking buddy became my best friend.

One August afternoon, as we loaded boats into the bed of his truck, Glen asked, "May I take you to supper?" The earnest hope in his blue-gray eyes overwhelmed my doubts. Romance blossomed over schnitzel and beer at a German restaurant, not the standard first date but just right for two rather quirky souls. Holding hands during a twilight walk through the nearby Civil War cemetery, we took turns reading the epitaphs aloud. With the veil of friendship lifted, love grew quickly. Perhaps it had been there all along just waiting to be revealed.

By the time *Barn Quilts and the American Quilt Trail Movement* was published in 2012, Glen and I had been living together for a couple of months. I found myself enjoying a shared life for the first time. I relished cooking for two and scoured my cookbooks for recipes, creating a profile of shared favorites. We were very different; I tended towards noise and chaos, while Glen was steady and reasoned. I struggled to remember to make decisions as a team and forced myself to relax and let Glen decide how certain things ought to be done. I still preferred my own method of folding towels but had grown to appreciate the merits of filling the car's gas tank before the warning light glowed.

I began receiving requests to speak to quilt guilds and civic groups about the quilt trail and welcomed the opportunity to do so. Glen often accompanied me on my talks, and soon he was as well versed in barn quilts as I was; we often joked that if I were sick, he could deliver my presentation from memory, though perhaps without my flair. Glen has competed with the quilt trail for my attention quite a bit along the way but has never complained. If he only knew what he was getting himself into.

FOLLOWING THE
BARN QUILT TRAIL

the adventure begins

AFTER TWO YEARS, Glen and I had settled into a comfortable routine—visits to our favorite Jamaican restaurant for spicy takeout after a session at the gym, kayaking the Chattahoochee or Etowah River most weekends, scouring the farmer's market for obscure spices and produce to prepare Indian and Thai meals at home. I had spent thirty-four years in Atlanta, all of my adult life, and had developed close connections to friends. I was entrenched in my routine and was proud of my skill at negotiating the infamous rush hour traffic.

When Glen mentioned moving from our home into a converted bus RV, my book club, his spacious office, and the folk art collection that had been ten years in the making flashed before my mind's eye. I doubted that I could give up all that I had accumulated.

My love for travel tugged in the other direction. We could see the country and savor each location as temporary residents rather than as mere tourists. The prospect of leaving behind what had become an unfulfilling job teaching high school was certainly appealing. More than anything, I was touched by the fact that Glen wanted to go and to take me with him.

And then there was the quilt trail. There were dozens of new community projects, and we could follow them to Canada and California, on a route that would wind through most of the country. Donna Sue and I talked, and we wondered whether we ought to update our earlier book with a section that discussed these additions. Over dinner with Donna Sue and Gillian Berchowitz, the director of Ohio University Press, I began to list the trails I thought ought to be included. When I

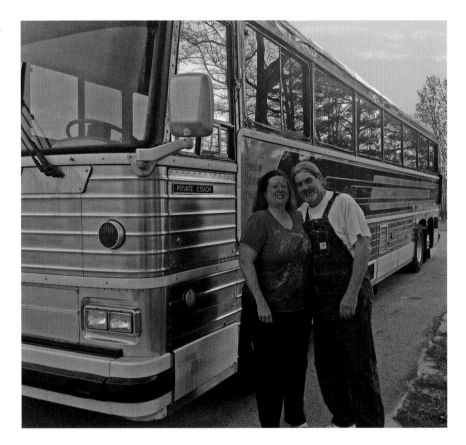

paused at about twenty, Gillian said, "Suzi, it sounds as if there is another book's worth of new quilt trails out there." Indeed there were.

In April 2013, Glen located a 1980 MCI bus that had been converted to an RV inside, with sofa, dining table, a full kitchen and bath, and a bedroom in back. "What do you think?" he asked. "Mighty sporty, huh?" It was a nervous, but exhilarating, purchase. We christened the bus Ruby to reflect the color of her retro paint scheme and took her to South Carolina for some renovations to the undesirably retro interior and thirty years of wear.

For Glen and me, the bus was a huge step forward. For most, commitments might be sealed with diamonds, but a bus said a lot more than any piece of jewelry. The promise was unspoken, but long-range plans for the future had begun.

In August Glen and I packed everything we thought we would need into that massive vehicle and set off to explore the quilt trail. I had already contacted several quilt trail organizers and set up a schedule of visits. I would also be presenting talks about barn quilts to quilters and civic groups along the way. Glen worked from home already; and though his new desk was barely big enough for his two computers, he would be able to continue full-time employment.

We drove to South Carolina on a hot August evening with both our kayaks strapped to the top of the Honda and two bicycles bouncing along on back. We

following the barn quilt trail

picked up Ruby and after admiring her clean new look we hooked the car behind her and set out for Kentucky. Glen had created a disc of favorite songs for our journey; we surrounded ourselves with everything from classic country to seventies pop and sang along. Instead of a map in the pocket next to my seat, I had a tambourine stashed—a gift from Glen who remembered my jokingly saying that it was the only musical instrument I felt competent to play. When an upbeat song came on, I whacked the wooden frame against my knees, slapped the skin with the palm of my hand, and joined the band. My rendition of "I Heard it through the Grapevine" is destined to be a classic.

We hoped to get to our campsite before dark that first night. Over the next several weeks, that hope would become a recurring theme. We seemed to always be running behind. I designed our route to follow my research stops and speaking engagements, and setting departure times was part of that. My devil-may-care attitude had always worked for tent camping; I could just about get those poles into place blindfolded. But backing that bus in between a picnic table and an electrical pole was precarious business, and doing so with only a flashlight beam as a guide was downright dangerous. I had often chafed against Glen's need for planning and precision, but here it began to make sense.

A spacious grassy spot at a state park along the Kentucky River set the tone for our new lifestyle. The dark skies and silent woods might have been eerie had they not signaled the start of an adventure. We slow danced in the parlor to Nat King Cole's "Unforgettable" with just enough room between the sofa and dining table for me to twirl at the end of the song.

The next morning I woke up invigorated and ready for my first foray along the quilt trail in nearly three years. My morning commute took me down miles of country roads through hills lined equally with pastures and woods. As barns appeared in the landscape, I spotted a few barn quilts and stopped to investigate. Some of the blocks were a bit weathered, which was not surprising. Most of Kentucky's quilt trails came about fairly early on, so many of the quilt squares were nearly a decade old.

The road turned to gravel, darkened by overhanging trees. I was so enjoying my reentry into the realm of country driving that I had forgotten to check the directions that Francine Bonny, one of my guides for the day, had provided. I was not sure which turn I had missed, but I was fairly certain that the wooded road did not lead to the McDonald's that marked the final turn. A quick call set me back on track, and soon I found my hosts waiting.

Mary Reed and Francine Bonny, who had spearheaded the local quilt trail, asked how I had liked the welcome signs with quilt blocks in their corners that were mounted at the Estill County line. I was embarrassed to admit that I had been concentrating too hard on negotiating the winding curves to have noticed. Once we drove to the nearest of the signs, we all realized that I had missed it because I had not entered the county by the intended route.

the adventure begins

"Neither of us is from Estill County," Mary said, "but we sure have a lot of pride in our adopted county." The two had worked with the area arts council and other volunteers to paint forty-five quilt blocks, and the scrapbook that Mary and Francine had created chronicled the process. We took a drive through a curving network of hollers and hills, where abundant wildflowers flourished, a yellow and purple quilt in the landscape.

We arrived at the Bicknell farm in the midst of a family Sunday dinner, and, as Southern hospitality dictates, were invited in and urged to help ourselves. I filled a plate with homestyle fried chicken and pork-seasoned greens and sat on a kitchen stool among the three generations of family gathered for the day. As the youngsters headed out to play, Lisa Bicknell talked a bit about the family farm and her quilt block.

The property has been in Lisa's family for seven generations after being settled as part of a large land grant in the mid-seventeenth century. The current owners were elderly cousins, who lived nearby but wanted a family to occupy the home rather than allowing it to sit empty. The house dates to the Civil War period, and the barn is probably about the same age. Lisa's dad recalled helping to renovate the house when he was a boy.

When Lisa heard about the barn quilt project, she attended the first organizational meeting with her sister, Pam. "She is the artist," Lisa said. "I thought if this

is going to happen, she is going to be part of it." The block that the two chose is called Sisters, but the two named it Sisters' Choice. Pam had already painted a small quilt block of the pattern, which she found in a quilting book that had belonged to the girls' Aunt Bessie, who had lived in the house before Lisa's family. "We both chose the block," Lisa said. "The smaller one was Pam's choice, and the larger one was my choice."

The two sisters met once a week in the basement of the church that Francine attends, along with a group of other ladies and, occasionally, their teenage daughters. They could not be more pleased with the result. Lisa said, "We wanted it to look like a quilt, and most are made from dress remnants, so we were going for a calico look."

Glen and I left Kentucky behind and headed north to Indiana. The view from the bus was exhilarating, and we relished the attention our vintage vehicle drew from other motorists. On two-lane roads, Glen raised a hand in greeting to approaching trucks, buses, and RVs and reported on the results: "Got a wave. No wave. Finger wave. Waved first!" We were proud members of a high-riding club on the road.

Gracie seemed to share our enthusiasm. G-Pup, as we called her, had always found our travel routine comforting, with her well-established spot in the backseat of my Honda her napping place for thousands of miles. On the bus, Gracie was not confined to one area, and despite my efforts to convince her that the couch was the best spot to ride, she planted herself between us, gazing out the windshield. I couldn't blame her. The vantage point was thrilling for us humans, and I supposed it might be just as much so for a well-traveled dog.

Indiana brought our first experience in camping in a single location for several days and provided a chance to sort through our belongings. We rummaged through our storage areas both inside the bus and underneath, and a series of "Did you bring the . . . ?" "Do you know where we put the . . . ?" conversations ensued. I am still not certain how my favorite cast-iron frying pan left Georgia stashed under the sofa or why I grabbed a dozen pairs of shoes but only a couple of unmatched socks.

In the evening we spread our patio mat, set up our camp chairs, and cooked dinner over a wood fire. Fresh local tomatoes topped off a feast of grilled T-bones, roasted corn, and marinated portabella mushrooms—perfect summer fare. Wood smoke infused my hair, a rich incense that lingered for the next couple of days.

I had no quilt trail tours scheduled but did enjoy a tremendous turnout at an evening talk, where not only quilters but also local farmers and farm wives filled the auditorium to capacity. Glen's work schedule allowed him to attend, and he helped greet those who approached me afterwards. As we loaded the last box into the car at the end of the night, Glen turned and pulled me toward him for a one-armed hug, "I'm just so proud of you."

The next night, we visited the Indiana State Fair. We strolled down the midway hand in hand, and Glen squinted up through the glare, "I will if you will." The

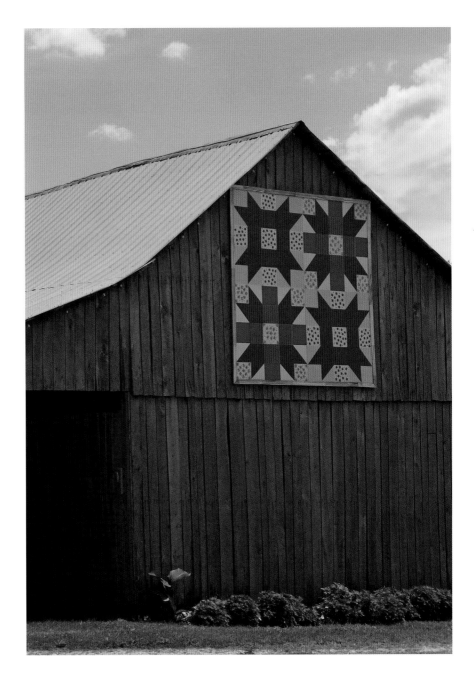

celebratory mood overcame our mutual fear of heights, and there we were, circling high over the sea of lights in a Ferris wheel, quite literally on top of the world.

There was still plenty of daylight when Glen finished work on moving day, and we had just a few hours' drive planned. We were headed for the home of Hugh and Kitch Rinehart in Vicksburg, Michigan, where we planned to park. Glen teased me gently that the flat interstate would be a good place to practice my driv-

8

following the barn quilt trail

ing skills, but I demurred. Within about ten minutes I was glad that I had let him keep the wheel. "I think I smell something," he said in a serious tone. I did not detect an odor, but just as I began to respond, Glen added more urgently, "I'm losing power. I can't steer." With obvious effort, he directed the bus towards the shoulder of the highway, and she came to a stop.

I grabbed Gracie's leash to lead her outside as smoke became visible along one wall inside the bus. The three of us climbed down quickly onto the roadside grass, and just as soon as we landed safely, Glen scurried back up the stairs. I could not follow, not only because I was holding Gracie but also because the bus had filled with smoke. I dialed 911 while standing on tiptoes, peering in, terrified. The operator came on the line just as Glen reached the kitchen and shouted, "It's back here!" I cringed as I saw him pull the refrigerator away from the wall and heard him cry out in pain as I frantically tried to describe our location over the phone. "No, I am not certain of the nearest mile marker. What? Are we within the city limits? I don't know!" After much discussion, firemen were on the way. Glen reappeared and the three of us stood at a safe distance as the volume of smoke began to wane.

I was proud of Glen but had to resist the urge to scold him. He had found the source of the fire and saved the bus from destruction, but had risked serious injury in doing so. As I examined the red welt that stretched from his wrist to his elbow, another thought occurred. Strangers had dinner prepared and were awaiting our arrival. I was on the phone explaining that we might not make it in time to eat when two fire trucks arrived on the scene. Still shaken and trembling, I waited in the car with Gracie as the firemen surveyed the interior of the bus. I had my purse and my pup, and Glen was safe. As night fell and Ruby was pronounced fire free, we waited for roadside service to tow the bus away.

Two a.m. found us exhausted and dejected, having grabbed a night's worth of acrid-smelling, smoky clothing from the bus and located a dog-friendly, but somewhat grungy, motel nearby. Our dreams of bus life seemed to have ended before they had fully begun. We were able to retrieve more of our belongings from the bus in the morning, but it would be several days before the extent of the damage would be determined.

We left Elkhart, Indiana, with the car packed to bursting. Two suitcases, several boxes of books, three laptops, and all manner of doggie supplies were crammed into the cargo area so that Gracie could occupy the backseat. We considered scrapping the trip. "We can be home tomorrow," Glen said. "They will understand." The comforts and safety of Georgia beckoned, but so did my obligation to those who were expecting me. Kitch Rinehart had assured me that we, and Gracie, were welcome in their home. Without knowing when we would see Ruby again, we rode on to southern Michigan and the Vicksburg Quilt Trail.

9

the adventure begins

michigan

G LEN AND I arrived in Vicksburg disheveled and exhausted, but Hugh and Kitch Rinehart were so welcoming that our tension soon evaporated. Their lakefront home provided the comfortable refuge that we needed. Gracie had the run of the backyard, and she splashed and slurped along the sand, relishing her freedom. Kitch and I set out on a paddle boat, laughing as we struggled to maneuver the craft along the shore, while Glen zoomed across the water on a jet ski at full throttle. I felt as if we were on vacation instead of at work. Dinner on the deck with cold wine and lively conversation helped relieve the strain of the last twenty-four hours. "This might just work out after all," Glen said, as we watched the sunset over the water,

The next morning, Glen set up his laptops at the dining room table where a wall of windows afforded him a sunny view. I often felt guilty spending time on the quilt trail leaving Glen behind to his work. He was stuck in front of a computer, manipulating data and solving global problems for his employer. The work requires a sharp mind, intense concentration, and decades of experience; I admired the fact that he was at the top of his profession. Of course I was working as well, but instead of data, graphs, and teleconferences I enjoyed lively conversation, fresh air, and a chance to enjoy the local sights. My workday was fun, and, when I returned, my bubbling forth with stories sometimes felt like mocking rather than sharing.

I grabbed a quick bowl of cereal and my morning caffeine dose of Diet Coke and was ready to join Kitch for the tour. We chatted along the way about favorite quilts and quilt patterns and ideas she had gleaned from other quilt trails. Cindi

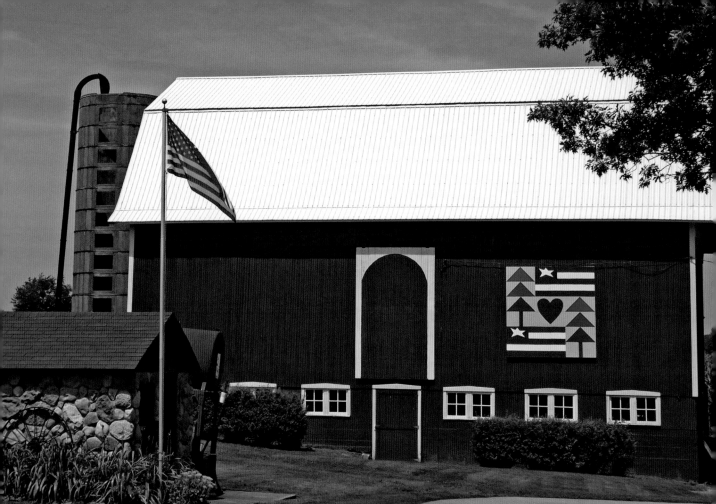

Van Hurk, who chaired Michigan's first barn quilt project, in Alcona County, had served as an early advisor to the Vicksburg group. This project is different from most, with its boundary not the county line but the Vicksburg school district, creating a compact and easily drivable route so that only a few minutes elapsed between barns. Kitch and I would stop mid-sentence, step out to view a quilt block and take photographs from every angle, then hop back into the car and resume our conversation seamlessly. After half an hour on the quilt trail, we had fallen into a rhythm like longtime friends.

Before we reached our first destination, Kitch said, "This might look rather familiar to you." As we rounded the corner, I saw a barn quilt that did resemble one I had seen before; in fact the block is in the Iowa chapter of my first book. Kitch said, "I give barn owners the book and ask them what appeals to them—not to select something from the book but just to get an idea of colors and what looks good. After all, the colors are great combinations." Freddi Coppes had been taken

following the barn quilt trail

with the quilt block created by the Reese family in Iowa to honor their heritage and wanted the same one for her barn.

Kitch agreed that the barn quilt was lovely but thought perhaps it would not be an appropriate choice. The original design features a German flag, and Freddi's husband, Richard, is a World War II veteran. "I just didn't think that would work well," Kitch said. A few changes made the block suit Richard and Freddi perfectly. Freddi's ancestors were Dutch loggers and woodcutters, so pine trees were added to represent her side of the family, and the stylized American flags to honor her husband, the veteran. The couple could not decide what to call the finished product, so Kitch suggested Love the Land. The American flag snapping in the wind next to the milk house out front completed the scene and the sentiment perfectly.

Kitch enjoyed the barn quilt project immensely. She said, "We all love our big barns, but most of us had never been inside of 'em." With local resident Sue Moore on board as the "mover and shaker" that Kitch needed, within two weeks the idea moved from a discussion to a reality, under the direction of a committee of four couples and the Vicksburg Historical Society. The Rinehart's garage served as the painting headquarters, but it was definitely a community effort. Kitch said, "We have everybody painting—neighbors, friends, grandchildren, and even paint parties in town. We spread a great big orange tarp and four sets of sawhorses, and it was nonstop for a year and a half."

Kitch and I visited the local farmers' market, where the music from a three-piece bluegrass band enlivened the shops and rows of vendors. I had no need for produce or cheese or even beefalo but I grabbed some homemade fudge—dark chocolate for me, and milk chocolate with pistachios for Glen.

The Unique Furnishings shop sits among the brick storefronts of Vicksburg's main street, and we found owner Christina Klok waiting. Within, a ceiling of creamy white tin set off antique light fixtures and fans. Glass showcases were laden with jewelry and trinkets, and shelves of handcrafted décor, soaps, and candles lined the aisles. I spotted a jar of salted caramels on a shelf along the wall and was tempted to grab a few, but Christina and Kitch were already seated, waiting for me to join them.

Before the conversation turned to barn quilts, Christina asked about our mishap. "I heard you had a challenging trip here. Holy Cow, when I read that email I thought, 'These things don't just happen to me!'"

Christina shared the significance of the Wreath of Lilies quilt block that she and her husband Leonard chose: "People traveled from far and wide to see the lotus lilies on Sunset Lake. They are what put Vicksburg on the map." Christina had photographs of Victorian-era visitors and articles about the unusual blossoms. She went on to say that the trains carrying folks to the Chicago World Fair stopped in Vicksburg so that passengers could see the lotus lilies and buy them. Local kids uprooted the plants and sold them for a quarter or fifty cents each. The lilies were

Wreath of Lilies

found in few other places, so the saucer-sized blooms remained a tourist attraction until the early 1930s, when they disappeared due to overharvesting. Referring to her quilt block Christina said, "We love flowers and the water, and we still have flowers over there—just not the lilies."

Kitch and I moved on, and again our drive provided a chance to chat. Kitch explained how the quilt trail got started. "I knew one person—Sue. She had come to do a talk about our lake and she took some pictures from my house. She introduced herself and we clicked. It just happened later that I knew the right person to call." One out of every five who were asked to host a barn quilt declined. An elderly woman was wary of having people coming into her property, and some others had recently added metal siding to their barn and didn't want holes punched in it. Kitch said, "They had good reasons, but they broke my heart."

I exclaimed, "That's a cool barn," just as Kitch slowed to pull into the drive where Dawn Hippen Hall stood ready to talk about her barn quilt. The family considered a patriotic design for their barn quilt, but the quilt trail already included a

14

red-white-and-blue quilt block. Dawn said, "My parents, me, and my brother, and my daughter; we are like a star." Dawn looked online and found Broken Star, which seemed appropriate. "When Kitch called me, my father had just passed away three weeks previous, and I had taken care of him for two years. I felt like the family had just broken up. The colors remind me of a rainbow and starting over," she said.

Dawn and her brother, Daryl, especially love the fabric designs in the quilt block. Hugh and Kitch primed and dropped off the boards at the high school, where students painted the star, carefully using texture to create the look of fabric. Afterwards, all of the painters signed the border with their names and where they were from. The group included international students from Morocco, Italy, and Germany. Dawn and her family signed the quilt block also, and Dawn was very pleased with the final product. "She saw it and immediately started grinning," Kitch said.

Dawn said, "It had been really tough. The farm was really important to my parents, and I have lived here almost all of my life. When I grew up there were

Broken Star

michigan

barns all over, and I realized when Kitch called me that there aren't as many as there used to be." Dawn had touched on a critical aspect of the barn quilt movement, that of barn preservation. Many a barn owner has reported saving his barn so that it could be home to a quilt square.

Kitch and I drove on to Deb Fisher's home, where we both commented on the well-tended gardens out front. Deb said immediately on our approach, "I hear you had some trouble on the way here." I told her the repairs to the bus would take a couple of months, thinking at the time that my statement was hyperbole. Kitch laughed and said, "This was the shakedown cruise of this RV," and she went on to relate that Glen and I were considering making the bus our permanent home.

"Not that one!" Deb exclaimed.

We got to the discussion of Deb's quilt block and the cloth quilt that it represents. The quilt belonged to Deb's great-grandmother Lenora VanGuilder Fisher, who lived from 1871 to 1941. Deb smiled when I asked how she came to have the quilt. Deb has no children, and her mother wanted the quilt to be passed down to someone in the family. "That's why I painted it," Deb said. "I had seen the blocks on the other buildings and decided I was going to put one up whether it's sanctioned or not." The Rineharts admired her work and appreciated the connection to the family quilt and welcomed Deb's addition to the quilt trail. Deb's mother was impressed as well, so she gave great-grandmother Lenora's quilt to Deb. The quilt will eventually go to one of her nieces or nephews, but for now it is Deb's to enjoy.

Deb said that Drunkard's Path was associated with the temperance movement, and I asked what she knew about the history. She told us that after the Civil War, a lot of men came home with substance-abuse problems. Also, a lot of those who were immigrating in the early twentieth century, such as Irish Catholics and Jews from Eastern Europe, used alcohol as a part of their religious ceremonies. They weren't teetotalers like the strict Protestants. Deb wasn't certain how the quilter felt about alcohol, but she knew one thing for certain. "My grandmother was very much against drink, and she was the one who first showed the quilt to me." I could understand a quilt being symbolic but wondered how quilt making could have actually supported the temperance movement. Deb explained that quilts might have been sold as fundraisers so that women could pamphleteer. Quilting might also have been a way to bring women together to spread the notion that drinking was evil. Deb said, "A woman in the house who didn't like alcohol was going to make a man's life hell and make him quit drinking. Maybe they used it as a way to proselytize among the women. If the scions of the community are anti-drink, the young ladies are going to want to be seen as morally upright people."

Deb's quilt, which is not a scrap quilt but is made of just three fabrics, is at least a century old. "I know that the majority of the quilt squares are about the

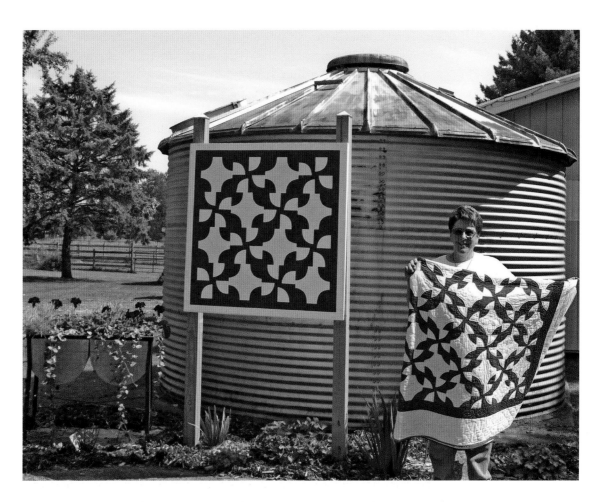

Deb Fisher with her
Drunkard's Path
quilt and barn quilt

barn and the farm, but mine is about the quilt," Deb said. "This place has been a farm for a long time, but none of the barns are left. The last one is under that flower patch," Deb said, gesturing toward the gardens we had admired earlier.

As we headed back to the lake and dinner, Kitch and I agreed that the day had been a success. The four of us relaxed around a bonfire in the sand that evening while Gracie attempted to stalk the Rinehart's yellow cat, Murphy. I was concerned, but Kitch assured me that Murphy could handle himself. Moments later a loud yelp confirmed that the cat had taught the seventy-four-pound dog a lesson. Poor Gracie refused to venture outside for the rest of our stay if she glimpsed Murphy anywhere nearby. Gracie's scratched nose and the cowboy costume that Hugh donned the next morning as he prepared for a shooting competition were the types of memories to which Glen and I would refer often over the next few months. We left Vicksburg knowing that we had made new friends and that we would return.

michigan

Elsie Vredenberg and I had corresponded for several years about the quilt trail she had spearheaded in Osceola County, Michigan. More than ninety barn quilts comprised the trail, and I had eagerly awaited Elsie's photographs that documented each addition. I was glad to have the opportunity to visit. I met Elsie and committee member Cindy Cambier at Elsie's home one dreary morning; it was a less than perfect barn quilting day, but our mood was ebullient. Osceola is a large county, and, rather than attempt a comprehensive tour in just a few hours, Elsie had carefully chosen a few of her favorites.

Our first stop was at the Schmidt farm in Reed City. The red barn's immaculate condition was impressive, but the quilt block looked mighty small. Before my disappointment could set in, Elsie pointed out the full-sized barn quilt on the far end of the barn. Jalayne Markey greeted us and invited us in. She beamed with pride as she told the story of her family's Blazing Star barn quilt.

Jalayne is the fifth generation of her family on the farm that was founded by her great-great-grandfather, John Schmidt. The barn on which the quilt block hangs was built in 1877, with the house built the following year. Jalayne's father, Garth, was born on the property in 1918 and farmed there for almost eighty years. "He was out riding his tractor, plowing fields with his nephew two weeks before he died," Jalayne said.

The family wanted to honor Jalayne's mother, Elvera, who had been a prolific quilter, with a barn quilt but none of her quilts seemed right for the barn. The family had a Blazing Star quilt made in the 1930s by Jalayne's great-grandmother to commemorate Elvera's confirmation, and the colors were a perfect fit. The farm had recently received its sesquicentennial certificate and the accompanying sign, which was hung on the side facing the house. Garth thought that the barn quilt and sign ought to hang together, but Elsie urged Jalayne and her husband, Jim, to place the quilt square on the end where it could be more visible to the public. A compromise was reached whereby the smaller version, which I had seen earlier, was painted by the family.

The family held a celebration for the barn quilt hanging, which included a cake dedicated to Elvera. For the next three years, Garth enjoyed looking out the window to see the family heirloom in place. The farm was founded on June 5, 1863, and Garth passed away on June 6, 2013, the day after the official sesquicentennial date.

We left the Schmidt farm and drove through the rugged countryside, where Elsie began to point out a series of barn quilts. My favorite was a large gray barn with a Rose of Sharon quilt block. I was excited to hear that we would see the cloth quilt that went with it, but when we entered the home of Wava Woods, there was so much more to see. Wava is a collector, and she surrounds herself with her favorite things. Many were passed to her from childless aunts and uncles and preserved in a room built specially to house them. A long dining table was set with a

Opposite page:
Blazing Star

perfect set of china; nearby were cabinets brimming with more. Teapots, lamps, exquisite embroidered pieces—I could have spent the afternoon plundering.

But of course we wanted to talk about barn quilts. An only child, Wava had come to own four century farms, two from each side of the family. It seemed only fitting that each should be home to a barn quilt. A Feathered Star quilt block that we had passed earlier represented the feather ticks that Wava inherited from her aunts and uncles and made into down pillows. A Nine Patch Variation decorates another family barn and is patterned after a quilt that is over 130 years old.

The Rose of Sharon was taken from a family quilt made by Wava's Aunt Mabel and her husband, John, sometime in the 1940s. Wava brought the quilt out and spread it so that we could see the pattern as she talked about how popular the quilt had been when entered in shows nearby. The Rose of Sharon barn quilt represents not only the cloth quilt but also Wava's daughter, Sharon, and her great-aunt, Rosiena. I found it interesting that Rosiena was Wava's great-aunt on both sides of the family, as aunt to each of her parents. In addition, Wava's granddaughter has the middle name Rose, so the names associated with the quilt are found in the first, third, and fourth generations of the family.

The barn itself is significant to Wava as the only barn raising in which she took part. "With one loud call and a lot of lifting in all corners, in a few minutes the skeleton structure was standing upright." Wava did more than observe; she helped the women who prepared food and set it on boards laid across sawhorses so that the workers could come by and pick up food and sit on the grass nearby. Young Wava also carried water from the kitchen stove to granite washbasins that were set on potato crates for the men to clean up before eating.

Wava's favorite barn quilt is the twelve-pointed star called Moon Lit Woods, which sits on a small barn visible down the hill from her home. Wava explained that the name of the quilt block was also the name of the property. Right after Wava and her husband, Dale, were married, Wava's father became ill, so the farm would have to be sold if the new generation could not take over. Dale worked in a factory and had cows of his own, and Wava worked at the hospital, but there was no other choice. Wava said, "We came home with our cows, tractor, and house trailer just like gypsies traveling down the road." At that point anything that got done on the farm was done by moonlight, so paired with their last name, Moon Lit Woods became the new name of the farm.

The Moon Lit Woods quilt block has twelve points: for Wava and Dale, their two children and their spouses, and Wava and Dale's six grandchildren. A dark blue background represents the night sky, yellow the moon, and, at the bottom of the block, five evergreen trees were painted to represent the couple's five living grandchildren. The trees are all of different heights, as the children were as well. At the suggestion of their son, John, a sixth tiny tree was added to honor his

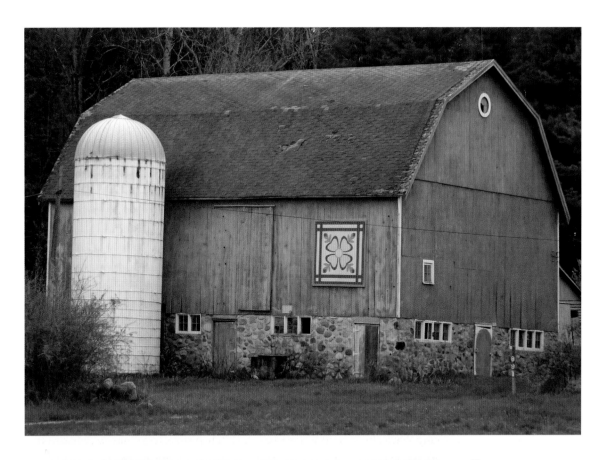

Top:
Rose of Sharon

Bottom:
Wava Woods's Rose
of Sharon quilt

daughter Elice, the grandchild who had lived only two days, so that she could stand next to her surviving twin, Katlin.

Wava had so much to share that I could have stayed all day, but Elsie had mentioned a very special quilt block that I wanted to see. In late afternoon, we headed to nearby Cadillac, where Elsie was working to get a new quilt trail started, for the last visit of the day. I had admired the Octagonal Building and was especially drawn to it because the quilt block was an exact replica of the Snail's Trail that Donna Sue and Maxine Groves had on their barn. Elsie could not have chosen a better tribute, and Donna Sue had already told me how much she appreciated the gesture. The thoughtful mood was broken as we entered the building and I realized that I would be discussing such an important quilt block with a clown.

Rudy Grahek is known to many as Dynamite the Clown. He had not dressed the part, but Rudy's exuberant smile and energetic storytelling gave the impression that he was good at his job. Rudy shared memories of growing up near the fair-

following the barn quilt trail

grounds. "I could see the Octagonal Building from my bedroom window, and I thought there must be a carousel inside. It seemed monstrously large as a kid." It was built in 1907 for the fair that would take place on the new grounds the following year. Over the years, the building fell into disrepair, but in 2008, for the one hundredth anniversary of that first fair, a restoration was begun. The local home builders association and the fair board, of which Rudy was a member, were instrumental in the project.

According to Rudy, the building was used as a marker for pilots, as the fairgrounds also functioned as an airport. The field had been cleared of stones and stumps for the fair, creating a large area that was safe for landings. The flag at the top of the building would act as a windsock. Rudy shared a bit of lore, stating that if there was no flag present another way to determine the wind's direction was to look at horses nearby, as they will stand facing into the wind to keep it out of their ears.

I had never met a clown, so I had to ask Rudy just a bit about his life. He bubbled over with excitement. "When we were kids, everyone else drew pictures of town, but I drew circus tents and elephants." He left the fairground in 1952 with one of the largest circuses, but was soon drafted to go to Korea and returned to travel with another circus, then later with carnivals. "I patterned my life after Red Skelton," he said. "You know, Freddie the Freeloader?" I left Cadillac smiling, having ended the day on just the right note.

23

canada

I HAVE TRAVELED enough to know that political boundaries are seldom accompanied by geographical change, but still I was surprised that Canada looked much like the American Midwest. Highways cut through farmland set into gentle hills, and small towns were surrounded by familiar chain restaurants and stores. Glen and I found the crowns on the highway signs amusing and the place names difficult to sort out; I am still not certain that I understand the difference between a county and a municipality. But with the help of electronic navigation, we managed to find our way to the motel in Chatham, Kent, that would be our home for the next few days.

Glen and I spent a full day driving the western fringes of Ontario, passing dozens of farms whose weathered barns were clearly of earlier vintage but were accompanied by massive solar panels. "Pretty impressive," Glen said. "Those farmers in the Midwest are behind the times." A side trip took us to Erieau, on the shores of Lake Erie, where we meandered through the boats in the marina and rode our bicycles along the chilly shore. It was only September, but I yearned for a hat and gloves, not having thought to grab them from the bus. After a day of playing tourist, I was ready to explore Ontario's quilt trail.

When I had first heard from Denise Corneil and Mary Simpson, they were in the early stages of an unusual barn quilt project. The women were designing a thirty-block barn quilt trail that would tell the story of Wardsville founder George Ward, who emigrated from Ireland in 1810 to establish a stopping point for travelers

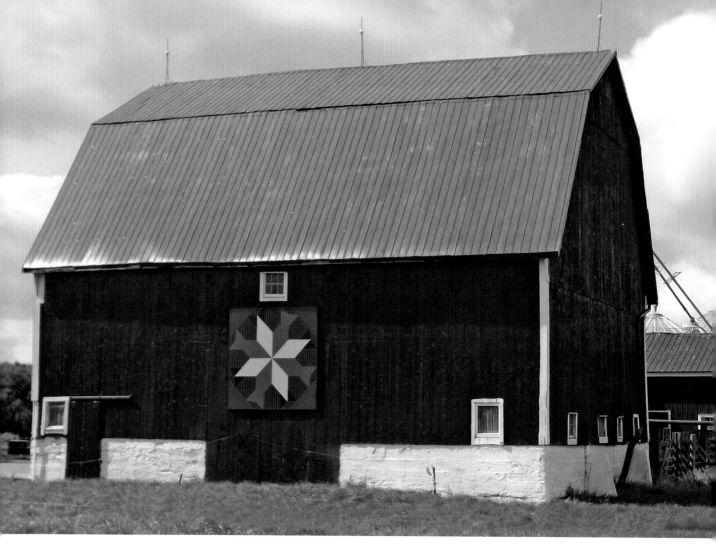

Bounty from the
Thames

in the region. I loved the idea. Many barn quilts or even sections of a quilt trail have ties to history, but a man's life story told through quilt blocks was unique.

Another unusual twist was having a cloth sampler quilt created prior to the quilt trail's inception. Denise and a group of local quilters chose thirty blocks to create the George Ward Commemorative Quilt, a brilliantly colored design. The quilting was completed by many in the community, as the quilt was pieced and then kept in a central location so that anyone who wished to do so—whether an experienced quilter or not—could add a few stitches. The quilt travels to area events and is an effective way to draw attention to the barn quilt project.

The first block, chosen to represent Ward's origins, was Double Irish Chain, a very popular pattern in the early nineteenth century. Cross, Country Church, and Stained Glass Windows stand for Ward's faith, while some quilt blocks tell the story of Ward's military service and loyalty to Britain. Ward's travels by river to

26

Ward's Landing are first represented by Compass and Crossed Canoes, then, as he approached his new destination, by Wagon Tracks and Woodland Path.

Denise and I visited one of the Wardsville barns, home to a Fish quilt block. I had seen the pattern a number of times along the quilt trail, and I love its many variations. The block has an additional name here, Bounty from the Thames. Native communities had settled along the river and used it as a source of food. When the earliest settlers arrived, learning the most effective fishing methods gave them access to this abundance, making the river and its fish key to the development of Wardsville.

Barn owner John Johnston is glad to be part of the quilt trail. "It was just my luck that Denise was looking for barns," he said. He grew up on a nearby farm but knew little about the founding of Wardsville. John enjoys informing visitors about the quilt trail and dispelling their fears that the barn quilts might indicate membership in some sort of secret society. "Now I try to talk it up and tell people about George Ward," he said. I smiled when he said that he always mentions that the quilt trail started in Ohio.

Denise shared an amusing story about work on the Wardsville project. The group was desperate for a place to paint, and a local nursing home offered their basement. Sixty sheets of MDO board were carried into the basement just after the funding for the project was granted in March. Two weeks later, a flu epidemic swept through the center, and the building was under quarantine for six weeks. When work commenced, the smell of the primer turned out to be too strong for residents, so an empty tobacco barn became the painting location, as the June bicentennial event was fast approaching. "Carrying those boards up and down, oh gosh, I thought my arms were going to stretch," Denise said.

The Wardsville Quilt Trail was received with great enthusiasm, and its creators had another endeavor already in mind. The Longwoods Road Quilt Trail has as its theme the women of the area and their lives as pioneers, as mothers and grandmothers, as well as the women's experiences during the War of 1812. The first block is Memory, which stands for the women who came from England and the things they left behind. A block named Broken Hearts represents the constant fear and worry of women whose husbands were gone to war and the sadness of widowhood for many.

Some of the quilt blocks represent more positive aspects of early pioneers' lives as they settled along what was once an Indian trail through the wilderness. Dogwood is a favorite, as it represents the first tree to appear in the spring. The center of the flower with its cross-like shape was further symbolic of religious faith. Common patterns such as Spools and Grandmother's Flowers Garden are emblems of women's domestic activities, and Baby Blocks stands for the new generation being born.

canada

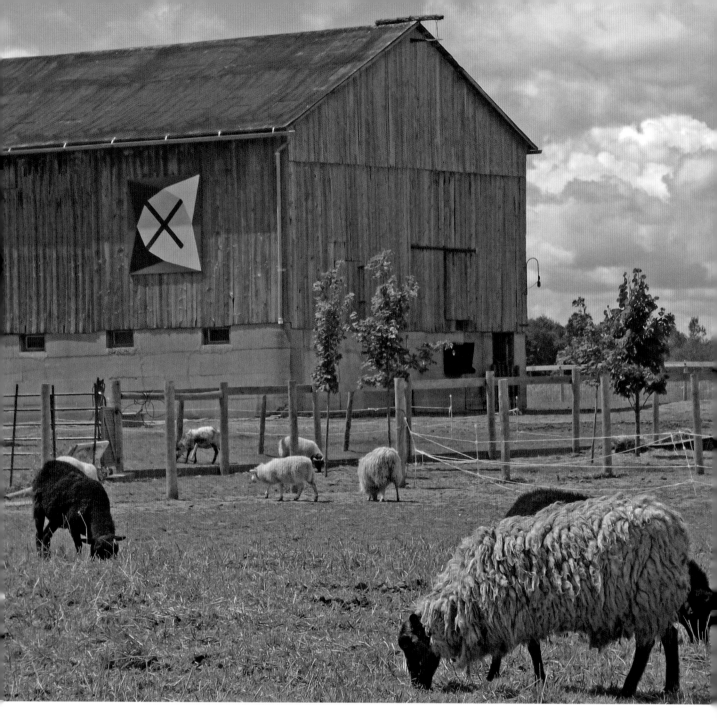

Old Indian Trail

The project opened up opportunities for community groups to earn funds for their organizations. We visited with a group of Boy Scouts who painted five of the barn quilts on the Longwoods trail. The scouts primed and drew out their quilt blocks after school and then taped on Friday before heading out for a camping trip. By the end of the weekend, the painting was complete. We joked that there should be a barn quilt badge, or at least a community-service badge, but the young men were just pleased to be able to say, "I painted that."

Two local Lions Clubs each contributed five quilt blocks to the quilt trail. The men of the Delaware Lions Club turned out wearing purple vests with brilliant gold fringe and pins designating their accomplishments, every bit as proud as the scouts had been. The men welcomed the chance to add barn quilt painting to their fundraising, which supports building of community centers and parks, and youth and sports programs. One of the members said, "We live the Lions' motto: 'We Serve.'" The Delaware Lions Club had painted a block in Lions' colors of purple and gold, as well as four others. My favorite was the intricately designed Thames River block at Roks Farms.

Mary Simpson explained that a wave of Dutch families immigrated to the area after World War II to seek better opportunities. John Roks came to Canada in 1950, having received a letter from his brother stating that he was immigrating. John said, "I was in the army in Indonesia for two and a half years, then came home for six weeks; that same boat brought me to Canada. Then we burned the boat on the shore." My confusion must have been evident, because John added, "You know —like burning the bridge."

John's wife, Lenie, had immigrated with her family as well. The two moved to the farm with their three children in 1958. Lenie said, "It was a big change for me. From a neat little house in the village to this big farmhouse. There was so much to keep clean—that's the Dutch in me. It needed a lot of elbow grease." The couple had three more children, and John farmed with his brothers, both on their property and on land owned by the seminary next door. The Thames River quilt block is on the oldest barn on the property, which, Lenie said, had been a house in the late 1800s. The blue and black are the water and the fish, and the yellow is the sun.

Denise recalled that when Lenie, an avid quilter, decided she wanted a barn quilt, she said to her reluctant husband, "John, I have never asked you for very much, but I want one of those on the barn."

The third Western Ontario quilt trail recognizes a group who are often absent from our historical narratives. Mary Simpson informed me that we were going to visit the First Nations Trail, and at my perplexed look explained that the tribal groups we refer to as Native Americans are called First Nations in Canada. I had seen one or two quilt blocks elsewhere with Native American themes but never an

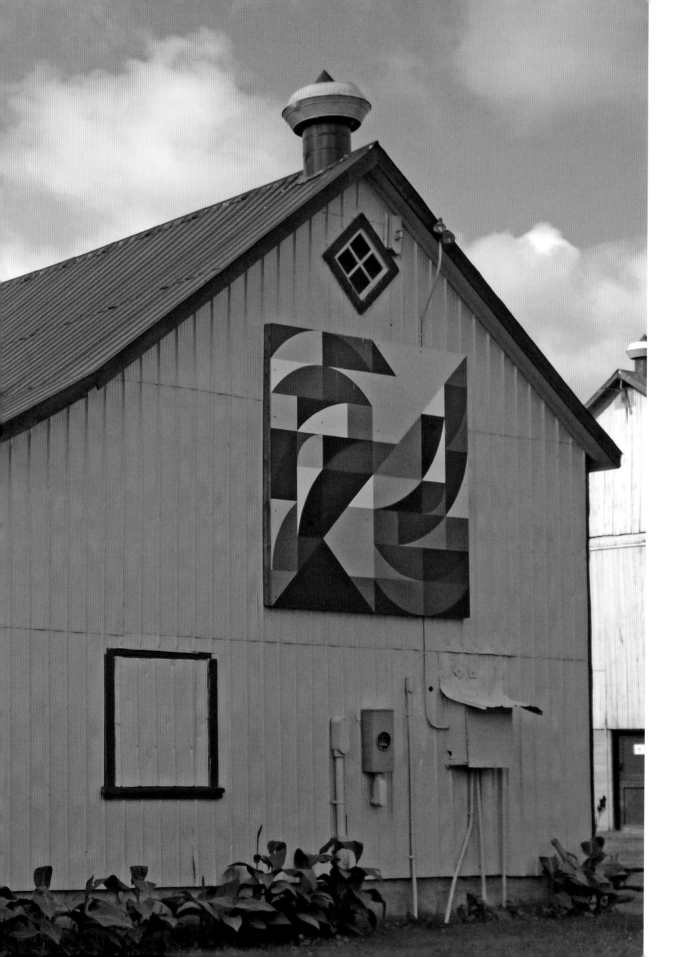

entire quilt trail. With all of the thousands of individuals to whom quilt blocks paid homage, it seemed fitting that the Chippewa should have their story told in barn quilts as well.

Denise said, "I was embarrassed that I didn't know about my neighbors. We learn about the Dutch and the Belgians who immigrated but nothing about the First Nations. Why didn't I learn about them?" After talking with some of the women of the nearby First Nation communities and inviting them to participate, it became apparent that their experiences comprised a completely different story. Denise described the interaction between cultures: "We are like canoes paddling down the stream, each in their own canoe."

Chippewa Nation member and quilter Alfreda Henry gathered thirteen quilters who designed thirty-one blocks that reflect the traditions and lives of the First Nation families during the nineteenth century. The cloth quilt was completed first, and the Chippewa Nation women called it the Trail of Tears Quilt because of the sadness present throughout many of the stories.

Several Chippewa Nation families worked together to paint the quilt blocks on the wooden panels and mount them on buildings and posts. The first was a tribute to Tecumseh, the Shawnee leader during the War of 1812 who was known for his ability to unite warriors from many nations to defend their way of life. The quilt block went up on the 199th anniversary of Tecumseh's death, October 5, 2012.

Freda Henry and her friend Maxine Hendrick joined us for the afternoon. Maxine had been instrumental in helping convince members of various tribes to join in the quilt trail effort. From the backseat of the vehicle, the two women shared their stories and guided Mary as she drove along the trail. We visited the Munsee Delaware Nation Tribal Administration building, where the Thames River Canoe block hangs. The block depicts a lone woman in a canoe, her paddle deep in the water displaying the physical strength that represents women's abilities.

A great deal of the conversation focused on the native women's lives and the ways in which the dominant culture attempted to teach them new ways. Maxine said, "They tried to take our language but they could not. They tried to assimilate us, but we still speak our language." The women did not seem bitter but did seem to believe that the story was one that needed to be told and remembered. Maxine explained that some of their English lessons consisted of songs, which they learned in their native language and then in English. She sang a song whose nasal-toned words we could not understand and then repeated the tune, this time in English: "Me and my teddy bear, have no worry have no care. Me and my teddy bear, playing all the day." I was reminded of high school German lessons that had employed the same method.

The trail includes symbols commonly associated with native culture, such as Bow and Arrow, Wigwam, and Peace Pipe. Others evoke natural elements, such

31

canada

Scorched Earth

as the Turtle, who plays a role in many native myths; Fire, which in native tradition lies at the heart of all creation; and Grandmother Moon, who ensures the rhythms of Earth and nature. Scorched Earth, an original design created by quilter Shirley Baker, stands for the struggles of women to navigate forests from one camp to another after their trails and gathering grounds were burned.

Denise said, "The Americans think they won the war, and the British know they won, but for sure the Indians lost. Indians saved the day but they get no credit."

Our time in Western Ontario ended with a social tea in Melbourne. Women in elaborate Victorian costumes served tea and cookies on elegant china, while those gathered had a chance to view the three cloth quilts that showcase the blocks in the Western Ontario quilt trails. Glen and I met a young woman named Christina who, with her service dog Charlie, had traveled all three of the quilt trails by scooter, taking about a year and a half to see all of the blocks. Christina was such an enthusiastic adventurer, and as she related her stories of stopping to speak with farmers, getting lost and asking strangers for directions, determined to find her way alone, I was reminded of my solo travels along the quilt trail in years past.

Glen and I made our way east and stopped for a couple of days in Niagara Falls before crossing into New York. An icy cold dousing aboard the *Maid of the Mist* at the base of the falls made for an energizing break from work for both of us. Wearing wide smiles and Smurf-blue raincoats, Glen and I celebrated the anniversary of our first date. It had been an exceptional year.

new york

I HAD BEEN in contact with Lynne Belluscio several times and we had developed a long-distance rapport. On hearing of our mishap, she immediately opened her home to Glen, Gracie, and me. Once again the generosity of spirit that underlies the quilt trail was manifested in welcoming hospitality. Lynne is director of the LeRoy Historical Society, just east of Buffalo, New York, and headed up the barn quilt trail there. I was eager to see what they had accomplished. Lynne is also the curator of the Jell-O museum, and we looked forward to adding a quirky stop to our itinerary.

We arrived at Lynne's home where we were greeted by Lynne's Whig Rose barn quilt and an unlocked front door, with a note on the table telling us that Lynne would be back soon. A heavy wooden door in the kitchen led to a one-room log cabin adjoining the house, our headquarters for a couple of days. Glen and I were glad to have our own space, especially since Gracie does not care for other dogs. She is sweet towards humans but seems to think that smallish dogs like Lynne's two Shelties just might be good for a snack.

The next day, Glen and Gracie began their day in the cabin, while Lynne and I hit the road. The first thing I asked was how to spell and pronounce the name of the town. She replied that as far as the pronunciation goes, it depends on who you ask whether it is LEEroy or LeROI, and it might be one word or two. But, "It's got to be a capital R."

The quilt trail was begun in the fall of 2011 in anticipation of the town's bicentennial, with a goal of twenty-five barn quilts by the June 2012 celebration. Lynne

Monkey Wrench
(Churn Dash)

knew she needed key people to get involved, and Shelley Stein was at the top of her list. Shelley had been town supervisor, and her family also owns one of the largest dairy farms in town. Lynne said, "She understands agritourism and pride in family farms." In one person, Lynne had both of the ingredients that, combined, were key to success.

Lynne and I stopped off to see one of the Stein barns, and I was dismayed that it was a modern building that lacked the character of a classic barn. "Some say that it's an ugly barn," Lynne said, "but it's a working farm. I know on some trails they limit it to barns that are a certain number of years old, but we wanted to showcase agriculture in our town." The philosophy certainly made sense. Lynne went on to explain that the Churn Dash barn quilt occupied the space where a Stein Farms sign once hung. Obviously, these folks were staunch supporters of the quilt trail. The yellow and green in the pattern stand for the green alfalfa fields and

36

yellow corn, with black and white for Holstein cows. We both liked the choice of Churn Dash as it might also represent dairy farming, and when we met Shelley, I was delighted to find that there was a connection to a family quilt as well.

Shelley talked a bit about how she views the barn quilts: "We have such a strong agricultural history here. The old quilts were icons that represented people's families, the way they were involved in agriculture or what their skill sets were." Shelley had brought some of her great-grandmother's quilts to Lynne and told her, "These are my heritage; this is what's going to go on our barns." Shelley was concerned that perhaps the men of the Stein family would be reluctant because the quilts were from her family, but they didn't raise a fuss. Shelley is proud that her status as an eighth-generation North American farmer is wrapped into the local project and the family farm.

Shelley echoed Lynne's earlier sentiment that even though the barn doesn't have a long history, it has a place on the quilt trail. "For us it has history because our hands built it. And it's agriculture today." Though Lynne used the name Churn Dash for the quilt block, Shelley preferred its other name, Monkey Wrench, because the family designs and builds farm equipment in their shop.

The Stein's other barn quilt is also one of Shelley's grandmother's quilt patterns. Shelley said, "When you look at the colors of the barn quilt, you think, 'OK, they must be hippies,' but you can see that we really were very true to the colors of the quilt." Shelley spread the tattered quilt out on the floor, a riot of bright greens, oranges, yellows, reds, and purples. Lynne said that the fabrics were actually typical of the 1930s when the quilt was made. The pattern is known as Robbing Peter to Pay Paul and also as Nonesuch, and Shelley chose the latter for the barn quilt. The barn where the quilt block hangs has a unique color as well. The barn was yellow when purchased by the family in 1989, and Shelley said it will remain that color, adding just a slight touch to the hippie-like appearance.

Lynne and I left Shelley behind and continued on our tour. As the discussion veered away from barn quilts, I realized that Lynne was, in fact, a scholar with a wide knowledge of history. She shared some tidbits about the area and hit upon a subject that has been the topic of many a barn quilt conversation—Underground Railroad quilts. Several quilt trails include these "signal quilts" in their narratives, and both Donna Sue and I are dismayed each time we encounter them. I didn't share my view but waited to see what Lynne had to say.

Lynne acknowledged that an Underground Railroad route runs through the area but doubts whether any of the buildings were used as hiding places. "Think about it; you don't know where you are going or who to trust. This is close to Canada, so it was like a funnel, with a lot of law enforcement. Why would you try to hide in someone's house? I don't think so. You would stay outside so that you could hear people coming and would move along as quickly as possible."

37

new york

The subject turned to those signal quilts. Legend has it that quilts were hung outdoors along the Underground Railroad and that the quilt patterns were a code that provided information to escaping slaves. One pattern was said to mean "time to gather belongings and prepare for the trip," while another might signify the direction of safe travel. The stories were widespread, but they just didn't make sense to me. Quilt patterns are not readily discerned at a distance, especially in the dark. Donna Sue agreed, "Unfortunately, we put a romantic spin on a terrible time in our history. Just imagine crossing the Ohio River in the dark of night. You would barely be able to see where you were walking; how would you possibly find a quilt? It's interesting lore, but it's just fake-lore."

Lynne stated her views emphatically: "The signal quilt story is a lie. Academicians have studied it, and it is bogus. But it's a romantic notion. It's like Washington cutting down the cherry tree. It's so romantic, like King Arthur. People don't want to believe it isn't true. A family offered a collection of quilts to the museum that they said were signal quilts. They didn't like it when I told them they ought to print out the reams of scholarship." Lynne dismissed the topic and I was glad that an expert had confirmed the view that Donna Sue and I both held strongly.

That evening, Lynne invited Glen and me to a horse-driving competition. Glen asked with a deadpan face, "How exactly do horses drive? Are there special cars?" He reveled in that brief moment during which she considered whether the question might be genuine. Of course the driving was on the part of the humans, who guided the horses as they pulled various sorts of wagons. We strolled the grounds where spectators enjoyed elegant picnics and the women wore extravagant hats, relishing the opportunity to be part of a local event. The categories of competition ran from formally dressed ladies and gentlemen driving grand carriages to commercial vehicles. In this category, the brightly painted Jell-O wagon was entered, driven by Lynne's daughter, Laura.

Lynne's wagon commemorates the fact that the product was introduced in LeRoy in 1897. She told us that a carpenter who dabbled in patent medicines trademarked the name; it was not a patent, because there were other gelatin products already being produced. The company that bought the name began an aggressive advertising campaign that made the product hugely popular and profitable. Glen couldn't resist the brilliantly colored wagon, painted in glossy red and his favorite bright yellow. He posed between the front shafts as if to ready to be harnessed and pull, and I added a somewhat goofy photo to my collection.

I was eager to visit with Carol Frost and her daughter, Marny Cleere. Barn quilts are seldom painted in pastels, as they don't show up at a distance, but the dark brown of the barn and its position close to the road made for a lovely exception to the rule. When Carol arrived with the Lady of the Lake quilt, the picture was complete.

Opposite:
Nonesuch

following the barn quilt trail

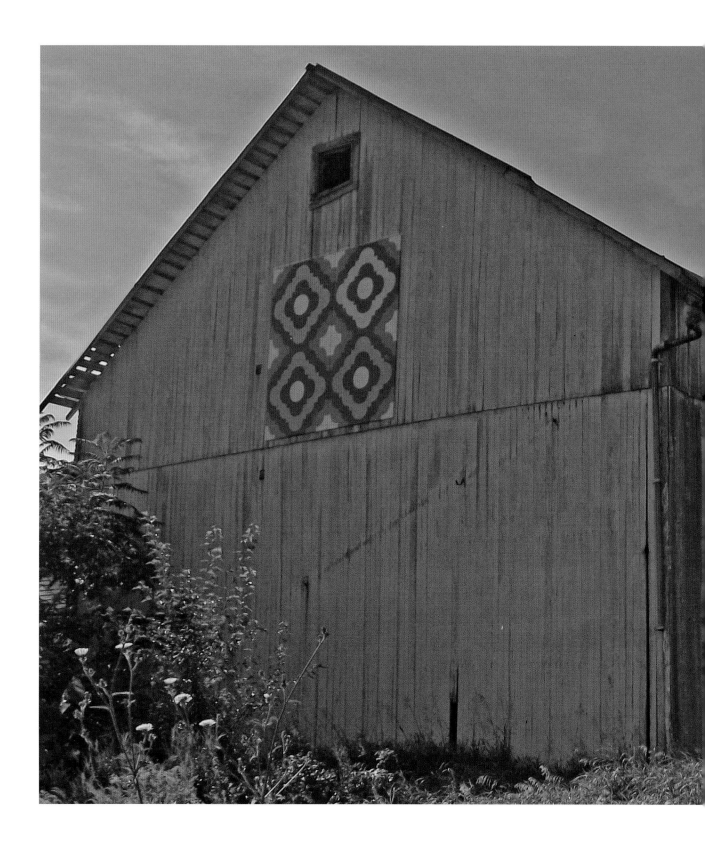

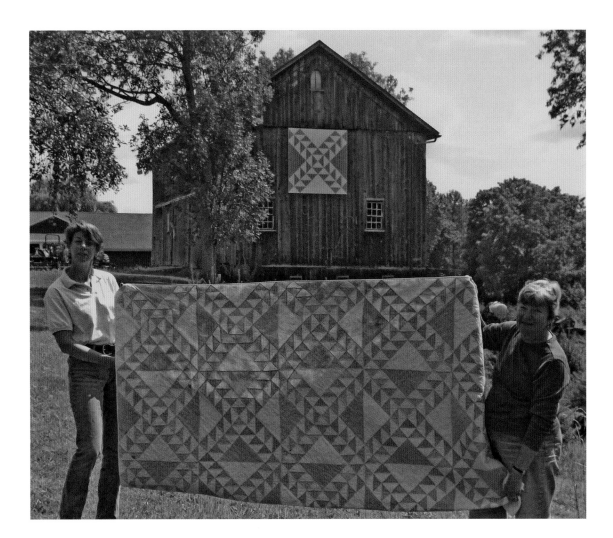

Carol Frost and
Marny Frost Cleere
with Lady of the
Lake quilt and barn
quilt

Marny said that the quilt belonged to her grandmother, who had left each of her grandchildren a family quilt. It had been pieced in 1867 by Marny's great-great-grandmother McPherson, using the pink fabric from one of her dresses. The McPherson family was one of many Scottish families who settled the area. "It reminded them of home," Carol said. The McPhersons were a prominent family; in fact the yellow barn that hosts the Stein family Nonesuch quilt block was a McPherson barn. The barn with the Lady of the Lake pattern is the last one on the complex where it stands.

The McPhersons were prolific diary keepers, and Marny's father, David, keeps the journals at hand and reads them regularly. Most journal entries are mundane discussions of the farm and weather, success and failure of crops, and the various additions to the homestead, but David chose a few of his favorites to share. Reading the handwritten text of the diary on pages deeply yellowed with age was quite

a treat. One of the earliest stories concerns Alexander McPherson, who emigrated from Inverness, Scotland, in 1801 and made his way to the area. A century later, Marny's great-great-grandfather, John McPherson, tells the story:

On reaching the Genesee River, "They found a good many families who wanted to get across the river but water was too deep at the ford. Grand Father McPherson did not propose to camp there until river went down, so suggested building a raft which they did. After raft was completed Grandfather was the first to use it. When he tried to drive his ox team onto raft one of them refused to venture on the raft, after long coaxing, which was of no avail Grand Father unyoked this ox and put his own shoulder under yoke and with the help of the men at wheels they succeeded in getting onto raft, and were poled across. When the ox saw his mate and cow going from him, he went into the river and swam across, none the worse of his cold bath."

Glen and I left the rich history of LeRoy behind and headed east to Schoharie, where quilt trail organizer Ginny Schaum and her husband, Bill, had generously invited us to spend the weekend. Here, the barn quilt community focuses not on history but on more recent events. The area was adversely affected by Hurricanes Irene and Lee in 2011, and a mural project had begun in Middleburgh to revitalize the community and make people feel good about the recovery. More public art was proposed to bring in tourists, and Ginny thought the quilt barn trail similar to the ones she had seen in the Carolinas would fit the bill. "People were overjoyed." Ginny said.

The ebullient mood was quite evident in Diana Cook's Garden Party quilt block, which is mounted on a restored former firehouse. I pronounced the block "spectacular" as soon as it came into view. The multiple designs within the block made it look like a cloth quilt and one that would have been fun to create. The block overlooks several garden plots where sunflowers and herbs proliferate.

Diana said that the building has had many incarnations. It was originally a church and then a firehouse, and later an upholstery shop. When Diana looked at the vacant building and saw the big wall between the windows, she thought it was perfect for a mural, and she wanted to move in. "My family thought I was nuts," she said. "The place was a wreck—needed new everything." The finished interior includes Diana's downstairs studio, with living space upstairs and husband Steve's shop in the basement. Diana showed us one of her quilts, which included half a dozen fabrics of intricate patterns. I could see why the complex barn quilt design appealed to the talented artist.

I admitted to Ginny that I did not know much about Hurricane Irene, the storm that had recently devastated the area, so she filled me in. First priority had

41

new york

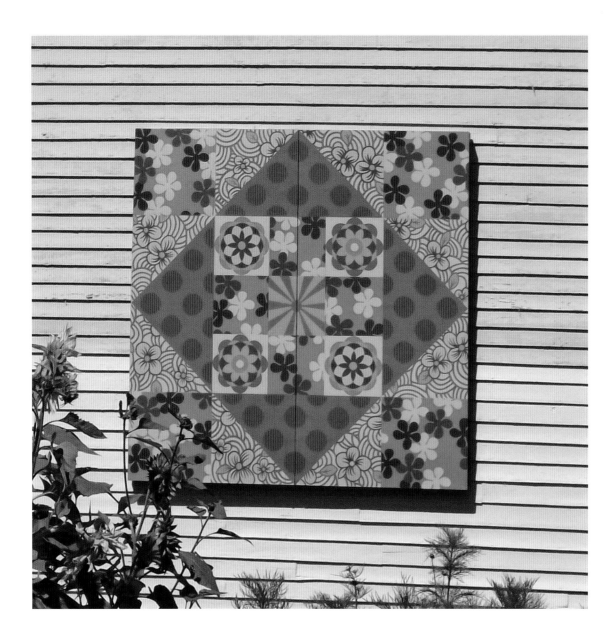

Garden Party

been to get people back into their homes. Some had their houses damaged or torn down; some had oil in their basements that mixed with their water. People needed furnaces and hot water heaters and kitchens ripped out, and some buildings were condemned. Ginny said, "I never realized how much I use the local grocery store. When it was gone, I couldn't get any fresh produce."

Ginny and Bill live on a mountain so they were not directly affected by the catastrophe, so as soon as they could make it to town, they worked with local churches, delivering food and bottled water to anyone who needed it. "The quilt trail is phase two of the recovery," Ginny said. "It's a happy phase to bring people back into the community." Ginny's partner in the endeavor, Sharon Aitchison, grew

following the barn quilt trail

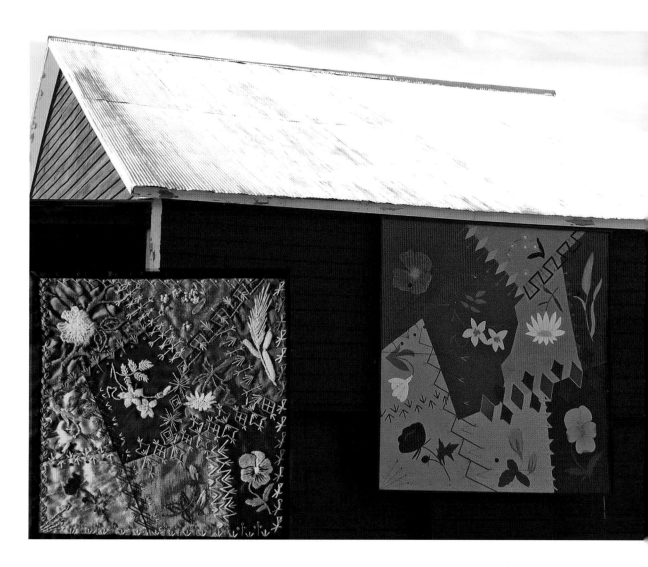

up in the area and was invaluable. As Ginny said, "She just knows this infinite number of people."

I adore crazy quilts, so the opportunity to meet a renowned designer was especially exciting. Betty Pillsbury's quilt block is an exact replica of one of her sewn creations. Betty explained how she became a crazy quilter. "Adjective on the quilt, not the quilter," she laughed. Betty taught herself to embroider when she was eight and learned new stitches from magazines. She practiced on jean legs and pillowcases and said, "I bugged my mother for floss and needles." Betty saw an article about crazy quilts about thirty years ago and has been sewing them ever since, eventually winning numerous awards and teaching the art to others.

The quilt that served as the model for Betty's painted quilt originated as a line drawing in a book of 1880s Victorian quilts. Betty stitched and embellished the

Stitched and painted crazy quilts

43

quilt and when a barn quilt was suggested, she wanted to paint the design as well. Betty also helped to create a community crazy quilt, another way to bring together those who were devastated by Irene. She pieced the blocks and residents could come by the library or Betty's home to add their own flair to the embroidery.

Betty is an herbalist and she took us out back to see her garden. I was fascinated by the mushrooms sprouting from logs lying on the ground. Betty explained that the hardwood logs are drilled and then dowels of sawdust and mushroom spawn inserted, and before long the rewards pop forth. Betty offered me some mushrooms for dinner, but of course I didn't plan on cooking anytime soon. I thought they were beautiful, though, so I accepted one to show to Glen. Months later, it still rode with us, dried and hard, a reminder of our time in Schoharie.

As Ginny, Sharon, and I approached our next stop, I exclaimed, "Oh, what a cool house!" The green-shuttered Victorian home with intricately designed woodwork grabbed my attention. Ginny was eager to visit the barn, which not only displayed a barn quilt but also housed a couple of historic carriages. After surveying the iconic vehicles, we ventured into the Best House to meet its director, historian Bobbi Ryan.

"It's like leather and lace," Bobbi said of the barn quilt. "The paint on the barn is worn, and you feel the history and richness that's in it. Then you have a piece of something new that ties in. I love this movement." The house itself was both the home and medical office of Dr. Christopher Best, a physician who practiced medicine from 1877 until just before his death in 1934. His son, Dr. Duncan Best, also had his office in the home where his unmarried sister, Emma, lived. The house was given to the area library, to be kept as a historical and medical museum.

The ornate house was impressive, with wooden fretwork in many of the rooms and original chair rails still in place. Dozens of photos are scattered throughout, from oval-shaped family portraits to local scenes of hops growers in the nearby fields. I looked around at the carved wooden furniture and horsehair cushions and could not imagine that a modern family had lived among it all.

I had seen homes restored and furnished with period pieces, but the collection of personal items here was astounding, and all had been in the house when it was turned over to the library. The family saved everything, from furniture to Victorian-era dresses, capes, and hats. "You could lock yourself in and stay for days and days," Bobbi said. "They never threw anything away, and I am so thankful for that."

The collection also includes quilts, hundreds of them. There is no documentation as to the quilters; some may have been produced by the women of the house and some perhaps given as payment for medical services. As we studied a couple of the quilts, Ginny and I agreed that hand quilting is by far our favorite. The blue and white quilt that is reproduced in the quilt block on the property was a fine example.

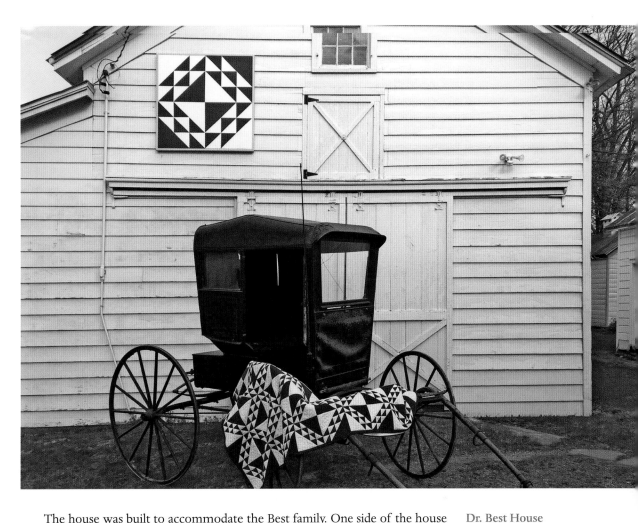

The house was built to accommodate the Best family. One side of the house served as the medical offices, which could be closed off from the living area. "The doctor could practice on one side of the house and you could be in your jammies on the other," Bobbi said.

Medical records of everyone who saw the doctor are still intact, including Bobbi's grandmother, who was delivered by Christopher Best, and her mother, who remembers that it was a bit scary visiting as a child. "If you lived around here, this was your practitioner," Bobbi said. Christopher Best was no simple country doctor. He stayed abreast of medical journals and was always cutting edge.

A rather unusual artifact was the electrostatic machine, where a patient would sit with a sort of crown on his head and be treated for any number of things. Bobbi said that the machine was used to treat old age, abscessed teeth, gray hair, and alcoholism. The machine could also generate X-rays, and turn-of-the-century images were found on the premises.

Dr. Best House
Photo by Bobbi Ryan

45

new york

The doctors served as their own apothecaries and filled prescriptions in a room off the examining area. A handwritten prescription for Lysol surprised us, as I had always thought it a modern name brand. Dozens of glass bottles lined a shelf, and Bobbi told me that thousands more were stored on the property. "I guess he knew recycling would be big someday," she smiled.

The kitchen fascinated me the most. A surgical table was situated near the double sink, and a cast-iron stove was used for cooking meals, for sterilization, and also to heat the upstairs through vents above. The tins and bottles that lined the wooden shelves looked nothing like their more modern counterparts but held many of the same staples—spices, cornstarch, coffee, honey, and corn syrup. Except for that table, the kitchen looked very much like the set for a 1920s movie.

As we exited into a hallway, we heard Sharon exclaim, from upstairs, "Wait a minute, this is hair?" Bobbi explained that she must be looking at a hair loom. We needed to get going, but curiosity got the best of me. The woven hair was kind of creepy but a beautifully intricate work of art. We wondered whether the piece was created from just one person's hair or from that of several people. Ginny mentioned that she had a hair loom as well, so I supposed they were not that unusual.

Bobbi was right in that I could have locked myself in that house and wandered for a full day, but others were waiting for us. With some reluctance and with the promise of a return visit to the Dr. Best House and Medical Exhibit, we continued our tour.

Marge Becker extended a gracious welcome to Ginny, Sharon, and me, and immediately started talking about her choice of quilt block. "I knew it was going to be a sort of forever thing, and I couldn't change it with the seasons like I do my wreaths," she said. Faced with the choice of a single season, Marge picked fall. "When the leaves are all turned, not that I am looking forward to cool weather, but that is such a pretty time of year." Marge had made frequent trips through Amish country to visit her sons in school and had purchased an Autumn Splendor quilt on one of her trips, and the quilt was used as the model for her barn quilt. I admired the green paint on the barn, and Marge said that it was part of a complete renovation that included a new foundation for the structure.

I was surprised to learn that Marge was more than ninety years old, but her age fit with her discussion of the family business, the local phone company. Her father bought the fledgling company and the phone lines for one hundred farms when Marge was six months old. Marge and her family still run the company, one of a handful of independent phone companies in the state. Marge said, "These days it's changing so fast. We are getting into the wireless and Internet and all of that. We are running fiber to other towns as we speak." I have to admit that I was amazed that a woman old enough to be my grandmother was intimately familiar with the latest in telecommunications.

Opposite:
Autumn Splendor

following the barn quilt trail

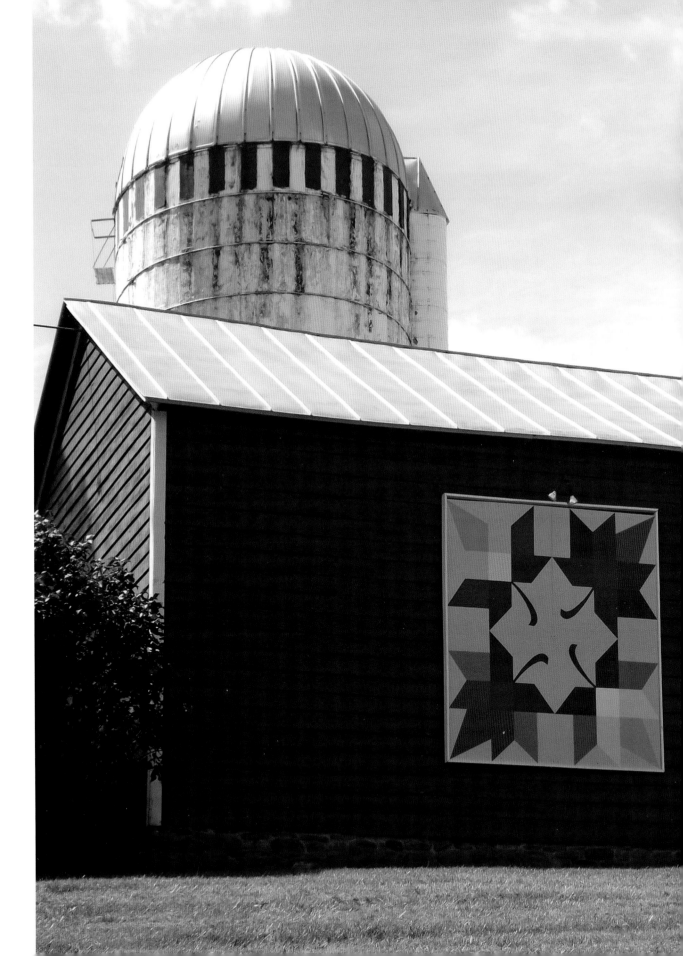

Marge is not just part of the company in name but an active participant, as she has been for many years, even more so once she got married and her husband went to work for her father. Marge taught school but worked at the phone company during the summers. She said, "When my husband needed someone to get easements or get someone to stake a pole line or something, I'd get one of the fellas and go out. I miss that. Teaching school, you were inside all of the time, so during the summer, I loved the chance to be outside. Of course that was back when if you were alive and breathing you could teach." I chuckled a bit at her assessment, having recently left the profession myself.

Marge went on to talk a bit about the events of the flood. "Every business was closed. We didn't have a place to go to eat and couldn't get our mail." Her hilltop home wasn't damaged, but Marge agreed with Ginny that the tragedy did benefit the community. "If there was anything good that ever came from that flood it was the resilience—everybody came out of the woodwork. Anybody who had grudges with anyone in the community, it just went away. It was the most amazing thing the way that people helped one another and everyone became so close."

The surrounding community has been good to the family, and Marge has plans to build an athletic center for the use of all its residents. She said, "I have a big bucket list of things for the village. People have been so loyal; you have to give back. If I can just swim in the pool, that will be okay. But it probably won't happen in my lifetime." I left Marge behind thinking about what an incredible lifetime it had been so far.

We headed into Middleburgh where we met up with Bill and Glen, who had spent the day cleaning cattails out of Ginny and Bill's pond and relaxing on the mountain. Glen reported that Gracie had enjoyed running around the property and had fetched decoys in the water. I worried about Gracie's health, as she was then thirteen years old, so I always liked to know that she had been active. After their time in the water, Glen said with a smile, "We sat on the beach by the pond, sat in the shade under the tree, sat on the porch." I was glad that he seemed to have enjoyed his day and, once again, was grateful for Ginny and Bill's hospitality.

Our visit closed with a celebration of the local hardware store's 125th anniversary. Country music played under a tent where dozens of families were gathered for a cookout. The mood was like a reunion, with kids playing along the fringes and adults talking from one table to the next. I loved hearing familiar songs played so far from home and grinned when I heard the lyrics from the stage: "You'd better leave this long-haired country boy alone."

When a watermelon-eating contest was announced, the emcee asked whether anyone in the crowd might be willing to take on the local champ. Glen is naturally reserved, but he does have a healthy appetite. I shouted his name, and before long the chant began: "Glen! Glen! Glen! Glen!" He nodded his agreement, and almost

immediately, I regretted having urged him to do so. He was wearing his Paddle Georgia 2011 T-shirt, a one-of-a-kind memento of the trip during which we had met. With his shirt turned inside out to minimize staining, Glen chomped and spit and chewed as fast as he could. In the end, he took second prize and donated his small cash winnings to the local quilt trail, in recognition of the warm welcome we had received in New York.

ohio

OUR LITTLE FAMILY moved on to southern Pennsylvania and a two-week break from travel. With no quilt trail stops to make, we began a series of lackluster stays in chain motels. The rooms were confining with no natural light, as opening curtains meant exposing ourselves to passersby just inches away. I appreciated having the downtime but missed the camaraderie of our visits to LeRoy and Schoharie, and the expansive lawns and pastures that had surrounded us. Restaurant fare was a poor substitute for the home-cooked meals we had enjoyed. And I was irritable from lack of sleep. Glen rises early and by the time I wake, he has been at work for a couple of hours. During our recent stays, he had been able to work in another room, and I could sleep undisturbed. Now we were in a shared space. Glen could not work without light, and I could not sleep with it. The clang of a spoon against a coffee cup, the jangle of Gracie's leash, the creak of a chair broke both the silence and my rest, and chattering keyboard clicks kept me awake.

The bus would not be ready for another three weeks, and we both were miserable and moody. We could not survive if we allowed our bickering to escalate. With some trepidation, we agreed to state our grievances with an eye toward problem solving rather than recrimination, and together we found solutions. Now Glen's soft voice woke me each morning, "Here is a towel for your eyes and here are your earplugs. Shh, now go back to sleep." We agreed that Gracie would wait a couple of hours before her morning walk, a habit that continues to this day. Our mutual dissatisfaction with constant restaurant meals led me to scour cooking websites for motel-friendly dishes. I put together a traveling pantry that included essential spices,

then visited a thrift store to find suitable utensils and dishes. Being able to prepare a simple meal of spaghetti with a Caesar salad in our temporary home restored a sense of control. It took a week or so, but together we created a pleasant motel lifestyle. More importantly, the habit that we developed during that difficult time—of sharing our frustrations and asking for each other's help—has served us well since.

Time away from the quilt trail did give us a chance to explore Pennsylvania. A kayak tour on the Susquehanna River took us through the heart of Harrisburg, a lazy day baking ourselves in the sunshine that we had craved. Gettysburg was a highlight of the year. The battlefields were immense, and driving through them impressed us with just how momentous the fight had been. Glen was especially moved when we stopped to read about a "witness tree" that stood near the road. "Can you imagine? This tree was here, right in the middle of things. It makes you realize that it just was not that long ago."

Heading west a week later, I was surprised at the terrain. Somehow, the Keystone State of my imagination was mostly flat; instead this was the first time in our trip that we encountered mountains. Part of me was glad to be in the nimble car rather than in the bus as Glen negotiated the twists and turns. Dozens of barns appeared along the roadside—red, white, gray, even yellow—some just a few yards from the highway. Most seemed to be in good repair, and some were larger than any I had seen, grand dames surveying the landscape and marking centuries of change. I couldn't help wondering how many barns had been lost when the road shoved its way through. After a day's long drive, we passed through the last tunnel and wound our way down the mountains to Ohio, birthplace of the quilt trail.

The corn was up, and abundant fields lined the roads, vivid green curtains shielding our view for miles at a time. As we neared our destination, a Victorian house with rounded towers and extravagant gingerbread trim popped up out of nowhere; we simultaneously said, "Wow. Look at that!" We drew close and were ready to stop for a closer inspection when we realized that we had arrived at Barb and Jim Gabriel's home, where we would be staying for the next few days. The interior of the home fascinated us. Dormer windows over each dark-planked door swiveled on pegs, and tall ceilings were higher than even Glen's long arms could reach.

There is nothing better than waking up to a cool morning with windows open, hearing Glen's voice from downstairs, enthusiastically engaged in conversation. He would spend the day alone, so this morning social time with our hosts was his. I lingered upstairs for a while, not wanting to break the spell by emerging downstairs before time to hit the road.

As Jim drove, Barb told me a bit about the Hancock County Quilt Trail. Several barn quilts were already in place nearby when Barb decided to create one for

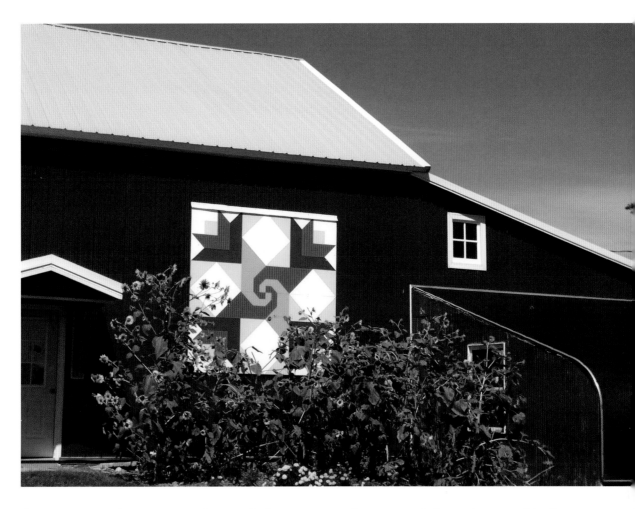

their property. Barb was soon working with the Arts Partnership to expand the quilt trail. During an event called Artswalk, a block designed by art teachers was painted by college students but no location for the quilt square had been determined. Jim pointed out the quilt block, mounted on an old grain elevator standing out front of a car dealership. "He didn't really know what he was agreeing to," Barb said.

Interest grew, and Barb soon found herself very busy producing barn quilts. Of course, the Gabriels added quilt blocks to their property, a Compass and a variation of the Ohio Star, which are easily visible on new garages next to the drive. One of the buildings is also home to a workshop where both Barb and members of the local community paint quilt blocks.

The quilt design on Dave and Jan Reese's barn echoed one that was well known to me. The center swirl of their quilt block resembled the Snail's Trail on Donna Sue and Maxine Groves's barn in Adams County, but the unusual colors

Flowers and Snails

53

ohio

and yellow flowers around the fringes marked it as an original. Jan invited us inside for lavender-infused lemonade and said that she grows flowers, including fragrant lavender, as a business. Before long, we were behind the barn checking out the lavender labyrinth she had created. Now the patterns and colors of Jan's Flowers and Snails quilt block design made sense.

Dave is the third generation on the family farm and remembers the dairy barn fondly as "full of noise and lots of chaos." His grandfather purchased the barn in 1918, but through Friends of Ohio Barns, the building was dated to the 1860s. The barn was in poor condition, but Dave and Jan had no qualms about the very costly renovation. "It was really important to us to save the barn," Dave said. "Jan's work area has brought new life to the barn; I think the barn quilt symbolizes that new life with the restoration and the barn being repurposed."

We drove with Dave to nearby Kaleidoscope Farms, where he had started a farm about twenty years earlier. The couple wanted their sons to experience farming because, as Dave said, "There are values that only come from growing up on a farm and having chores—the value of hard work. The farm grew mushrooms and raised sheep and Great Pyrenees dogs, but eventually Christmas trees seemed the most prosperous. Now twelve hundred to two thousand families visit each year. "Seeing my boys interact with customers is priceless," Dave said. "They learned well, and now the grandkids are set to learn the same values. It's a dream come true."

A Double Aster quilt block on the side of a brick building was visible as we approached our next stop. As we got out of the car, Barb pointed out three additional blocks on a barn at the back of the property and introduced me to one of the most ardent supporters of the local effort. Tom Rader welcomed us into the 1870s schoolhouse that he and his wife, Pam, had restored. The exposed wood beams and brick walls of the interior created a wonderful space for antique furnishings and quilts hanging on walls, on racks, and across furniture. Larger pieces in progress stretched out on racks waiting in turn. The studio would have been the envy of many a quilter.

The barn where the three quilt blocks—Star of the East, LeMoyne Star, and an unusual Star Table Runner—hang is a modern building. "When you spend that kind of money on a barn, why not decorate it up?" Tom said. Corn was visible on one side of the property but not in front of those barn quilts. Tom intends to grow only soybeans and wheat so that the quilt blocks that he is so proud of are visible all year. It was no doubt the first time I had heard of a farmer changing his planting scheme to show off his barn quilts.

"Now I look at barns differently," Tom said. "When I see a barn I tell them it needs a quilt."

"He gets credit for the whole row in the neighborhood," Barb added.

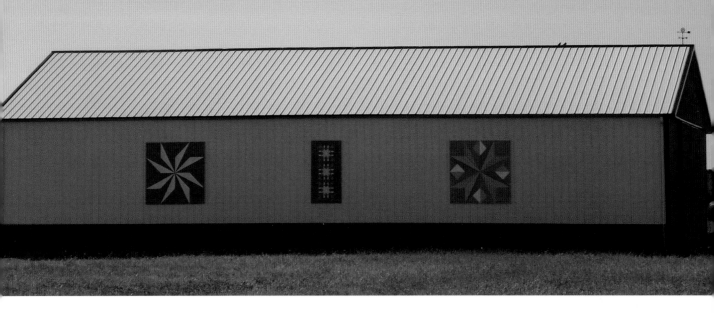

Barb Gabriel has made lots of new friends through her work and is proud of all that the community has accomplished, both with her help and on their own. Anyone who creates a barn quilt is welcomed to the quilt trail. "I don't care who paints it," Barb said. "I want to get them on the trail."

Barn quilt trio: (*left to right*) LeMoyne Star, Star Table Runner, and Star of the East

Glen and I left the Gabriels and the quilt trail behind and headed to Adams County, where a special event was scheduled for the next evening—a benefit for Donna Sue to help defray her mounting medical expenses. She had survived breast cancer but a host of other health issues remained.

Jo Hall had offered to host the benefit dinner in the event facility that she owns. Appropriately enough, we were greeted by an array of quilt blocks that lined the fence out front of the building. A larger block on the building itself, Jo's Sunflower, is dedicated in memory of Jo's mother, Dot Stern, and husband, Jim Hall, and her friend Ralph Burnes, who worked with Jo to establish an annual festival on the property when she was starting her business.

Inside, over one hundred friends had gathered for dinner, served by women of the local Amish community. The evening's auction included baskets of local goods sent by quilt trail organizers from across the country, in recognition of the role that Donna Sue's vision had played in their lives. Adams County residents John and Sylvia Stadtmiller have made a business painting and selling custom barn quilt blocks for customers both near and in neighboring states. John and Sylvia donated for auction a brilliantly colored quilt block which was second only to one of Maxine Groves's quilts in the excitement that it created in the bidding.

55

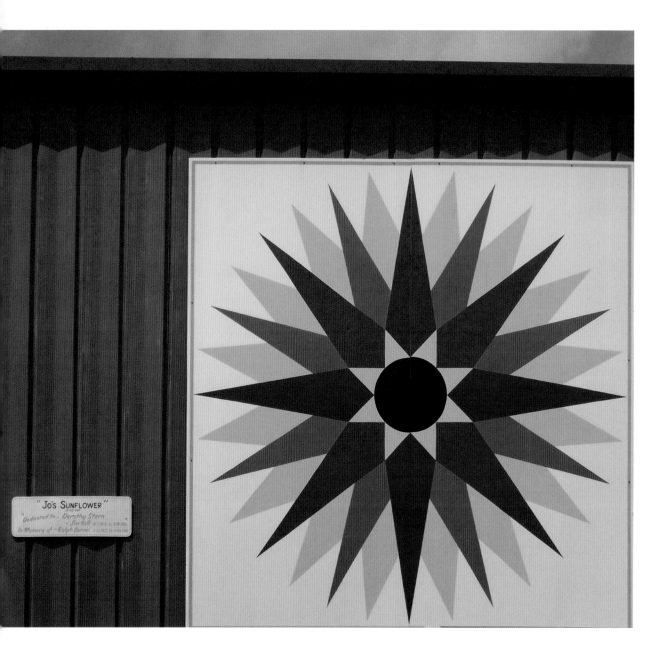

"JO'S SUNFLOWER"
*Dedicated to... Dorothy Stern
~ Jim Hall 12-7-1923 to 8-19-2001
In Memory of ~ Ralph Burns 11-23-1925 to 9-09-1998*

Jo's Sunflower

Glen and I had no need for artwork or other décor, but a black raspberry pie caught Glen's eye. A consumable item was just right for us, and, in-between flitting from table to table visiting with quilt trail friends, I managed to win the bidding. The pie was scrumptious, and helping to support Donna Sue made it that much more so.

At the close of the evening, Donna Sue spoke to those assembled about what the quilt trail has brought to her.

56

following the barn quilt trail

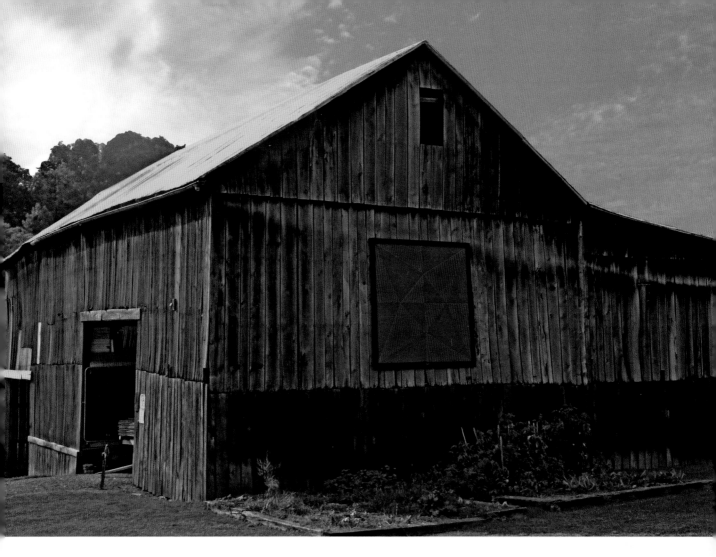

It is the camaraderie, the forging of new friendships; it is finding our commonality. It is realizing we are not alone in our dreams, hopes, and desires. At the end of the day we are left with one another—knowing our quilt trail network includes new friends that helped develop something special. As the quilt trails spread across the nation—our network of friends becomes stronger and unbounded. Yes, I am blessed. I found the joy factor thirteen years ago and I celebrate each of you as I watch you grow and as I listen to you talk about finding your own "joy factor!" Life is good.

Glen and I drove down to the riverfront the next day to meet Donna Sue for lunch at Moyer's Restaurant, where Donna Sue and I have eaten often enough to have a regular table. On the way, I spotted a barn quilt with which I wasn't familiar, and since we did not have time to spare, we marked the location. A couple of hours later, Glen and I returned and found Joe Newman on his tractor. On seeing us, Joe stopped his work and walked over to welcome us.

Tippecanoe

57

ohio

Joe had moved to the area from England. His wife, Lisa, is from nearby Pike County, and when visiting the area, the two decided to make the move. "We brought the kids kicking and screaming," Joe said. Once they had settled in, the couple started to notice the barn quilts sprinkled throughout Adams County. Joe had no idea that he lived in the spot where the quilt trail began. "It just seemed like you had to have one of these things to fit in around here," he said.

Lisa suggested a simple pattern, and Tippecanoe was the choice. I was familiar with the pattern but not with the name. That wasn't all that unusual, since quilt patterns often have multiple names; I had heard this one called Crossed Canoes. Glen and I had admired the block but, of course, preferred its lesser-known name, Crossed Kayaks. The quilt block hangs on the barn just behind the home, but a smaller building a bit farther back on the property was of far more interest to us.

The log cabin that Joe was building was actually being reassembled, as he had found it inside a tobacco barn, disassembled it, and moved it to his property on a trailer. We walked inside to admire the structure, and soon Joe and Glen were clambering up and down stairs and between the supports, discussing the details of the construction. Joe pointed out the Roman numerals he had chiseled into each of the rough-hewn timbers. Each notch was marked so that he could match them correctly and then refasten each pair using wooden pegs. "That place was mighty nifty," Glen said as we walked to the car, and I was glad we had stumbled upon Joe and his cabin together.

As Joe had noted, Adams County is host to dozens of barn quilts, and, like him, many local residents had painted quilt squares on their own. One addition was the Pineapple block at the Rock, where Susan and Doug Ruehl have a vacation rental across from their home. Quilt blocks are known for bringing attention to out-of-the-way destinations, and Donna Sue suggested to Susan that they add one to the property. There was one problem. The building cannot be seen from the road, so a barn quilt mounted there would not have the desired effect. Donna Sue offered a simple suggestion. "You can make something."

Doug had a construction and excavating company, so it seemed natural that he would build a wall of stone on which to hang the quilt block. "I started out with a little bitty wall," he said, "but I ended up with a great big one." Over one hundred pieces of stone comprise the wall, which Doug said amount to about four hundred tons. Susan chose the Pineapple pattern to stand for the hospitality that they extend to their guests, and artist Randi Gish-Smith painted the brilliantly colored quilt square.

Another Adams County business is home to several quilt blocks, but this project is quite unusual. The walls inside Ann Taylor's quilt shop, The Quilt Barn, are lined with quilt squares, each a replica of one of the original barn quilts on the nation's first quilt trail. "I wanted to incorporate the quilt trail," Ann said. "After

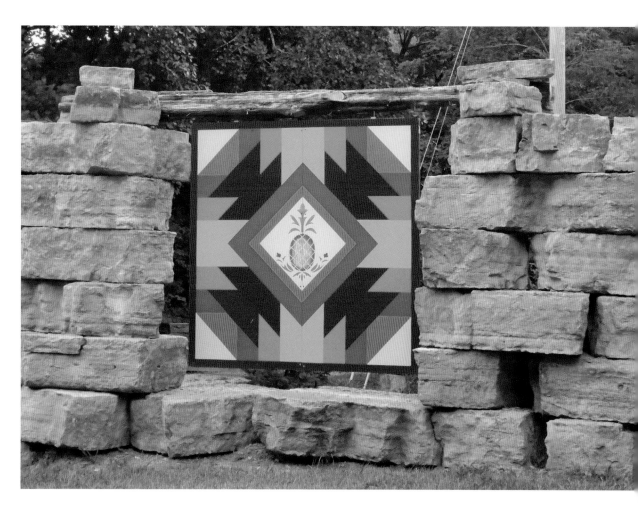

all, I am right in the middle of it!" Though the barn quilts in the area are fourteen years old and showing their age, Ann's brightly colored reminders of the nation's first quilt trail will remain perfectly preserved.

Pineapple

■

One Sunday morning I left Glen and Gracie behind to take a quick tour of the quilt trail in Tuscawaras County, where extension agent Chris Kendle had facilitated the project with the county's 4-H clubs.

The morning sky was blue on one side, white on the other. Each time the GPS announced that I was approaching my destination, I thought, *Please let the barn be on the blue side*! Each time I drove past a barn or around a curve, I felt that sense of the hunt that I hadn't experienced in a while. Sometimes when I made a precarious turnaround in the middle of a curve or hill, I could imagine the headline: "Georgia Author Killed in Tragic Accident." Or perhaps more accurately: "Georgia

Author Dies of Stupidity." I was relieved when the next stop on my list turned out to be a quilt block on an easily accessible barn. Lynn and John Foust were at home and invited me into their garage where they were hard at work.

Immediately, Lynn apologized that the garage might smell a little gassy, as the two were getting ready for a tractor pull. John added that they would travel all over the Midwest in competition and that Lynn had won the national circuit 3500 division last year. In answer to my quizzical look, Lynn explained that the 3500 designated the combined weight of her and the tractor. "I am a woman in a man's sport," Lynn said. "It took a while but I am really respected by the men. We have friends all over the country; we are from all walks of life but we have this one common thing that we love."

"Everywhere we go, it's like family," John said. I asked whether there were prizes involved in tractor pulling, and Lynn said that the only things she earned were bragging rights and a jacket with her name on it. She quickly fetched a bright red wearable trophy for me to see. Lynn told me that she pulls a sled, like a semi-trailer but without tires, with a Ford tractor. The sled would be placed on an incline with a pin on it, that goes into the ground as the sled is pulled.

Having learned about tractor pulls, I was ready to find out about the Foust's barn quilt. The 4-H quilt square represented the importance of the organization to their lives, both as young people and as adults. The two met fifty-one years earlier at 4-H camp. "Then we returned to our friends and our lives. He was from south of here, and I came back here," Lynn said.

"It was a good weekend," John said, as he continued the story. Lynn had given him her phone number, and in December he called. "John, who?" She asked, almost causing him to hang up. He said, "John from 4-H camp. I wondered if you wanted to come and go out to a movie."

"It was *West Side Story*," Lynn recalled. The two were together from then on. They even attended each other's proms, and John reported that the city girl with her strapless gown was quite a hit with his small-town classmates.

The two married at nineteen and, once John and Lynn moved to the farm, they started their own 4-H club. Lynn said, "We weren't much older than they were. We camped up on the hill—I can't believe they let us do all of that." The 4-H members were like family for John and Lynn. "It was fun, really special, having that bunch of boys always around," Lynn said. One family had ten children, and all but one were members of 4-H with the Fousts. Lynn talked of one who lived in their basement for a year after his parents kicked him out and another who used to go with them pulling tractors. The boys made themselves at home, and locked up after themselves if they were at the farm when John needed to go on the road for work.

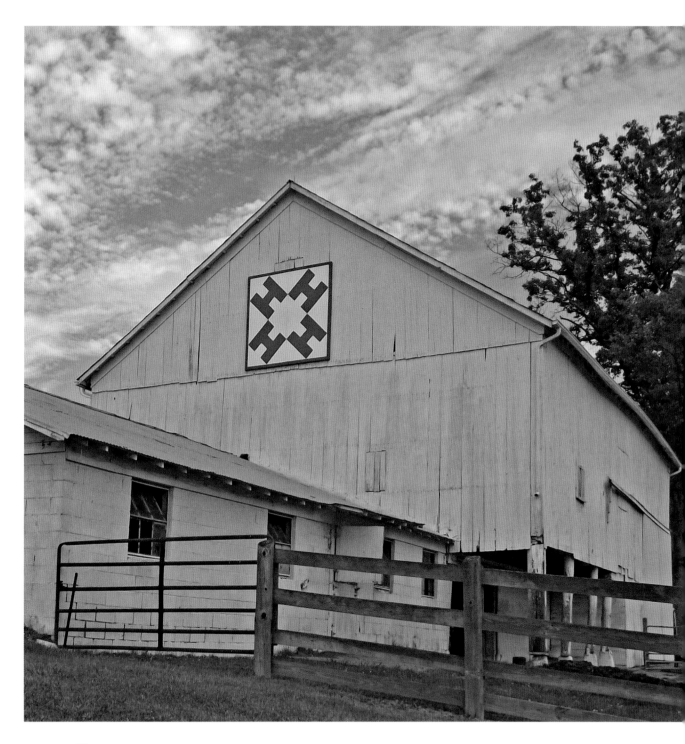

4-H

Kathy McCarty tentatively asked the quilters in Ashtabula County whether they were interested in creating a barn quilt trail, and said the next thing she knew, "we were in it knee deep." Along with quilter Chis Angerman and with the support of several community organizations, a steering committee put together a plan to install a barn quilt in each of the county's townships. "We thought if we could do that, we would have a trail that would take someone all over the county," Kathy said. From there the project began to take on a life of its own, with more than forty blocks in its first year. Kathy said, "You don't plan your trail; your trail plans you. Now I am learning a lot about the county where I have lived my entire life."

Glen and I enjoyed the county, especially the rails-to-trails bicycle path. He loved riding the gravel roads of RV parks, but for me the uneven terrain proved treacherous, and I much preferred paved routes. Glen thumbed through the brochure that contained barn quilt locations. "Hey, this area is known for covered bridges and wineries. What's not to like about that?" We delighted in being able to drive through a couple of the bridges and reading about the structures of both old and new. Of course my favorite didn't actually span a river but happened to be adorned with a quilt block.

Local historian Carl Feather is a member of the barn quilt steering committee and also an expert on the historic structures. He shared his knowledge of what had come to be called Benson's Bridge. Like many in the area, the bridge was built using the Town Lattice design, in which diagonal planks are pinned together. This design was fairly easy to build because a sawmill could be erected near the stream and the wood cut on-site. No carpentry skill was needed; once the holes were drilled, local farmers might be hired to perform the actual labor. The bridges were inexpensive, with the stone abutments being the major cost. The floor of such a bridge might have two rows of planks down the middle for tires to run on, which could be easily replaced rather than installing a completely new floor.

Feather said that though the saw marks on the timbers might give an idea when they were initially cut, it's hard to be certain when a bridge was built. Bridges would wash out and then be rebuilt. During the Great Flood of 1913, this particular bridge was washed away from its original spot over the Grand River. The timbers were collected and brought to a spot where a new bridge was needed across the east branch of the Ashtabula River.

The timbers were reassembled by Albert "A. D." Benson, with the help of his son-in-law, who milled the red beech plans for the floor and made the wooden pins that held the trusses together. The round pins, about the diameter of a silver dollar, fascinated me; they appeared so smooth and uniformly formed. Feather explained that they were created by driving an eight-inch block of oak or hickory through an iron throw to form the round shape.

The bridge sits in a grassy park, an extension of the lawn next door. Robert Benson and his wife, Helen, rescued the bridge when it was set to be replaced by

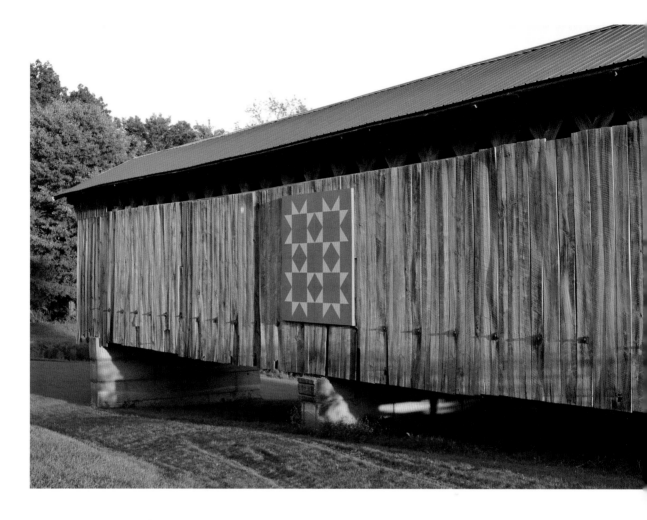

Four Stars
*Photo by Carl E.
Feather*

a stronger structure. Robert said that the bridge was never strong enough to carry the loads farmers needed to haul across the stream or the wagons full of gravel from a nearby pit operation. When he was a boy, a gravel pit operation was nearby. If a team pulling a wagon full of gravel had to cross the stream, it would descend the hill on a spur and ford the east branch rather than risk crossing the bridge with the heavy load. By 1970, the bridge was slated for replacement.

In the summer of 1971 the bridge was moved to the current site and installed on a permanent foundation next to the Bensons' home. The county replaced the roof and siding and since then the bridge has been the site of many a picnic and even the occasional wedding. Robert assists with events at the bridge by running a power cord to the structure if electricity is needed and keeps the grass neatly mowed, as it was the day we visited.

The Four Stars barn quilt was dedicated to the Benson family in recognition of Robert's grandfather who rebuilt the bridge, the family's generosity in giving

63

the land on which the bridge sits, and their being good stewards of the bridge for more than forty years.

Jenny Morlock, who works with 4-H clubs through the Wood County extension office, contacted me to share some information about the Wood County 4-H Quilt Square Trail. Wood County turned out to be not too far off our path, so of course I signed on for another quick detour.

Creating a quilt trail had been on Jenny's bucket list for a while, as her mom and both grandmothers were quilters, and she had seen the 4-H Quilt Trail in nearby Greene County. Meanwhile, 4-H leader Karen Kotula attended a talk that Donna Sue Groves gave and said, "It was like a two-by-four hit me over the head." The two women joined forces with Karen as committee chair and the county's 4-H clubs painted the blocks. The blocks were sponsored by a local family or business, and several are dedicated to quilters.

I became fascinated with the creative names of the 4-H groups and the way they reflected the clubs' missions. The Beaver Creek Boosters, Leaders of Tomorrow, and Perry Go-Getters were indicative of the organization's focus on leadership. Clover Crew, Colorful Covers, and Four-Leaf Clovers referenced the 4-H logo, which in turn represents Head, Heart, Hands, and Health. Blue Ribbon Rangers and Livestock Unlimited surely pointed to participation in county fairs. I was surprised that one club—Stitch, Stir, and Stock—seemed to incorporate traditional women's activities of cooking and sewing. And as for the Black Swamp Outlaws, I was a bit puzzled until I was told that the club was sponsored by the county sheriff.

The Wood County 4-H quilters created a signature Hole in the Barn Door block in 4-H green, which was mounted at the county fairgrounds. The block was dedicated in memory of Dena Henschen, the grandmother of Jenny Morlock's husband, Robert, as it was one of her favorites. Each of the quilt blocks that has been added to the trail includes a tiny replica of the original block, a logo that serves as a reminder of the project's roots.

Arnold and Barbara Brossia's barn was one of many I had seen in the area that looked like two separate structures joined at right angles; the barn's brown paint was also unusual to me. Barb grew up in the area and remembers that when her family made car trips, she begged to drive by the barn to see the horses on the farm with its yellow barn. "I never dreamed that I would own it," she said. When she and Arnold met at a mutual friend's wedding, he and his brothers had already purchased the land and barn, and later, when the house came up for sale, Barbara and Arnold moved to the property. Their son, Adam, used the barn for his 4-H pig and steer projects, but these days, Barbara said, "The only animals are a herd of cats."

Barbara shared with us the most dramatic event of the family's time on the farm, a tornado that ripped through the area in June 2010. The storm cut a pathway

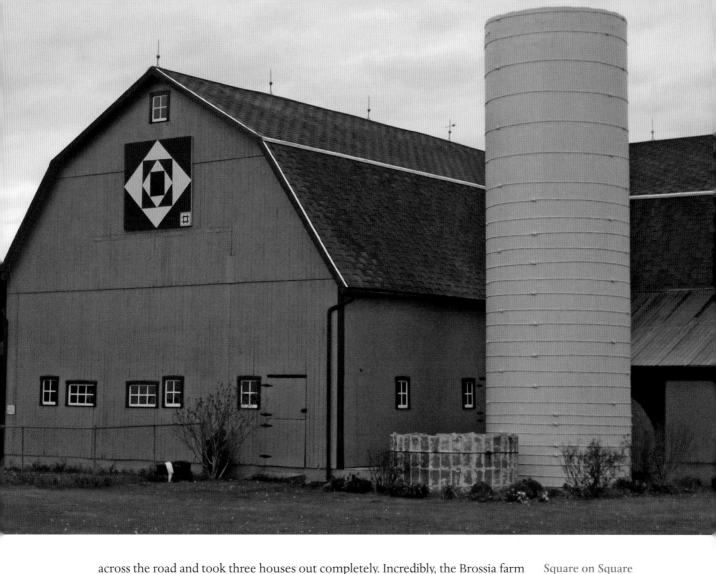

across the road and took three houses out completely. Incredibly, the Brossia farm was unscathed except for a couple of trees that were plucked from the ground, but debris stacked up in the fields. Barbara had a scrapbook full of photos of what ended up as two dumpsters filled with plywood, glass, railroad ties, and other material from nearby farms. A couple of cell phones were found as well, and I couldn't help hoping that they had been on a table and not in someone's hand when ripped away.

The Square on Square quilt block was chosen by the Farmcrafters 4-H club. The barn had been painted brown to match the siding of the house, and Arnold thought brown and orange would work well in the quilt block. "He had to be convinced," Barbara said, but the choice of red and black to represent International Harvester farm equipment suited him fine.

Square on Square

65

ohio

Clinton County quilt trail organizer Diane Murphy had kept me abreast of the quilt trail's development for several years, faithfully sending the newspaper articles that accompanied each of the county's barn quilt hangings, and I had promised her a visit. Diane was inspired after reading an article about Miami County, Ohio, and the quilt trail they created for their bicentennial. Clinton's celebration was coming up in 2010, so the timing was perfect. The community had lost a lot of jobs recently, and Diane wanted to do something that would be positive. Quilt shop owner Carol Earhart worked with Diane to organize the project, and soon they had a core group of volunteers painting, with the local vocational high school building frames for the first thirty blocks.

Diane and I visited with Carol, who talked a bit about her quilt block. Her father, Earl Jenkins, had passed away three years before the project began. He had been a woodworker, so Saw Blades seemed the perfect tribute. The block includes four round saw blades, each in a different color. Carol's daughter Stephanie picked yellow, and her son William, green, to represent his service in the army. Carol and her husband Kevin added purple, and Carol's mom, Anna, selected blue as her husband had served in the marine corps. The border of the block is red to represent the cardinals that Earl loved. Carol said that her son helped paint the block but was reluctant to do so, as he was afraid he might mess it up. When he finally came out to paint, he said, "You didn't tell me it was paint by number!"

The Atley farm is home to a white barn that is nicely situated for barn quilt visibility, on a ridge facing the interstate highway. Diane had promised that the Atley's choice of Indian Trails for the block was significant. Barb and Denny Atley greeted us enthusiastically, and as I made my way towards the sofa, I noticed the dreamcatchers over the fireplace and other Native American themed décor throughout the room. Barb took a seat on the hearth as Denny spoke with great enthusiasm about Native Americans and Clinton County.

"We chose the Indian Trail quilt block to honor the importance of the aboriginal influence in the settling of our county," Denny said. He explained that the area is crisscrossed with eight major Indian trails, four of which are within a three-mile radius of the property.

Denny had a map that delineated all of the trails, which would later be used by settlers to reach the area. He had several books on Indian artifacts on hand as well. According to Denny, the Indians followed paths created by prehistoric animals, since the buffalo and bison would show them the way to clean water. The high ground along which the farm sits was a natural path along which the natives could travel.

The family has found dozens of arrowheads on their land. Denny has also found pestles, trading beads and nutting stones, which he said are smooth rocks similar to mortars, used to crush shells for coloring. "It's neat to find an artifact," Barb said.

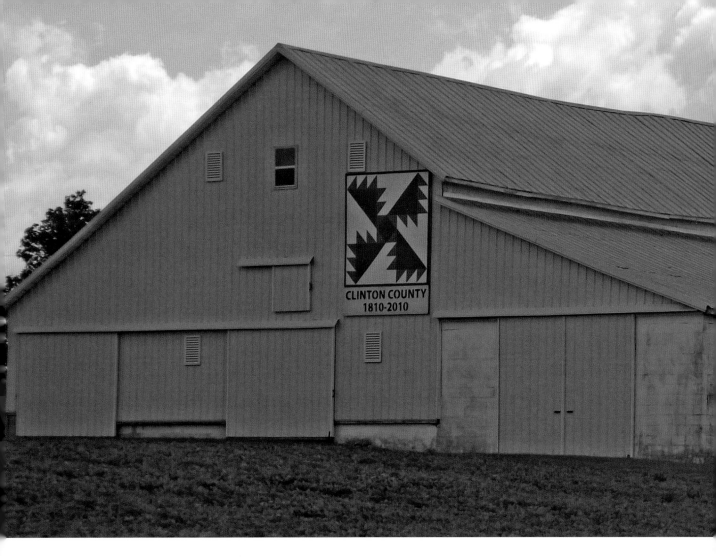

CLINTON COUNTY
1810-2010

Diane and I set off to view a few more quilt blocks before visiting the Stokes farm, where a stand advertising berries for sale stood at the entrance. Many a farmer had left his work over the years to visit with me, but I was somewhat taken aback when Mark Stokes offered what looked to be a dirty hand in greeting. A second look revealed that the raspberry farmer's gray hand was quite clean but deeply stained from the fruit that his family has grown for over fifty years.

We gathered in the kitchen as Mark told us a bit about the family farm. His dad, Dale, was an agriculture teacher who farmed two acres of black raspberries. The farm eventually grew to the current forty acres, six of which are planted in strawberries. I love raspberries but had never heard of black ones. Mark explained that they are much more perishable than the red and yellow, so they are not shipped as widely. He went on to talk about other ways that the fruit was important.

In the 1980s, Dale began working with Dr. Gary Stoner, a researcher from Ohio State University, on clinical research into food-based cancer prevention. Science

67

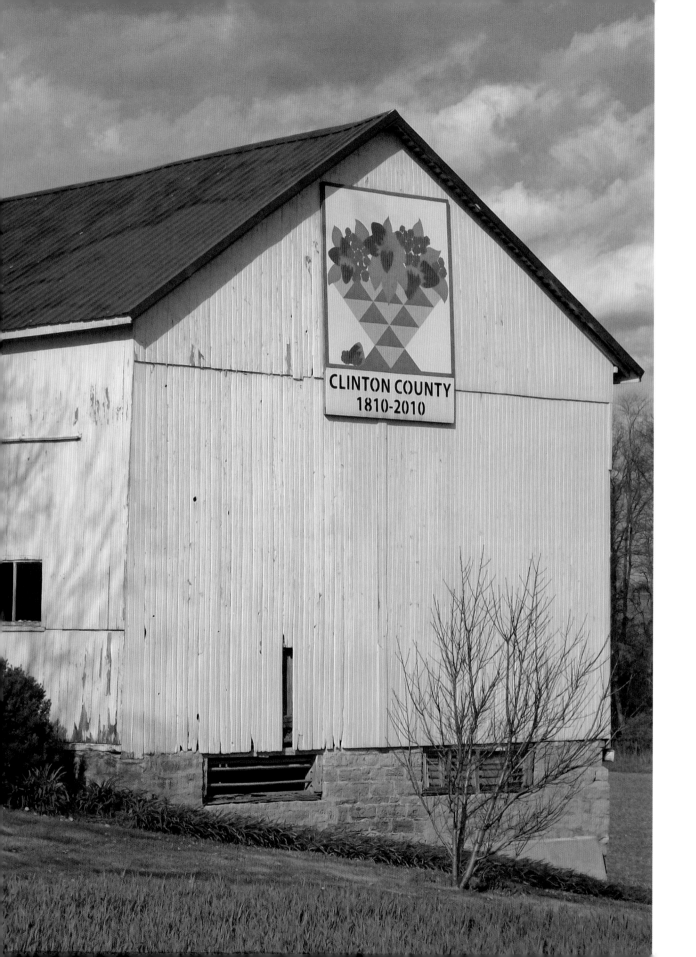

suggested that eating black raspberries could help prevent colon and esophageal cancers, so a means of ingesting the chemicals present in the fruit other than daily consumption was sought. The berries were machine harvested, frozen, and then freeze-dried into a powdered supplement. It was hoped that a single chemical found in the fruit could be isolated as a cancer-reducing drug, but it seems that some combination is needed. "It's a whole host of chemicals, a synergistic effect," Mark said. Scientists also thought perhaps a skin-cancer cream might develop, but since the chemicals are not found in the more esthetically pleasing yellow varieties, it seemed that such a product might not be marketable.

Opposite:
Berry Basket

Mark and his wife, Stephanie, still enjoy the simpler aspects of berry farming and regard the farm's "pick your own program" as important for those who are not exposed to farm life. "Kids can see that food doesn't just come from containers," Mark said. The barn quilt that Diane Murphy designed is based on a Fruit Basket pattern, with the more traditional bananas and apples replaced by berries. "We need to give Diane credit for all of her work. She stayed the course and got this done," Mark said. As Diane and I drove away, we stopped at the berry stand near the entrance to the farm. Diane asked for a couple of pints of berries, one of which I was to take with me. In typical small-town fashion, she told the young woman, "Just write down what I got, and we'll take it off the meat bill."

We ended the day at the farm where Diane and her husband, Milton, live. The farm and barn are owned by Milton and his siblings, so when Diane decided to create a barn quilt, she suggested a pattern that might appeal to them. Sunbonnet Sue was accepted, as their mother's name was Susie. Once the pattern was chosen, Diane went to work adding meaning to the painting. The apron is blue, for Milton's sister, Ellen. Grandma Murphy had seven boys, and their names are written in cursive along the bonnet's edge to resemble lace. Diane said, "If you know what you are looking for, you can actually see the names," and sure enough I could. The bonnet is also decorated with violets on the hatband, the flower for Diane's Alpha Delta Pi sorority. The last touch is a few forget-me-nots on the dress, for Diane's mom, Joy, who had passed away recently.

Diane believes that construction of the house was started prior to the Civil War, stopped when so many men went off to war, then completed shortly after. The house is filled with antiques from both sides of the family, including an early 1900s dining room suite from Diane's grandmother, paired with a china hutch that once belonged to Milton's maternal grandmother. Most notable for me were the bed in which I slept, a precious antique refinished by Diane's grandfather, and the many quilts that represented several generations.

Of course, Glen was more interested in farm machinery than in furnishings, so the men left Diane and me in the parlor to chat. Milton collects tractors and houses them in a new barn that is home to an Overall Sam barn quilt. As an

engineer, Glen loves mechanical things of all kinds, whether in a factory or on a farm. On their return an hour later, Glen was exuberant. "Can you imagine? Milton has some of the earliest John Deere tractors, and they run!"

Milton and his brother, Steve, operate the farm, along with Milton's nephews, Nick and Willie. Milton was concerned that seeing the cattle out back might ruin our appetites, but our enthusiasm for Diane's brisket told him otherwise. We left our new friends behind with a promise to return for the community Fourth of July celebration that is held on the Murphy farm each year. Glen already had his tractor chosen for the parade.

Opposite:
Sunbonnet Sue

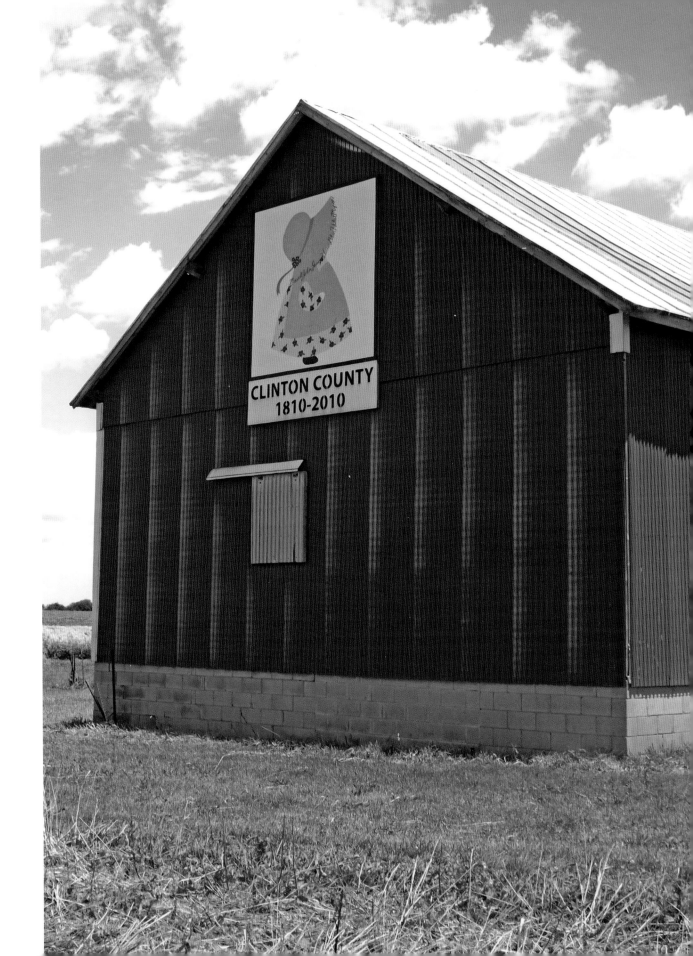

CLINTON COUNTY
1810-2010

indiana

GLEN AND I were set to pick up Ruby in Elkhart in one more week, and that left just enough time to visit a couple of Indiana quilt trails. Miami County had been on my list for a while, as Jayne Kesler had reported that she and other local volunteers had painted close to one hundred quilt blocks.

Once again, we were touched by the fact that strangers offered us a place to stay. It was dusk when we arrived at Jayne and Keith Kesler's home but the brilliantly colored Flying Geese quilt block on the side of their barn assured us that we had found the right place. Jayne greeted us at the back garden gate, where I could just make out the knee-high rosemary, dusty sage, and crawling of thyme interlaced with walkway rocks; it looked every bit the country cottage. The guest apartment above the barn was far more spacious than a motel room, and I was thrilled to see that we would have a full kitchen. Glen made his way to the back door. "Perfect—a deck for us and a yard for you, Gracie!"

The next morning, Glen took his place at the kitchen table with Gracie lounging at his feet, and Jayne and I set out. Jayne and I traveled the back roads for a couple of hours, photographing barn quilts and chatting about our teaching careers. We talked of the challenges of getting through to kids and the creative methods we had each employed, and I could tell that we would have enjoyed working together.

After lunch we rendezvoused with Barb Krisher so that we could see some of the barn quilts her mom, Nancy Sarver, had painted. Nancy and Jayne had started painting at about the same time, and Chamber of Commerce director Sandy Chittum put the two in touch. The women agreed that Jayne would fill in the map

on the north side of the county, while Nancy continued to add quilt blocks to the south. Unfortunately, Nancy was out of town that weekend, but her daughter grew up in the area and knew it well, so she stepped in to give us the tour.

Soon we were barreling across country in Barb's truck. The heavy vehicle reminded me of the one Glen drove when we were in Georgia, but Barb's aggressive driving style was much more like mine; I found the ride invigorating. Barb beamed with pride as we stopped to see some of her mother's work, including a quilt block on a building that was said to be home to a famous animal trainer's tigers. Peru is known as Circus City, as it is the winter home of several circus troupes, so that bit of information was not as shocking as it might otherwise have been.

As we approached the Sarver farm, I noticed a painted sign on the end of the barn, Putt-Putt Acres. I had to laugh, as Glen and I call my Honda the putt-putt car, since it has so little power compared to Glen's truck. Barb said that for the Sarver family, putt-putts are the John Deere tractors the family collects and that the barn quilt painted in that signature yellow and green is called End of the Day, John Deere Style.

The family had owned the property for about twenty years. When I later spoke with Nancy, she told me a bit about the farm: "It was homesteaded by people from Ohio and had been in the family for 144 years, just a beautiful self-sufficient farm." Nancy was most impressed with the fact that all of their rainwater was caught and piped out to the hog feeders.

I was tickled when Nancy told me about the way the former house had once been used. It was once a grand farmhouse with an iron railing around the top and stained-glass windows. But after years of sitting empty, it had fallen into disrepair. The state police took advantage of the opportunity, and the property became a location for target practice. "The lane would be blocked off with a yellow ribbon and the officers would play war games, lying on the hill and shooting at a pile of old cars and things. I think they had shot a bazooka off in the furnace," Nancy said. When the Sarvers purchased the farm, the house was in such poor condition that it could not be restored, so it was burned, giving the fire department an opportunity to sharpen their skills.

Seven buildings were burned, including a chicken house, a hog house, and a syrup house. "I was sad we had to burn it down, but they were just not going to make it," Nancy said. The barn and a small smokehouse were the only buildings saved, and siding was added to the barn so that it would be preserved with the original timbers inside. As for the End of Day quilt block, Nancy said, "It seems like on a farm the end of the day is the most pleasant time. Your work is done and you can enjoy your surroundings. It's just a great time of day."

That night Glen and I were alone, as Keith Kesler had departed to attend a rally where he would show off his restored 1949 Glider camper, and Jayne was visiting their grandchildren. I ventured into the kitchen near midnight for a glass

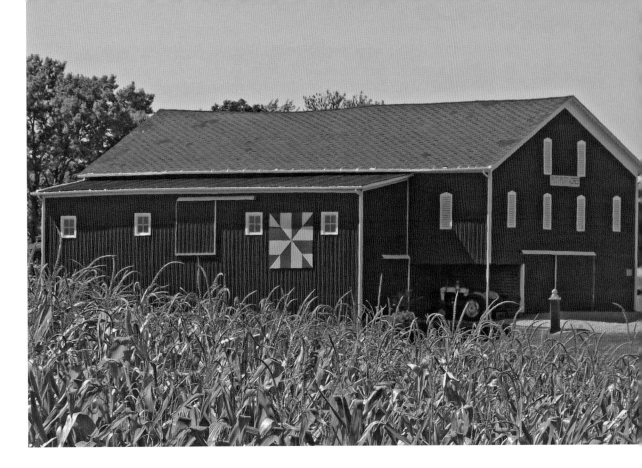

of water and noticed all three of our laptops out on tables, and my purse, my camera, and a couple of hundred dollars from the last few days' book sales strewn across the kitchen countertops. Gracie was sound asleep in the bedroom and at her age was no longer much of a watchdog anyway, but somehow it would be sacrilege to lock those doors.

End of Day, John Deere Style

Jayne and I visited Doud Orchard the next day and immediately noticed the barn quilt, Nine Patch, Apple Style—a custom pattern that Nancy Sarver had painted to resemble red work embroidery. The rich fragrance of fresh apples mixed with a metallic clanking sound. The two seemed at odds, but as I soon found out, they went hand in hand.

The Doud family had owned the orchard for five generations. Connie Doud and husband, Steve, bought the orchard from his parents, Lorne and Betty, in 1994, the centennial year of the business. Doud's has always been known for its antique varieties, and Connie said that they grow about one hundred different types of apples. These days they are leaning towards some newer varieties that are resistant to virus and disease as they not only require less work but also less chemical spray. That sounded like a winning proposition to me.

Becky Shanley, whose family operated the orchard at the time, explained that the clacking and squeaking of machinery I had heard were the apples being sorted

and graded. Women worked along both sides of a belt where apples passed in front of them, each being inspected and then placed into a bag or box according to its quality. The noisy machine had been in service for over one hundred years, and because this had been a good year, it would run forty hours per week for nearly four months. The best fruit went into boxes to be shipped to specialty grocery stores, the next into bags, and any that were unattractive into a bucket to be made into cider. "We have zero fruit waste," Becky said, adding that anything that cannot be eaten is turned into compost.

As we walked towards a row of trees, Becky told us a bit about apple cultivation. To create a particular variety of apple, perhaps Honey Crisp or McIntosh, she said, "You take a scion piece of tree, then buy root stock and graft them together." They are then rubber-banded and dipped into hot wax. At that point, according to Becky, the sap can go up and down and the two pieces will become a tree. With all of those thousands of trees, and so many of them created by hand, I wondered why they would not simply use seeds. Becky said, "You may have a McIntosh blossom, but you don't know where that bee was before. If you plant the seeds, you don't know what the two parents were." Each year, two to three hundred new trees replace those that are older and slow to produce, so that the yield remains steady.

I was about to ask whether it was all worth it, but Becky answered without prompting. "In the spring it's magical. The blossoms are from pure white to deepest crimson. We walk the entire property and tell all of the trees how beautiful they are and how thankful we are for them. We think about how many people are going to have apples this year because we sweated and worried and cried over this crazy crop."

One of my favorite quilt blocks was the Fish block at the Kesler farm. The block was chosen because Keith is a fisherman, and as Glen and I walked through that barn to get to the stairs each day, we could not help stopping to check out the impressive collection of fishing equipment on display. Hanging from the walls, in display cases—everywhere we could see were tackle boxes, bobbers, nets, fishing poles of every type and vintage. "Pretty nifty, huh?" Glen asked, as each time we walked through we discovered something new.

Jayne explained how her husband ended up as her dad's fishing buddy. "My father was a fisherman, with only a daughter who liked to be out on the water but was just fair to middlin' at sitting still to fish."

His father-in-law's hobby in turn sparked Keith's interest. Keith and Jayne enjoyed accompanying her dad on annual trips to the Muskego River each fall. Keith's collection included hundreds of lures, both for fly fishing and flat fishing. Keith said, "When we would go out anywhere, if he bought something, he bought me or Jayne something to fish with him."

Keith's collection included two heavy wooden canoes, which Keith said dated to the turn of the twentieth century. Mounted in the barn, they looked as if they

Opposite:
Nine Patch,
Apple Style

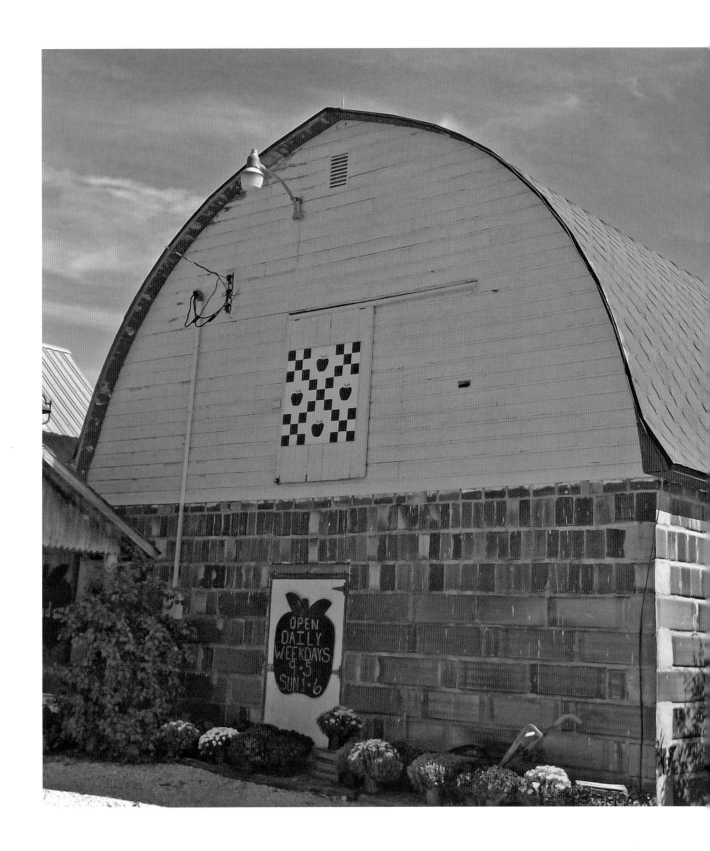

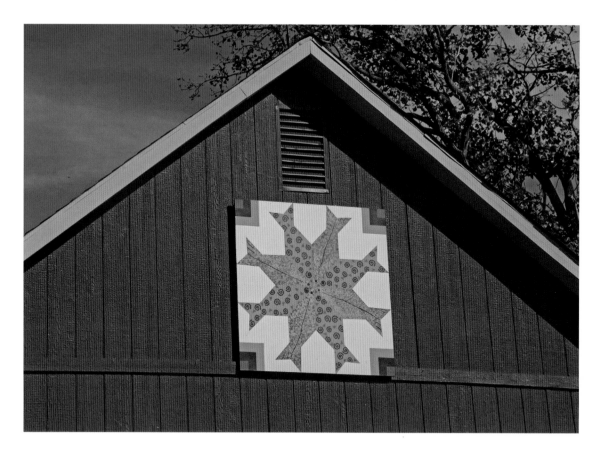

Fish

ought to be part of a museum display, but Keith assured us that the canoes were solid craft, as long as they were soaked once in a while to keep the wood from drying. The couple's son, Dylan, and his children are in line to take up the family hobby, and the young ones have already caught fish out of the pond out back.

I try to stay abreast of developments in the world of barn quilts, and keeping track of the progress of larger quilt trails is always of interest. Long before I scheduled a visit to Gibson County, Indiana, I knew that they had more than two hundred quilt blocks in place, and I was eager to see what they had accomplished. Eric Heidenreich of the Convention and Visitors' Bureau was delighted that I would be visiting, and we set a date.

I left early in the day, with the threat of a storm looming, driving quickly as low-slung dark clouds began to appear and circled like a pack of hungry wolves. I had an appointment to keep and really no chance to reschedule, so I pressed on. I often drive in silence, using the time to gather the many threads of my thoughts or to untangle those already woven. But distracted as I was, I thought the radio might provide a respite from my worries. Of course, as soon as I tuned in, the

following the barn quilt trail

weather service warning alarm sounded, and almost simultaneously, sheets of hail began to assault poor Putt-Putt. The thunderous sound and near-blinding volume of the storm sent me to the shoulder of the highway, where pellets of ice gathered into drifts.

I waited out the storm and arrived in Princeton a bit late. When I saw the ice piled up next to the depot building that houses the Convention and Visitors' Bureau, I knew that Eric would understand my tardiness. Eric explained that the idea was to kick off the quilt trail as part of the county's bicentennial celebration. He liked the "homespun and rural" feel of barn quilts and felt that they were a good fit. The idea came to Eric from local quilter Paula Key, who saw the barn quilts in Kentucky and was inspired by a Double Aster barn quilt she saw a few miles from her home. Soon, Paula had something of an assembly line going in husband Jim's wood shop, and others joined in the effort.

I love a quilt block on a well-used barn, and Carol Slinker's Log Cabin certainly fit the bill. Carol told us three generations of the family helped to create the quilt square, which honors her parents, Francis and Lucian Hyatt. The Hyatts were lifelong farmers whose farm was settled in the nineteenth century. Like many who inherit a family farm, Carol had the house remodeled, and in the process found that newspapers and bib overalls had been used as insulation. Country ingenuity at its finest, I thought. Her mom had sewed a lot of Log Cabin quilts, and the pattern also represents Carol's "country upbringing." A schoolhouse pattern sits in the middle of the painting, a reminder of the one-room schools that Carol attended.

I learned a bit of history when Eric and I visited Lyles Station. As we made our way up the long drive to the house, I noticed the unusual quilt block perched on a post in a side garden. Eric said that the quilt after which the block was patterned was soon to be installed in the Smithsonian's new African American Museum. Volunteer Stan Madison, who was hard at work in the Lyles Station museum, explained why an artifact from this location would be worthy of such an honor.

Lyles Station was a community that occupied about a three-mile radius at the turn of the twentieth century. The first settlers were free blacks who came to the area during the previous century. Resident Joshua Lyles had given some of his land so that a railroad station could be built, hence the name Lyles Station. At one time about eight hundred African Americans populated the area, which included a lumber mill and blacksmith shop. The location at the intersection of three rivers proved devastating when a series of floods covered most of the area about one hundred years ago, but some descendants of the original settlers remained.

The school whose restoration began in 2003 was built in 1920 as the Lyles Consolidated School. We walked through a 1920s era classroom where vintage desks, each equipped with a tiny chalkboard, were lined up in perfect rows. In the museum, a display of tools and farm implements highlighted the importance of agriculture to the community. Nearby, antiques such as an ornate grandfather

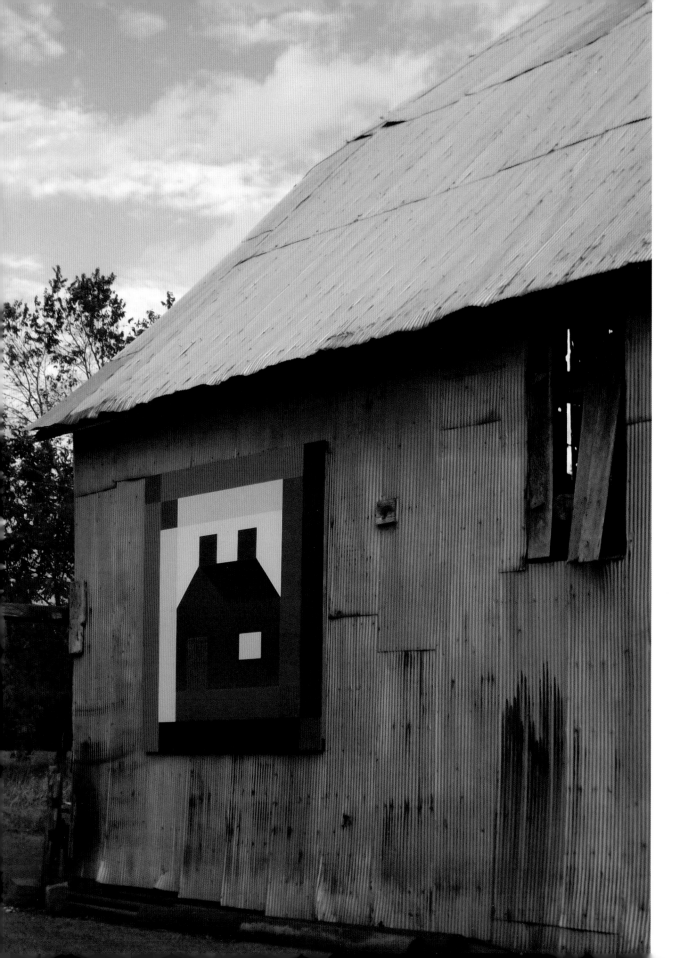

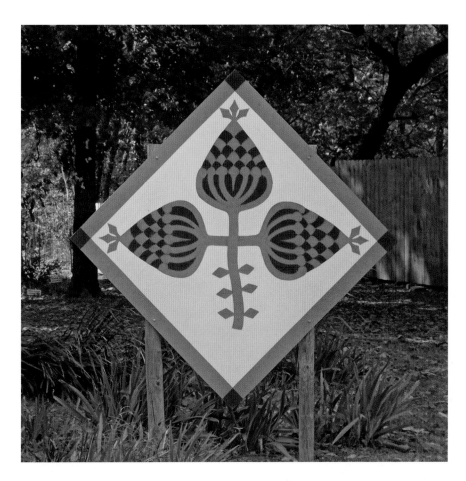

clock and a humble wooden flour mill evinced the range of lifestyles in the community. Finally we toured the Alonzo Fields Gallery whose displays highlighted the life of the chief butler at the White House who had served under four presidents, as well as others from the community who had achieved prominence. I was as impressed by the history of Lyles Station as I was by the accomplishments of the Gibson County Quilt Trail.

Glen and I eagerly drove to Elkhart, where Ruby was ready to roll. The fire had been traced to one of the air conditioners, and those had been replaced along with the refrigerator and much of the wiring within the walls. Every article of clothing had been laundered and the mattress replaced, so that no trace of smoke lingered. We were more than ready to be back in our home on wheels and to continue along the quilt trail.

Opposite:
Log Cabin with Schoolhouse

81

indiana

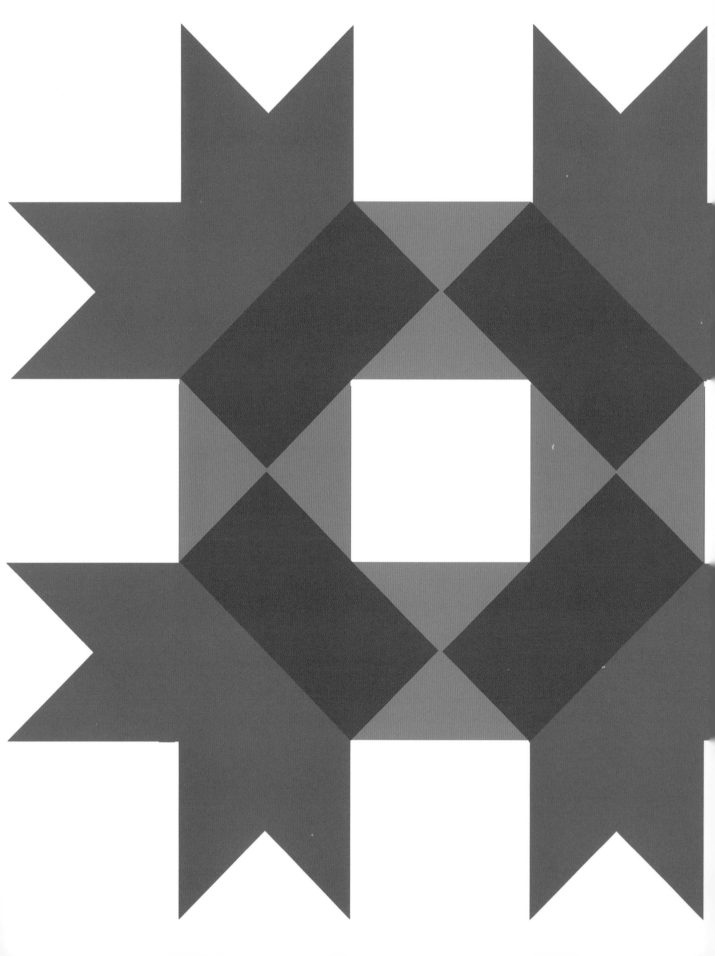

pennsylvania—and a side trip to vermont

GLEN AND I were excited to be back in the bus, but I was nervous. The whine of the engine didn't sound quite right, and each bump and rattle inside jangled my nerves. The fact that we were in a hurry did not help matters. It had taken an extra day for the bus to be ready, so we had a single day to get to Emlenton, in northwestern Pennsylvania. But before long our favorite songs were on the stereo, and my tambourine was slapping away. We passed over rivers and creeks, and each time I would peer down and give the quick scouting report: "No water. Kinda low but paddle-able. Too many trees down, not safe. Ooh—looks good!" Or sometimes, "Lots of rocks. You could paddle that one and I'd wait," because Glen is a far better paddler than I. For us, all waterways are potential kayaking destinations, and I weighed in as we crossed dozens of bridges over the course of our journey.

Packing our belongings from the car back into the bus and making the five-hour drive had taken the better part of the day, and once again we arrived at our destination after dark. We turned off a two-lane highway onto a narrow blacktop road, and, as we crept along, Glen asked, "Are you sure there will be enough room?" The road was unlit and hardly two cars wide; I was not at all sure but did not see the use in expressing my doubts. I have always enjoyed being in charge of my life and being confident in decision making. But making arrangements for two of us and a twenty-ton bus was another matter. It is one thing when being wrong meant retracing my steps but quite another when a massive tow truck might be involved.

When we pulled in front of Barb and Glenn Gross's home, I let go the breath I had been holding when I saw that the driveway was plenty long enough for Ruby. I was glad to be there and ready to meet Barb, so I jumped out and headed off to chat about barn quilts, leaving Glen to park the bus.

A lot of maneuvering was required as Glen attempted to angle the bus into the drive, pulling a few feet forward, then back, then forward again, with a slight change of angle each time. Before long, Glenn Gross was behind the bus on one side directing Glen to turn one way, and his son-in-law on the other side insisting on the exact opposite. The bus rolled a couple of feet back to the sound of intense shouting—"No, this way!" "Wait! Stop!" The scene would have been comical if not for the risk of running the bus against a tree or into the ditch. After half an hour, Glen had the bus turned straight enough to back into the drive, and Ruby took her place under the trees along one side. "You could have taken the dog, you know; she was barking the entire time," Glen said as he made his way down the steps. His frustration was clear when he didn't refer to Gracie by name.

Barb and Glenn Gross were just the right hosts. We were parked just a few yards from their home, and the garage door was always open. We had lunch together each day, then Glen and I returned to the coach to work. The first night we learned that dinner was served promptly at six, and we became part of the family as we joined the couple, along with their daughter's family, for hearty home-cooked meals. I helped set the table and felt right at home. Our stay was the polar opposite of the weeks of living out of suitcases and eating restaurant meals and exactly what we needed to reestablish our sense that our adventure was going to turn out well after all.

Of course, Barb, Glenn, and I took a chance to talk about barn quilts and to see some of the ones they had created. The project in Pennsylvania was sponsored by the Grange, a community-service organization that exists in each county. We met with a group of local residents at the Scrubgrass Grange, of which Barb and Glenn Gross are members. Glen was delighted with the Carpenter's Wheel quilt block on the building, as it was painted in blue and his favorite color, bright yellow. Out front of the grange hall, we discovered our first "little library," a covered box on a post where anyone could take a book to read and leave one for someone else to enjoy.

Most Pennsylvania counties had only a few barn quilts, but here a large number of quilt squares had been installed at the local fairgrounds. The first one that we saw was a yellow and green spiral pattern in what I took to be John Deere colors. Barb explained that the block had been created by a county Grange that made sauerkraut each year as a fundraiser. The white represents the inside of cabbage leaves, green is the outside, and when ground up, the yellow results. So much for farm equipment; this was the first time I had seen a fermented vegetable represented in a painted quilt.

About a dozen buildings comprised the fairgrounds, and each was home to at least one quilt block. Glenn Gross told me that the first block installed was on an

outdoor stage that the Scrubgrass Grange had built for the fair. Glenn said, "The sound is so mellow, it's unbelievable," but the construction was not so easy. "We had to dig holes by hand for that stage—you can't drill, it's just rock."

The quilt pattern is Prizes, because, as Barb said, "You come to the fair to win prizes." The county fair started as a 4-H fair, so the clover in the center represents that organization. Three blocks decorate the front of the Scrubgrass Stage as well. Once those were installed, the fair directors said they would like more, so the Grange bought materials and announced a contest for barn quilt painters. Thirty-three people attended workshops at the Grange hall and the fairgrounds. Once they learned the technique and drew out their pattern, each person took home the paint and supplies to finish the block.

The resulting barn quilts were sprinkled throughout the grounds, mounted on each of the buildings. Some included silhouettes of animals such as a cow, a pig, and a horse, while others were traditional blocks. The overall effect made for a miniature quilt trail within the grounds.

The three of us took a leisurely walk, stopping to see the quilt squares. One favorite was a Dahlia, which Barb said was painted by an eighty-year-old lady. Barb cautioned her that curves were hard to do, but "She put her hands on her hips and said, 'I can do it,' so I told her to go for it." The block won first prize among the thirty submissions. "We never expected people to do this kind of work," Barb said.

Barb and Glenn took little credit, though. "We just instructed," Glenn said, with pride in the success of community members.

85

pennsylvania and vermont

Stained Glass

I loved the sound of The Quilted Corners of Wyalusing; the name alone compelled me to visit the quilt trail in northern Pennsylvania. Chamber of Commerce Director Wendy Gaustad and I took the tour, which included dozens of quilt blocks on buildings in town—those "quilted corners," and a number of barns as well.

Rene and Randy Brigham's Stained Glass quilt block honors the memory of Alan Adams, a high school teacher who had created a stained-glass window for the couple and was beloved by the community. "Everyone in the area loved Alan," Rene said. "He passed away too soon."

The barn was built in 1905 by Frank Gray and was passed down to his daughter, Margaret, and son, Paul, neither of whom married. Paul was the farmer, and Margaret, a registered nurse, looked after the hired hands who lived on the farm, including Rene's dad, Dick Bennett, who lived there in the 1950s. "They raised close to one hundred boys as hired hands," Rene said. "They were so influential in a lot of young boys' lives—some only for one haying season, some for years."

Rene has fond memories of her dad taking her to visit "Maggie" and enjoying a fresh cup of milk in an aluminum cup. I remembered those cups well, as my great-grandmother had served my milk in them, icy cold in Florida summers.

Randy Brigham came to work on the Gray farm in the 1970s, at the age of thirteen. He stayed on the property from then on, going home only to attend

church with his family. Rene and Randy met in eighth grade, and, through her dad's friendship with Margaret, Rene discovered that Randy lived in Margaret's home. The Gray farm was the source of her family's milk, and Rene talked her mom and dad into letting her make the trip to the dairy each day. "I poured milk down the drain so I could come see Randy," she said.

Randy remained with Margaret after Paul passed away in 1976, and when Rene and Randy married in 1979, they had already made their first payment on some of Margaret's land, where they could build a home and live nearby.

"Aunt Margaret" took the boys to antique shops and gave them an appreciation for history and antiques. Rene said, "They would rather have something old and sentimental than something new." Margaret let the boys play her piano and pump organ and built a tepee out on the lawn with poles and old blankets for the children to play in during the summer. "There was a path between our houses; she was very much part of our family," Rene said. "Margaret is our sons' other grandmother in their hearts."

Rene and Randy cared for Margaret until she died in 2006 at the age of ninety-one. Rene said, "She helped to raise my father, my husband, and our two sons. There is not a day that goes by that my husband and I don't say how much we miss her. We see things that remind us of her and say, 'Oh, she would have loved this!'"

■

Recently, a new single-county quilt trail initiative began in Pennsylvania. The Crampton barn in south central Pennsylvania is home to an Oak Leaf and Acorn barn quilt. Mike Crampton explained that the one-hundred-acre property is almost all oak and maple hardwoods. "We love the oaks and the acorns and the food that it provides for the animals on the property," he said. "They reflect our interest in conservation of our forests, streams, and agricultural land, and the rural lifestyle here in Fulton County, Pennsylvania. We could not think of a better image to place upon our oak and hemlock timber frame barn."

About five years earlier, Mike had seen barn quilts and thought that a quilt trail might be a great way to attract people to his beautiful rural community. He mentioned the idea to some folks in the community but said, "It didn't gain traction." A few years later, Mike and his wife, Linda, decided to build a timber-framed barn. The new structure is a bank barn, an earlier style similar to those that were built when the area was first settled. Though he had not been successful in engaging the community in the effort, Mike went ahead and created a quilt block for the new barn.

It took a while to decide on the Oak Leaf and Acorn design, but once it was chosen, Mike did something that few barn quilt painters do. He searched for the designer of the original block so that he could ask permission for its use. Most barn quilts use patterns taken from traditional quilts, and of course those patterns are in the public domain. But some more recent patterns can be attributed to a single artist, and just like any other work of art, they are subject to copyright. I

pennsylvania and vermont

have been dismayed to see barn quilts that were replicas of quilts that I knew to be original works of art, knowing that the designer was never consulted. Mike was persistent, though. It took six months of searching to locate designer Joni Prittie. "She was elated that we would use her block as a barn quilt. That was very gracious of her." Mike said.

Soon, the support for a local quilt trail developed. "Now they could see what a barn quilt looked like. When I invited them out, they said. 'Ooh, I thought you were thinking of hanging a real quilt on the barn.' Silly me, now I knew why the idea was never accepted," Mike said. An in-depth article in the local newspaper increased interest, and Mike began putting together a committee. Cindy Glessner, a quilter and historical society member, met with barn owners and helped in selecting their pattern based on what is unique or significant about the farm or family. Soon, painters and other volunteers were in place, and a partnership with the local historical society established. The Frontier Barn Quilt Trail of Fulton County, Pennsylvania, was born.

The name had a nice ring to it but I immediately wondered what Pennsylvania had to do with the frontier. Mike explained that the county sits on the west side of the Appalachian Mountains. Early settlers mostly established themselves on the east side, where German stone masons built barns of brick and stone. When the settlers crossed the mountain to what is now Fulton County, they needed to build their barns more quickly and took advantage of the available resources. Barns along the frontier are more often made of wood for those reasons.

As for the quilt trail, Mike says, "It's been a journey, but now I am confident." The goal was twenty blocks in the first year, and that number was easily met. For the most part, the barn quilt painting is done by the hosts, using kits provided by the committee. The kits include pre-primed MDO boards, brushes, rollers, a utility knife, instructions, and a half-price paint voucher to be used at a local store. I thought this an ingenious method to provide support to the painters but allow them to take ownership in the process.

On hearing of the novel approach, Donna Sue agreed: "What a wonderful twist! They have come up with a way to engage more people—I would be much more likely to buy the kit than to do it on my own."

Mike Crampton is pleased with the way the trail is progressing. "I have a great group of people. I can't say enough about their wonderful support and help and dedication."

A Virtual Visit to New England

Opposite:
Oak Leaf and Acorn
*Photo by Lisa's Photo
Creations*

I would love to have added Vermont to our route, as neither Glen nor I have visited New England, but there was simply no time to make the trip. I did manage to speak with quilt trail organizer Fern Mercure and to learn a bit about what they

had accomplished. Fern retired from nursing in 2009 and was glad to finally have the chance to do some traveling. She and her husband, Jim, set off cross-country in a camper to visit their daughter in California. Fern said, "On the way back, we were disappointed that all we saw were corn and beans." The couple made a stop in Shipshewana, Indiana, looking for some interesting sights and came across the quilt gardens there and the quilt squares that accompany them. Though some of the blocks were large, many were four by four feet, and Fern thought, "That might be doable." Her Sheldon Raiders homemakers' club did a lot of community-service projects, and Fern had an easy time convincing them that they ought to start Vermont's first quilt trail.

The women worked together to choose designs and color combinations and then commenced painting. The Mercures own a clock shop, and the workshop there was large enough for six quilt blocks to be laid out. With all of the patterns drawn, one color at a time was painted on each of the blocks, in assembly-line fashion. "Many of us work, and some have grandchildren or elderly parents to care for," Fern said. "It was a lot of commitment." Two batches of six blocks were completed, including Mariner's Compass for the clock shop and Basket of Flowers in memory of recently deceased member Thelma Stebbins, an avid gardener who Fern said had been something of a matriarch for the club. Some of the homemakers' gardens include perennials that Thelma gave them over the years.

The initial dozen quilt blocks were installed on Mother's Day of 2010. Since then, community members have embraced the project; "It seems like a new one pops up about once a week," Fern said. This quilt trail is a bit different from most, as the organizers do not impose rules but simply encourage participation. With support from a local restaurant that printed brochures and the Franklin County Quilters Guild who added the quilt trail to their website, the project was deemed a success.

One of my favorite Vermont quilt blocks is the Radiant Star, which was completed in 2013 to help Sheldon celebrate its 250th anniversary. "That barn had been speaking to me since I saw the barn quilts," Fern said. She was surprised to learn that the barn belonged to her neighbor, Maxine Ovitt, who told me a bit about the dairy farm, which had originally belonged to her grandmother.

I was intrigued by the fact that Maxine's grandmother kept boarders at the farm, in the family home. When Maxine's family moved to the farm in 1947, her mom continued the tradition of renting out rooms. A road was being built next to the barn, and a number of the highway workers stayed at the house. Men from the local mill also visited during the day. "I guess they really liked my mother's cooking, so they always came for lunch," Maxine said.

Maxine's father expanded into nearby acreage and sold milk at the local creamery until his death in 1976. Maxine is pleased that when the land was eventually sold, her niece, Deborah, purchased the original homestead, which included the barn. Maxine said, "That was the only place for that beautiful barn quilt."

Radiant Star
Photo by Steven Mercure, 2014

Fern said that recently awareness of the quilt trail increased through exhibits that the organizers displayed during the celebration of the 150th anniversary of the St. Albans Raid. I had never heard of St. Albans, so Fern went on to tell me that the Vermont town was the site of the northernmost action during the Civil War. A small group of escaped Confederate prisoners gathered in Canada and mounted a raid on the banks in St. Albans in an effort to fund the South's failing war effort. They raised havoc in the town and managed to make off with over $200,000. The raiders had planned to burn the town but only managed to destroy a woodshed and then set fire to a hay wagon in a covered bridge to escape the pursuing posse. The raiders were arrested in Montreal but not convicted of a crime, as their acts were considered part of the ongoing war.

The St. Albans Raid Commemoration Event took place over four days in September 2014. Civil War era military and civilian re-enactors recreated life in that time period including an elaborate re-enactment of the raid. Barn quilt painting workshops inspired even more residents to paint a quilt square and gave them the knowhow to do so.

With over 150 barn quilts, local resident Sharon Perry said, "I bet we have the most per capita of any county in the United States." I believe that she might be correct.

pennsylvania and vermont

west virginia

DRIVING FROM Pennsylvania to West Virginia meant mountains, and once again I was running late. Glen says that I run on Suzi Standard Time, and my relaxed notion of what "on time" means is an affront to his engineer's sense of order. It seems to me that circumstances do conspire against my punctuality. That morning, the bedroom lights in the bus had suddenly stopped working. Getting dressed in a confined space with Gracie lying between my legs was often akin to wrestling out of and then into a straitjacket. Doing so in the dark took far more than the five minutes I had allotted. I hurried by car to West Virginia to find that my poor timing was exacerbated by a thick swath of fog that obscured my surroundings. Visible snatches of golden leaves flashed by, some already beginning to drop. It seemed a bit early for fall, but we were in the mountains, after all.

Glen was to continue on that morning in Ruby to Highland County, Virginia, where I would meet him in the evening. We hated to travel separately, but West Virginia was quite a detour from our path, so it just made sense for him to take the more direct route. I passed a truck chugging and struggling to crest a hill on the interstate and cringed, knowing that Glen was in for a tough drive up those mountains.

I met Monroe County tourism director Helen Graves in Lewisburg and joined her for our tour. Helen and Joan Menard, who met when both were on the board of the Monroe County Arts Alliance, initiated the quilt trail project, but they proceeded without a committee in charge. "Joan's idea was that people would see them

and think they are beautiful and want one and they would get them painted," Helen said. We passed a number of striking barn quilts and stopped several times along the way. Narrow, winding, shoulderless roads meant driving past each barn and pulling into a driveway, then hiking through damp grass back to a suitable vantage point for photographs.

Helen and I visited with Mary Ann Hinkle, who told us about her patriotic quilt block. Mary Ann was in Germany during her husband's military tour in the late 1950s and gave birth to a daughter while there. Mary Ann very much enjoyed the military parades. "I wasn't homesick, but I was far away from home with a baby in my arms and my husband out on the field. That was the start of my patriotism. I have always saluted the flag and loved the flag," she said. The farm on which Mary Ann lives was once known in the small community for its gristmill, so Joan Menard added a border to the block that resembles millstones. I asked how small a community it was, and Mary Ann said, "Well, let's just say that you don't talk about anybody because that might be your cousin."

Mary Ann escorted us to a historic home in Union owned by her sister, Julia Higginbotham, where a Civil War Trail marker along the sidewalk provides information about the location. The stately white house had once been the Union Academy and, according to the marker, was where wounded Confederate soldiers were housed in 1862. It was later raided by occupying Union forces, who requisitioned half a barrel of flour but were said by the lady of the house to have done so "in the politest manner imaginable."

The sisters' great-grandfather, Joseph Davidson, bought the school building, which became known as the Davidson home place. It was known as such for three generations; Mary Ann and her sister, Julia, grew up in the home. When Julia married James Higginbotham and they took over ownership of the property, the house was renamed Higginbotham House.

As we walked the leaf-strewn grounds, Mary Ann pointed out where the cistern and summerhouse had stood. The Confederate Rose quilt block hangs on a wood and coal house next to the former smokehouse. The pattern seemed just right for a location that was important to generations of Southerners as well as a part of the Civil War Trail.

Our next stop involved more recent history. The Buffalo barn quilt on Bobbie Reed's barn is both a memorial and a symbol for the school spirit she embodies. Bobbie is a staunch Marshall University fan. A Marshall logo flag flies outside her door, and signs at the top of the driveway designate "Marshall Fans Parking Only." Bobbie welcomed us into her Green Room wearing a dark green shirt decorated with an M and a buffalo. She blended in well with the décor, which includes several Marshall-themed throw blankets on back of the sofa, school placards, and a stuffed buffalo with a green cap, who was introduced to us as Marco.

Opposite:
Confederate Rose

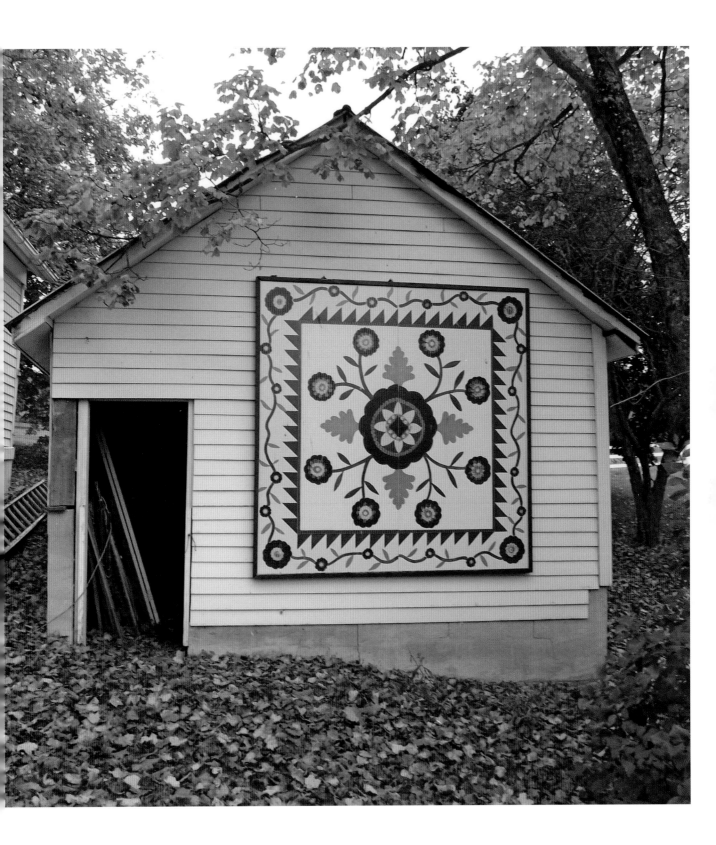

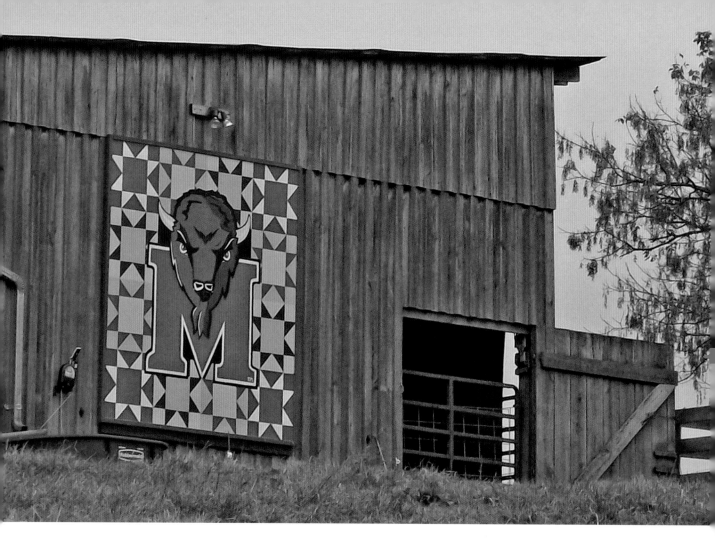

Tribute to Marshall

Bobbie graduated from Marshall in 1967 and loved the school and the town, where she lived for five years after graduation. She provided Joan Menard with a blanket to use as a pattern for the barn quilt, but Joan changed it up a bit, since they did not have permission to use the actual logo. The "M" and the bull mark the farm as home to a Marshall fan.

Her children attended West Virginia University, so Bobbie is even more entrenched with her alma mater. "I have all of this up to aggravate people," she said. Her kids have been known to steal Marco the buffalo and take him to Morgantown and take photos of him out and about. They once sent a condolence card with a photo of the scoreboard after WVU beat Marshall in football. "That's OK, they enjoy it," Bobbie said. She is lighthearted when discussing family rivalries but also shared the sadness that her barn quilt represents.

I had heard of the plane crash but was not old enough at the time to remember the details. The plane was carrying football players, coaches, and boosters re-

turning from a game in North Carolina. It crashed when attempting to land at Huntington in rain and fog. "I lived real close to the airport," Bobbie said. "We heard something but we didn't know what it was until the next day. It gives me cold chills now."

Bobbie recalled going downtown the next morning and seeing black shrouds hanging on buildings. She said, "It was pretty close to a ghost town." A lot of local businesspeople had been on the plane, and a number of children were orphaned, including one family of six. "It was sad, devastating for weeks and months, years after that," Bobbie said.

"My quilt is in honor and memory of them," Bobbie told us. She also hopes to inspire some of the young people in the community. Bobbie was a Special Education teacher for twenty-three years, and is proud that several of her students went on to college, but she wants more of those kids to do so. She said, "I want them to see Marshall and of course to remember me and how much I love my Marshall."

When I saw the Farmer's Fancy quilt block on the Shire family's white barn, I gasped. It takes a lot to cause such a reaction in someone who has seen thousands of barn quilts, but the myriad bright colors were extraordinary. There was no question that I would track down its story, especially when I discovered that Farmer's Fancy was a replica of a cloth quilt by a well-known quilter.

Leona Mae Jones Long was born in 1900 and passed away just a few months shy of her 101st birthday, having been a quilter for eighty-six years. Fawn Valentine, author of the book, *West Virginia Quilts and Quiltmakers,* visited with Mae (as she was known), who shared stories of her life. At the age of ten, she would come home from school, hitch up draft horses, and drive out to help her father bring in the hay. When Mae was fourteen, her mother gave birth and had a difficult recovery, so the young girl took care of the family, cooking and making clothing, and, of course, quilting. At sixteen, after she eloped with a farmer, life was a bit easier. Mae had store-bought clothing and shoes for the very first time.

Mae moved with her husband to a farm in Greenville, West Virginia, where, in addition to housekeeping, she helped work the crops and put up hay. It seemed as if the work ethic she had learned as a girl was still very much in place. Her granddaughter, Linda Long Dixon, said, "I spent as much time there in the summer as I could. Grandmother would show me how to sew on the treadle sewing machine. Even later on, she never used an electric."

Mae moved off the farm and into town when she was widowed in 1965. She began sewing quilts and selling them for a bit of extra income. The hand-quilted pieces displayed her skill. Linda said, "She told me one time that a good quilter has ten stitches to an inch. She did those neat tiny stitches." Mae's reputation spread across the country. She might sew a quilt for a local resident who had a friend or relative elsewhere. Soon, a request would come from far away for a piece of Mae's

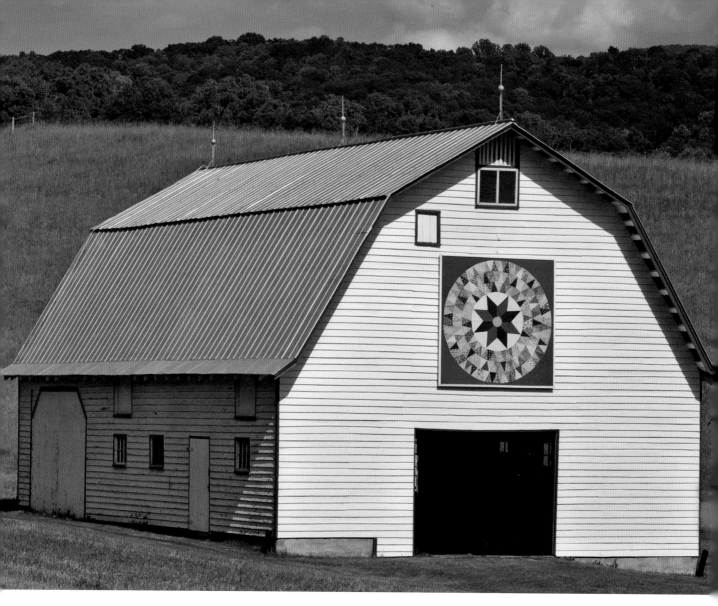

Farmer's Fancy
Photo © 2012 Drema Morgan

quilting art. She had quilting frames set up in her living room in front of her picture window, always quilting no matter the season. She loved her gardens and being outdoors, but nothing took her away from her quilts.

As part of her research with the West Virginia Heritage Quilt Search, Fawn Valentine visited with Mae to document her quilts. Mae had some of her appliqué patterns ready to show, as she expected them to be the most interesting. "The Farmer's Fancy quilt was on Mae's bed. I was going nuts for it, and she was really surprised," Valentine said. The quilt-study group looked through many pattern books and could not find one exactly like it but did find two similar quilts elsewhere in the state. Mae said that her quilt, created in 1925, was based on a quilt

following the barn quilt trail

that her mother, Bertie Jones, had made. She used her own template and held it against the fabric rather than pinning it and tracing. "We cut 'em by guess," she said. Looking at all of those tiny triangles, I concluded that Mae had been a very good guesser.

As for the name Farmer's Fancy, Valentine said she took the word Fancy not to mean intricate but "the old meaning, something a farmer would like. Maybe it meant the sun because a farmer is happy when the sun shines."

The quilt was still in Mae's home when she passed away, and it went to her son, Linda's father. The treasured heirloom is being kept in a cedar chest for Linda, who gladly retrieves it for anyone who wants to see her grandmother's masterpiece.

Farmer's Fancy,
cloth quilt
*Photo © 2012
Drema Morgan*

west virginia

virginia

I LEFT WEST VIRGINIA and began to make my way up into the mountains towards Hightown, Virginia. Twilight crept in as I navigated the winding mountain roads, and, with the car's headlights just barely illuminating the shoulders, I gritted my teeth. I am usually a lead foot, but here the undulating curves and switchbacks demanded slow speed and constant braking. Just as I became accustomed to the rhythm and began reviewing the day's events, a deer flashed in front of the car. I was startled out of my reverie and leaned forward in an effort to peer more closely into the brush to watch for deer as I proceeded. I crept along for about a mile and spotted a family of four standing by the roadside observing my approach. When I was no more than ten feet away, they decided to pounce. I recalled what Barb Gross had told me when we left Pennsylvania—if you see a deer, don't hit the brakes. Better them than you. *Don't hit the brakes* became my mantra as I made my way along, with five more deer encounters during the forty-five minutes it took to reach Margie and Mike Boesch's home. I arrived shaken and exhausted but relieved to see Ruby parked just down the road in the pasture.

As it turned out, Glen's drive had been stressful as well. He had slowed to about twenty miles per hour at times, both because the bus struggled to climb the steep grades and because he wanted to avoid the sheer drop-off along the shoulder. A collision between a logging truck and a train had sent traffic off onto a two-lane detour, where the bus could not make the sharp turns without veering into oncoming traffic. "I sure could have used your help," Glen said, He had been reluctant to make the solo drive but had done so at my urging, only to have his dread

of a difficult journey realized. Still, we were together in a pastoral setting, and before long settled into the deep, dark silence.

Gracie relished life in the pasture, as she was allowed to run free during the day. That became a problem when Margie picked me up the next morning, as Gracie took off down the road chasing the car. We corralled the wayward pup and soon were off again. The first barn quilt we saw was a beauty. The white barn with its Jacob's Ladder barn quilt was just barely visible in the distance shrouded in morning fog. Margie said that the property is called Dividing Waters Farm because the water on the north side flows to the Potomac and on the south side to the James River. "It's the dividing line of Highland County," she said. As we turned the corner at the edge of the property, Margie pointed out the white clapboard building that had until recently been Hevener's General Store. Jacob Hevener had operated the store, and his wife had served as postmistress there for many years. In addition to the barn, a Victorian home and several outbuildings were visible, all painted in gleaming white.

Margie and I headed up the hill and visited with Jacob's cousin, Miriam Helmen. She shared with us her memories of life on the historic farm. "I spent every summer of my life there with Jacob's sister, Charlotte Anne," she said. Miriam displayed a picture of the original house on the property, where her mother was born. The house was large enough that each child had a room. Miriam's family lived in Tidewater, Virginia, but her mother hated the humidity. Miriam said, "Daddy would bring us back here, and mother would go straight to her room." Miriam loved visiting, though she and Charlotte Anne did have chores. "We did the dishes, and after a while Charlotte Anne and I had to help with the canning. I remember cleaning the corn and gathering apples. But we goofed off as much as we could."

Miriam recalled, "Charlotte Anne and I wandered for acres, just hiked everywhere. We would go swimming where they used to freeze the ice because they had dammed it up. They would bring it down to the icehouse. It was an amazing farm. I did learn to milk; it's not hard." The cousins played the piano after dinner, and other families would come down and play and sing. When Jacob came back from the service, they played from sheet music and Charlotte Anne sang, "I'll be seeing you . . ." Miriam added, "They maintained a lovely household. We always had a tablecloth and cloth napkins, and that barn was just wonderful. Oh, the square dances they threw!"

When Jacob's nieces, Sharon and Carolyn, wanted to commission a barn quilt for him, Margie Boesch felt it best to check with him. They didn't want it to be a complete surprise, as it might not be welcome. Miriam added, "They were hesitant. Change and new ideas you have to think about. But he was so excited and glad to have it." The block was perfect, not only because of his name but also be-

cause Jacob was a devout Christian. Cousin Miriam said, "He never brought hay in on Sundays."

Miriam feels fortunate to enjoy the spectacular view from the vantage point of her vacation home overlooking Dividing Waters. She went away for college in 1944 and met her husband, Bob, when she visited VMI. "He was from the Midwest, and I had never been west of West Virginia," she said. On visits to her family in Virginia, Bob grew to like the area. "He fell in love with this county and he was so fond of Jacob," Miriam said." One day the farm up the hill from Jacob's was listed for sale, and soon Miriam and Bob had a home in Highland County. The farm's role as a summer home where Miriam visited with her daughters echoes the times she spent on the farm as a child.

When Jacob's barn quilt was installed down below, Miriam said. "I was not going to let him get ahead of me. I have a prime spot and a barn that just calls out

103

for a quilt." Her husband, Bob, didn't really care what pattern they chose, but he did want to incorporate the red and yellow colors of his alma mater. Miriam and Margie looked for a suitable quilt, and when they came across Robert's Choice, the women knew immediately that the block was the right one. I had never heard of the quilt block, but it seemed the perfect way to both please Bob and tie in with Miriam's cousin down the hill.

Margie and I stopped to take in the scenery many times, whether a barn quilt was present or not. The steep hills flecked with hints of yellow and orange set off the brilliant pastures below and the mist that drifted on the mountains above. As we drove, Margie told me how she got started with the project. "I am blaming it on my husband," she said. Margie had been a quilter, but when the couple retired from Rhode Island to Virginia, she took up watercolor painting. Both Mike and Margie had seen barn quilts in magazines, and when Mike saw how much Margie liked working with paint, he asked her to paint some barn quilts for their barns. "It was a perfect merging: he is a farmer; I am a quilter and a painter," she said.

Things on the bus were not going well. Glen needed a solid Internet connection for work, and despite all of the technology available to us, he had no signal when parked in the pasture. It was hard enough for him to spend the day alone in a remote location but even harder for him not to be able to do his job. That afternoon, Margie hosted a tea for some of the barn owners, and when we mentioned our difficulty to Pat and Valerie Lowry, the two were quick to offer a spot for us.

The next morning, we moved the bus to the driveway of the Lowry's Cabin on Back Creek, next to the Lowry's sugarhouse, where Glen and I had a chance to learn about the maple syrup production that takes place at the sugarhouse on the property. We had noticed the blue tubing zigzagging across the wooded hills behind the cabin and were eager to know what happened from there.

Valerie immediately apologized for the mess in the sugarhouse, and Pat laughed, "Suzi's from Georgia; she has seen a mess before!" Pat is a character; he inserted a humorous comment or observation into the narrative at every turn as Valerie talked about making maple syrup. The blue tubing we had seen carries the water from the trees down through the hills into orange tubing, which runs into holding tanks. Water? I was confused. I had always thought that the trees released syrupy liquid that was simply refined and bottled. Valerie explained that the liquid that comes from the trees looks like yellow water and had a sugar content of only 2 percent. It is boiled and reduced into the thick golden syrup, which is 66 percent sugar.

Valerie pointed out the huge woodpile outside of the sugarhouse and said that they had cut eighteen cords of wood. "No," Pat said emphatically, "We cut,

Opposite:
Robert's Choice

following the barn quilt trail

Back Creek Farms

split, and stacked eighteen cords of wood." At first glance, the two pans in which the syrup is made looked something like coffins to me. Pat said that each was made of a single sheet of English tin folded into its rectangular shape. "If this thing could talk," Pat said. The pan came from his step-great-grandmother's farm and is at least 135 years old.

Valerie explained that each of the two pans has a firebox underneath, and they slid one of the pans aside so that we could see the area where the fire would burn. Valerie told us that her job is just to "stay here and keep boiling and boiling" until eight to twelve gallons of syrup are produced. The pan is removed from the fire so that the syrup can be scooped out, and then another pan is started. The syrup is then filtered a couple of times before bottling.

It sounded like a leisurely time, sitting and watching the syrup thickening, but Valerie dispelled that illusion. She explained that the trees run only when it is above freezing during the day and below at night, usually starting in February and lasting for about six weeks. The tanks fill up with sugar water, which is fed into the pans and boiled. "It's not a stable product," Valerie said. "It has to be boiled as we get it." They had thought they could boil and bottle at the same time, but as Pat pointed out, "Two people only have four hands."

106

As Valerie showed us three different bottles of syrup, she explained that during the course of the season, the syrup gets darker. It starts out very light, then gains a richer flavor and a bit more color, and towards the end of February turns dark amber. The earliest syrup is very sweet, and later in the season it will have more of a caramel taste and more maple flavor. Finally at the end comes Grade B syrup, which is almost like molasses. Glen interjected, "Oh, I love a peanut butter and molasses sandwich," and Pat agreed, "Woo! That's good stuff!" I couldn't help noticing that like mine, Glen's accent was becoming much more pronounced in the presence of our new Virginia friends.

When Pat was growing up, every farm had its own sugarhouse as its source of sugar. In spring when everyone was boiling there would be a haze over the valley. Pat added, "You didn't want to be the last one to get your steam out. They would think you were shirking if you didn't have your steam going by daylight." These days, if passersby see the steam rising they know it's open house: they can stop in to visit. And of course, visitors are treated to the sight of the barn quilt with its maple leaf and the single drop of sugary goodness waiting to be gathered.

A handful of women lingered after my presentation at a library in Lexington, Virginia, and soon were gathered around talking excitedly about a barn quilt I just had to see. It took three women to come up with the best way for me to find it, but I left that afternoon with a hand-drawn map. A few days later we were slated to leave, and I realized that I had not taken the time to seek out that barn quilt. No matter, I thought. There were thousands I had not seen; this would just be one more. But those women had been so insistent. I got up the next morning an hour early and found my way. I was certainly glad that I did, as it was a striking quilt block and an unusual pattern.

Nan and Dennis Coppedge spend time in their mountain cabin in Highland County and had enjoyed seeing the barn quilts there. Nan loves to quilt, so Dennis asked if she would like a barn quilt for Christmas. It took a few months for Nan and Margie Boesch to come up with the pattern and colors, but by the end of the summer, they were ready.

Nan knew she wanted a star in the middle, but that didn't narrow things down very much. Margie located a suitable pattern called Nancy's Fancy. Of course, as Nan said, "Being a quilter, I didn't want to go exactly by the pattern." They started with the star surrounded by two interlocked squares but then repeated the pattern to create a lattice effect; Nan's Fancy Lattice was the result. When she talked about choosing the colors, Nan spoke as if selecting cloth for a quilt. "I wanted to use as many colors as I could. I laid one against the other until they created this color combination that contrasts with our big white barn." Dennis wanted to mount

Nan's Fancy Lattice

the quilt block on the side of the barn that faces the main road but Nan was having none of that. "It's my quilt, and I want to be able to see it. Now I can look at it out of my kitchen window."

The farm, with apple and peach orchards on both sides of the road, belonged to Dennis's grandfather. Dennis's father grew up there, and two of his brothers continued farming, but no one in the next generation was interested in orchards. "It's not a very secure business," Nan pointed out. "You can work hard to get the crop ready and something happens and it will just go away." The barn was still in use, storing hay for Dennis's brother's cattle on the property. Though the age of the house is uncertain, local lore has it that it served as a hospital during the Civil War. The house was renovated in 1986, and since then it has become the center of the entire Coppedge family for Christmas lunch. The tradition that was started generations past has been restored, with a barn quilt added to the festivities.

following the barn quilt trail

Virginia was our home for about a month, as I traveled to give lectures across the state. Ruby was parked at the Virginia Horse Center in Lexington, where a series of dressage events was being held. "Horses with dresses?" Glen quipped, knowing I would sigh at his silliness. Of course the next morning, we looked out the window to see horses buttoned up in multicolored blankets that hung over them, looking like—dresses. A trip to Williamsburg was a highlight of the year. Both Glen and I were surprised to discover that the tradespeople were not actors but experts at their crafts, and we watched the silversmiths, basket weavers, and shoemakers with great appreciation. "Now I know what I am going to do when we retire," Glen said as we stood in the blacksmith shop. "You think we will have room for a forge?"

virginia

north carolina

I HAD VISITED the quilt trails of western North Carolina half a dozen times over the years but had always missed fall leaf season, sometimes by only a week or two. This time the yellows and reds were splendid, and our campground nestled in the woods was the perfect place to relax. Glen and I crunched along leaf-strewn lakefront paths with Gracie each evening and watched the fog rise as cold settled into the mountain air.

Randolph County barn quilt painter Louella Caison and I enjoyed a perfect fall day—slightly crisp with golden leaves blanketing the landscape, some still clinging to branches and occasionally twirling to the ground. We toured the countryside, stopping to view and photograph about a dozen barn quilts along the way. Late that afternoon, we visited Maria Dombrowski, whose Liberty Star quilt block Louella had painted. Maria's voice filled with emotion as she spoke of her beloved parents whom she honored through her barn quilt.

Maria's father, Kenneth Shaw, had left Denton, North Carolina, for a career in the army. In the late 1950s, while stationed in Germany, he met his wife, Karola Voss, in the restaurant where she worked. Karola had lost both of her parents in World War II, but when she came to North Carolina, she was welcomed by Kenneth's mother, who told her, "I am your mama now." Kay, as she became known, enjoyed the military life, having coffee with other officers' wives and sharing similar experiences. When Kenneth retired and moved the family back to North Carolina, Kay was at a loss. The small farm that Kenneth built was a source of great pride but Kay did not have a place in the small community.

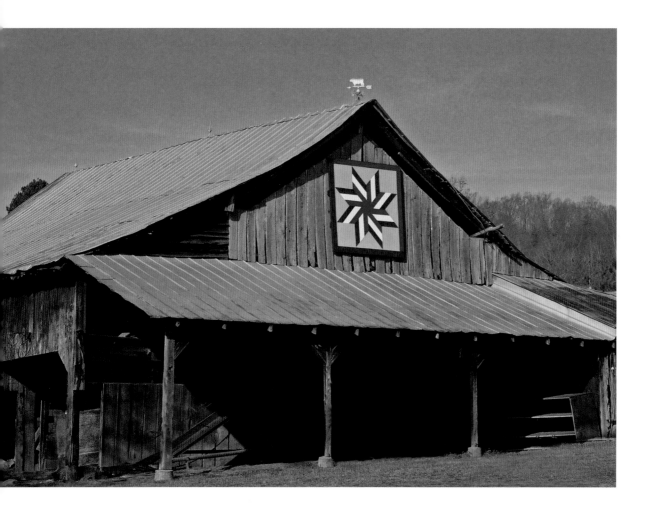

Liberty Star
*Photo by Maria Shaw
Dombrowski*

"Mom hated it here," Maria said. "She missed her life." One afternoon an Electrolux vacuum salesman stopped by, and was delighted to find a loyal customer in Kay, as he was looking for a salesperson. The social interaction that developed out of Kay's part-time job was transformative. She grew to love her adopted country and, though she returned to Germany every couple of years, Kay also enjoyed traveling the States, which she finally thought of as home.

Maria's parents meant the world to her. "They were such a force in my life; they were my best friends," she said. Maria described her father as a gentle soul and her mom as strong and determined. "I got my best qualities from both," she said. Throughout the community Maria was known as Ken and Kay Shaw's daughter, and she loved that.

Ken was diagnosed with a brain tumor in July 2009 and passed away that October. Maria recalled sitting on the back steps with the hospice nurse, who told her, "There's a crack in your foundation now, but time will make it smaller."

following the barn quilt trail

The crack didn't get a chance to shrink; Kay was diagnosed with cancer in 2010, a year after her husband. When the family celebrated the first anniversary of Ken's leaving, Kay told her daughter, "I won't be here a year." She planned her memorial and wanted to be sure that her name was correct on the headstone—Kay Shaw.

Maria honored both of her parents with her patriotic barn quilt. Her father not only served his country, but the farm meant so much to him, and Maria said, "Mom made this her home."

Trips to the quilt trail in Ashe County afforded a drive north almost to Virginia, and I had made the trip often, even when I was not on a barn quilting mission. The quilt trail was created under the direction of the arts council. Director Jane Lonon said that the project fit well into the community, taking public art into the rural community as it brings together quilting, agriculture, and barn architecture. Jane went on to say, "The Ashe Barn Quilt Project has been a strong contributor to tourism. It's a very accessible art form and folks from all over delight in discovering it with us." As a sometime tourist in the area, I could certainly attest to the truth in her statement.

I had passed Cline Church Nursery a couple of times as I wound my way through those mountains and admired the Pine Tree quilt block, but I also wondered why a church would operate a Christmas tree farm. Now that I had a chance to return to Ashe County, I took the time to visit; it turned out that Church was the surname of a prolific tree farmer. I found Cline taking a break, and my education into the world of Christmas tree growing began.

Cline said there were only two native stands of Fraser Fir trees, one on Roane Mountain in Tennessee and one in Southwest Virginia. Seeds were harvested and seedlings grown, to be planted in the area where the seeds seemed most adaptable. He began planting Fraser Firs while still in high school, through a program run by the Forest Service that provided high school FFA members who bought seedlings from the Forestry Division a second one at no cost. Cline gives credit to the Forest Service for bringing economic development: "They had the foresight, and there was a lot of work to get this done."

The lesson continued. Seedlings would be grown in a seed bed for about three years until they stood about five inches tall. They would then be placed about six inches apart in a transfer bed where they would remain for another two years. Finally after five years, the trees would be about a foot tall and ready for planting. With proper treatment and fertilization, the Fraser Firs grow about one foot per year, so that meant that a six- or seven-foot tree is generally eleven or twelve years old. After years of farming and both renting and acquiring land, the

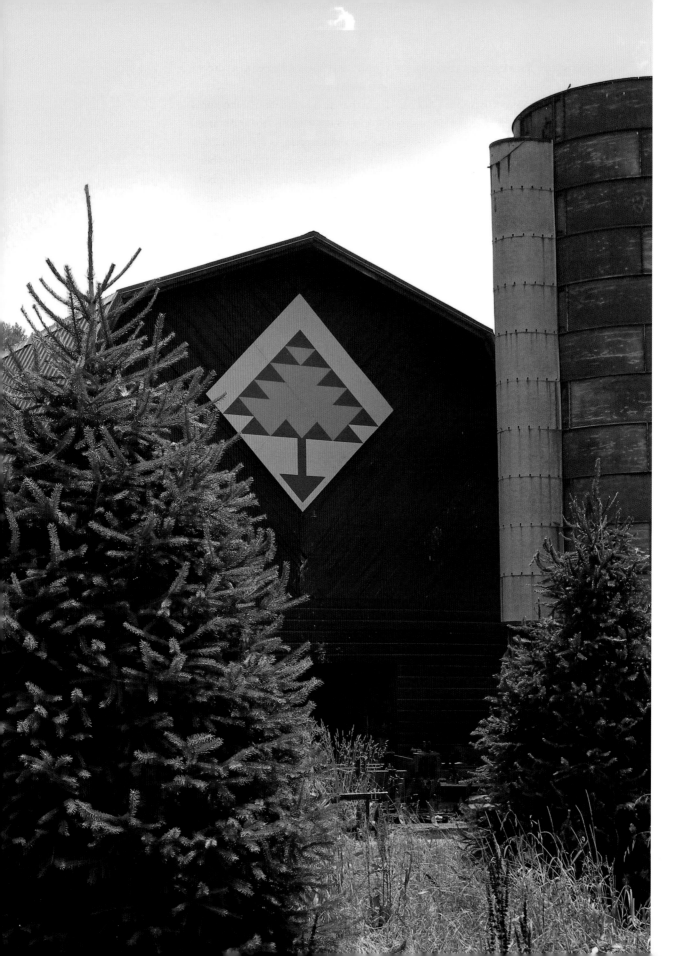

family business has expanded to about seven hundred thousand trees in a fifteen-mile radius, with about seventy-five thousand harvested each year.

Opposite:
Pine Tree

Cline's wife, Ellen, arrived, and Cline shared that he and the woman he refers to as "the real boss" were high school sweethearts who married early and started farming right away. The first trees were planted about forty years ago, and Ellen said that the two had been married for thirty-nine, so it was clear that they had been a team from the beginning. The barn that serves as the central location for the business once belonged to Ellen's grandparents but was lost during the Depression. A few owners later, Cline and Ellen were able to buy the barn back into the family.

Cline is especially pleased that daughter Amber and son Alex have interest in continuing the operation. He enjoys the camaraderie among the growers' associations and has served as a leader of both state and national groups. Twenty-nine states grow Christmas trees, with Oregon the most prolific. Cline said that though the size of the farms has grown, most are still family run. "I don't know of any other type of farming I'd rather be involved in," Cline said. "Sometimes I want to pinch myself."

Dana Johnson had been a board member of the Ashe County Arts Council and participated in barn quilt painting since the project's inception. When Jane Lonon asked about painting another block, Dana thought maybe it was time for her middle-school students to get involved. I had met many an art teacher who had brought quilt blocks into the classroom, but this was a new twist.

Dana teaches eighth-grade math. "I came up with the idea of getting the students involved when we were doing geometry," she said. "All of the angles and triangles, of course, and then enlarging and reducing and keeping the proportions correct." It made perfect sense to me. As a former teacher, I knew that creating a connection to the material was the perfect means to engage young people.

After studying the math skills, students were given quilt patterns, which they enlarged on graph paper, using their new knowledge to keep everything in proportion, then colored their patterns and displayed them in the room.

The Bare family had chosen the Robbing Peter to Pay Paul quilt pattern for their barn, painted in blue, red, and yellow. Once each student had graphed the quilt, they set to work manipulating the colors, then about ten of them volunteered to stay after school to paint the block. The students not only reinforced their knowledge of the Pythagorean theorem but also created a piece of art of which they could be proud.

Jane Lonon said, "There were curriculum connections made, but the connections with community and the sense of pride in their work and giving back were intangible successes for the project."

Glen and I had met Syndi and Renee Brooks a few years earlier when they had just begun painting barn quilts as a business. The two women moved to Jefferson,

115

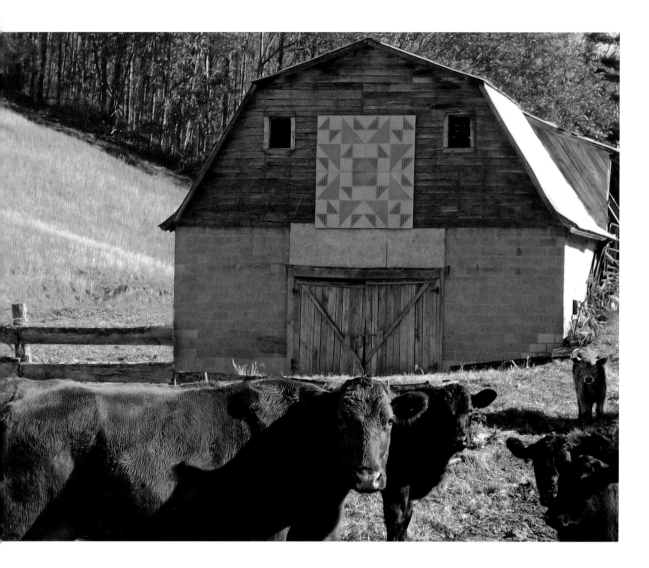

in Ashe County, to care for Syndi's grandmother and painted a quilt square as a gift for her. After adding a block to the shed at their home, the two decided to try barn quilt painting as a way to earn money. Their artistic talent and ability to connect to their customers quickly made the Quilt Square Girls' venture a success, with hundreds of quilt blocks to their credit. The two women became firmly rooted in the community and opened a shop in West Jefferson where they sell their artwork and an assortment of handmade products from other artisans.

Soft-spoken Renee's talents lie in graphic design. Whether by computer or by hand, she skillfully blends the geometric patterns with color combinations, often based on suggestions by customers. If someone sends an idea and a photograph of their barn, she will create the block and then place it on the barn electronically. Renee said, "It's easy for them to visualize and to make changes."

116

following the barn quilt trail

Syndi is the hugger, who sits down with each client and listens to their story. At some point in the conversation, Syndi is bound to say, "Bless your heart." She especially loves to work with older people who appreciate their efforts. Syndi has also been responsible for developing the pair's social media following. "We all know what's ugly out there," she said. "We don't need more of that. We share something positive and uplifting." I often did find Syndi's posts a bright spot in my day.

The three of us visited with some of their clients, and the mood really was as if we were dropping in on family. Sandy and Dal Lassen shared with us the Drunkard's Path quilt square, patterned after a quilt made by a group of African American quilters in Iaeger, West Virginia. Sandy cherished the quilt that came from the town where her mother was born and where her grandparents still lived at the time.

The barn quilt hangs on the front wall of their home accompanied by kitchen implements, which symbolize traditional woman's work. Sandy considers the kitchen implements art themselves, combining form and function. She said, "I look up and see the quilt and think of mother and the women in the family. I have no skill with the needle, though. I was the mother whose little boys' Boy Scout patches were sewn on crooked."

A sign displaying four barn quilts and "The Huck Cabin" marks the foot of Cleo and John Huck's drive. The Hucks have half a dozen other quilt blocks, including one mounted by magnets to a steel door. "I love barn quilts, the way people memorialize their family, their history, their town—whatever is important to them," Cleo said. The Huck's most prominent quilt block combines the insignia of the United States Navy with dolphins, to honor John's twenty-six years of service and membership in Brothers of the Fin, an honor that signifies expertise with the submarines on which John served. Renee was proud to paint the block that serves for her as a reminder of all veterans.

Martha and Rocky Nelson's barn quilt was one of the special ones that Syndi said are "a privilege to work on." The couple moved to Ashe County after Martha's brother, Brooks Duncan, was killed in a traffic accident. Brooks lived on the farm and did some farming but made his living as a truck driver. After twenty-seven years of driving without incident, he was killed while on a trip to Texas.

Brooks wasn't married but shared his home with three border collies and looked after his mother who lives nearby. After Martha and Rocky moved to the home, there was so much sadness. "We wanted to do something special for his earthly home." Martha said. "He loved it here and couldn't wait to get home when he was traveling." Martha loves quilts and when she saw a display of barn quilts in town she thought something bright might be good for the barn.

The pattern is appropriately enough, Memory, but an extra touch was added to the center. Martha considered having a trailer added but thought it would make her sad. Then it occurred to her to use the Border Collie to represent Brooks's "three little children."

north carolina

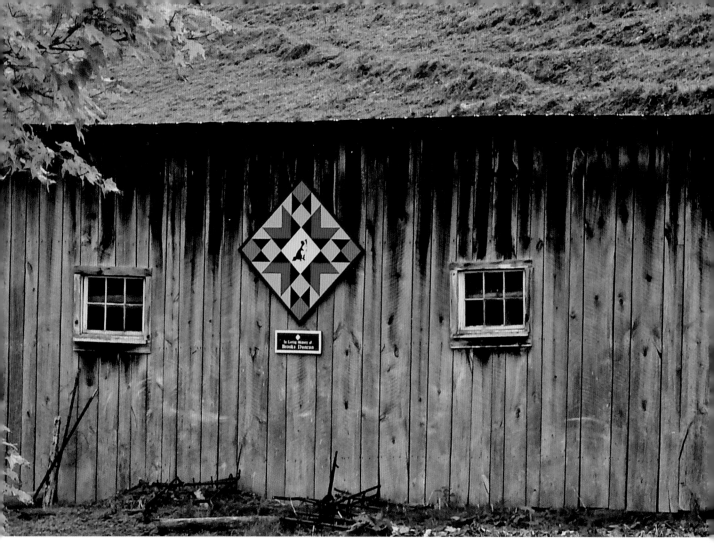

In Memory of Brooks
Photo by
Martha Nelson

Martha said, "When we see it or people mention it to us you feel like you have made an earthly connection to his heavenly home." Martha takes her mother to the cemetery regularly to put flowers on Brooks's grave, but doing so creates sadness for her. "This is more of a happy feeling: it's got color and it's bright. I think he would love it." Brooks's mother cared for his dogs after his death, and when they passed away, they were buried right behind the barn where the memorial quilt hangs.

When Martha and Rocky went to pick up the memorial quilt, they saw a round quilt block with golden colors and knew it was just right for the other barn on their property. Rather than placing it facing the road, Rocky mounted the block where it could be seen from the house. The block is centered in the kitchen window, and Martha said that if it's raining or snowing, "It's like sunshine."

Martha's comment reminded me of Glen who sings a verse or two at least once a day: "You are my sunshine, my only sunshine . . ."

following the barn quilt trail

We had spent three months on the quilt trail and despite the challenges still loved the life we had chosen. We planned to take a break in Georgia for the holidays and then return to our travels for most of the following year, and it just didn't make sense to keep an empty house. But could we really let go of our stationary home? Mile after mile as we headed south, we debated the subject. We arrived in Georgia and walked into our home, laden with suitcases and both stopped in our tracks. Glen exclaimed, "It's so BIG." A wave rushed over me; after living in a bus for three months, I felt as if I had walked into one of the world's great cathedrals instead of the living room of our modest home.

We realized that we had come to accept a forty-by-eight-foot space as sufficient for a home and began to talk in earnest of leaving the house behind. With a nine-month road trip on the horizon, keeping a vacant house waiting for our return just wasn't practical. Still, the prospect of not having a location to actually call home was discomfiting.

After weeks of discussing, list-making, deciding, and changing our minds, we decided that our house on wheels was plenty of room for us. Bus life had been difficult at times, but by now that confined space felt like home. Over the next few weeks we donated and discarded about two-thirds of our belongings. We applied the philosophy that six months without use meant that the item had to go. My boxes of clothing, sorted by size and waiting in the garage for hoped-for future diet success went to charity. Glen's outdated computers and computer parts found their way to electronics recycling. We sorted and boxed, held a yard sale and took truckloads to charities and the local landfill until we were down to what would fit into half our basement and the storage bays of the bus. A tenant moved into the house on a long-term lease and Glen and I set out again with Ruby as our only home.

louisiana

GLEN AND I left Georgia behind in March 2014 to follow a rather circuitous route that would take us to California and back by way of a dozen quilt trails. Our first stop was Ponchatoula, Louisiana, and the Louisiana Northshore Quilt Trail, so named because the trail extends through five parishes along the north banks of Lake Ponchartrain. The quilt trail in Louisiana is a very unusual one, both because it is a barn-less trail and because many of the quilt blocks are very complex interpretations of fiber art. "They have brought modern quilting to the quilt trail," Donna Sue said, and we were both excited about the development.

Donna Sue had introduced me by email to Ann Boudreaux, whom she called the matriarch of the Louisiana group. Ann had invited us to park Ruby behind her home and promised that she had plenty of room. I had tried to politely refuse her hospitality, as parking that huge bus on private property had proved problematic even in rural areas. But Ann insisted, and despite our misgivings, we set the GPS for her address. Ponchatoula proved to be a small town, with brick storefronts that are home to family businesses, many of which were decorated with colorful quilt squares. We came to a stop in front of an elementary school, with houses on small lots visible beyond, and Glen asked, "Are you sure about this—I mean absolutely sure?" I wasn't sure at all, and I was becoming less so by the minute. Still, Ann had sounded so certain, and I had not formulated a plan B.

The route took us into a neighborhood of older homes set closely together, and with less than a mile left to go, we were confronted with a Dead End sign. Glen stopped the bus. "OK, this is it. We may get stuck down there." I urged him

to drive on, and as we crept past a handful of houses, the situation looked grim. Thick trees lined the road on both sides. I sucked in my breath and through clenched teeth, said, "It will be all right." A moment later a larger house came into view—no, there were two houses with a double driveway in between. I hopped out and introduced myself to Ann, and the two of us guided Glen into the RV parking pad behind the carport.

I expected the woman whom I had been told to call "Miss Ann" to be an elderly "Miss Daisy" sort. While her biological age might put her squarely in the ranks of the elderly, Ann proved anything but. She was tall and sturdy, with eyes that smiled and radiated warmth and a sly sense of humor that complemented the back and forth that Glen and I enjoyed. Within a couple of hours, the three of us had developed a rapport; both Glen and I looked forward to spending time with our new friend who asked to be called "Just Ann." Of course, Glen responded by saying, "So, 'Just Ann,' can we take you to supper?"

Ann's Family Ties quilt block became a sign of welcome for us, as it was positioned beside Ruby's door. The quilt block incorporated the things most important to Ann—family and faith. The diamonds that formed the border of the block represented her four children, the jewels of her life. When designing the block, Ann intended to add five triangles to represent her five grandchildren, but one of her daughters pointed out that the number of grandchildren was constantly increasing and that another generation was coming along soon. Ann searched through quilt patterns until she found one that she adapted into an Infinity Cross. The design was inserted into the center of the block to represent the expansive faith that occupies a central place in Ann's life and the growing family that by then included eight great-grandchildren.

Ann, Glen, and I took in the sights nearby, including the turtle farm owned by Ann's nephew, Keith Boudreaux. In the 1940s, Ann's husband, Leon, and his brother, Ralph, would accompany their father when he dug turtle eggs along the railroad track. The eggs were carefully placed into ground that was tilled as if for a garden. "The way you took them out is the way you have to put them in," Ann said. "You can't turn them over." The eggs would be covered with tin and then dirt, and once hatched, the turtles could be sold as pets.

The business expanded over the decades, and Keith now runs the farm they call Tangi (for Tangipahoa Parish) Turtles. Keith told us something startling—the little turtles that we remembered as childhood pets were no longer sold in the United States. A ban was imposed because the turtles sometimes carry salmonella. Despite stringent measures that ensure that the eggs and turtles are disease free, the business is limited to selling to clients overseas. Keith showed us the ponds where the adult turtles breed and the warehouses where thousands of tiny turtles were stored, ready for shipment. The most popular is the red-eared slider, so named because of the colored streak on the side of its head.

We left Keith, having become well versed in turtle husbandry, and visited another local attraction, an alligator farm, whose owners proudly informed us that they were the original Swamp People. The three of us lined up against a chain-link fence and watched a young woman climb onto the back of a huge alligator where she lay spread-eagled and fearlessly stroked his snout.

Of course food had to play a role in a Louisiana trip, and Ann made sure we had plenty, including her rich homemade crab pie. We were greeted warmly at Paul's Café, owned by Ann's son-in-law, and after a couple of visits, we felt like family. Before our sausage gumbo and cornbread hit the table, we had been introduced to half a dozen locals. It seemed everywhere we went Ann was well known and loved. At the Millside restaurant, "Miss Ann" was greeted with hugs, and I finally learned to appreciate crawfish and discovered the crunchy bread of a properly made po' boy.

The Louisiana Northshore Quilt Trail began when Ann traveled to West Virginia to visit family and took a detour to visit the Adams County Quilt Trail and to meet Donna Sue. "I love everything she represents," Ann said, "her strength

123

Seafood Platter

and her positive attitude. I wanted to bring some of that home." Kim Zabbia, a well-known artist and community leader, was the first person Ann called, and along with half a dozen other women, the two set to work. At the time of my visit, they had painted more than sixty quilt blocks, some directly mounted and some on posts, at businesses and homes throughout five parishes.

The Louisiana feast continued when I lunched with Kim and the quilt trail board members at the landmark Middendorf's restaurant in Manchac, famous for the baskets of thin catfish that have been served up for over eighty years. Owner Karen Pfeifer took me on the tour of the building, which began as a simple café and tavern but now spans several wood-paneled rooms. Photos of the restaurant

following the barn quilt trail

in every decade from the 1930s forward line the walls, creating a timeline of both the building's incarnations and customers' cars and clothing. Of course, the restaurant has its own quilt block, Seafood Platter. Kim Zabbia's design incorporated a mélange of crabs and catfish, the iconic building and its red and white striped awnings, and a couple of alligators that might be found lurking in the swamps nearby.

Kim had chosen some of her favorite quilt blocks for my visit. The first, mounted on a post at the edge of a lawn, looked like a double-crusted pie with a piece already cut and served. On opening the door to Frances Chauvin's home, we found the air awash with the smell of baking. The rustic dining table off the kitchen would easily seat twenty had it not been covered with two dozen pies. Frances, who is known far and wide as the Pie Lady, was busy at work.

Frances rolled balls of homemade crust into rounds and placed them into pans, talking in detail about her baking without a single pause in her progress. Frances learned the art of making pie crust from her grandmother at the age of

nine. The first lesson was, "The less you handle it the better it is." Frances became well known for the pies she baked for special occasions, so when her son and his wife opened a farmer's market in Hammond and needed vendors, she contributed a product that few others made. For fifteen years, she has sold pies at farmer's markets, moving on to New Orleans and then Baton Rouge, where she has a loyal following.

As she spoke, Frances crimped the edges of the crusts with nimble hands, creating perfect flutes without even a glance. "The secret is to roll from the center, not from one edge," she said. "Lift and roll. If you don't lift, the dough will get tough." Scraps of dough go into a ball to be rolled out and made into crisps with cinnamon sugar that I have always called elephant ears, but in Louisiana are called shoe soles. "I don't waste even a smidgen of dough," she said.

Frances usually relies on two helpers to fill and bake the pies, but for Thanksgiving the entire family pitches in. Two hundred and fifty pies were ordered the previous year, so her children and grandchildren all came on Sunday to help. "We had a priest come to say mass because nobody could go to church," Frances said.

"I never expected to be doing this for so long," eighty-two-year-old Frances told us. Her eight-year-old grandson told her recently that when people got to her age they ought to retire. "But I never have to retire; I like to be busy."

The Mother Crust quilt block was Kim Zabbia's idea. The seven slices stand for Frances's seven children, and the missing slice cut from the pie is for her late husband, John. A saying goes with the block: "Ms. Frances rolls the entire family together." It seemed to me that she rolled together not just a family but a wide community in southern Louisiana.

A drive through Ponchatoula and Hammond revealed a symphony of colored quilt squares—the pink and yellow on the local pharmacy, a butterfly surrounded by flowers that marks a butterfly garden, and a more traditional Rose of Sharon pattern at a church—painted by quilt trail committee members, local artists, and sometimes the quilt block owner. One of my favorites was Elemental Balance. Kim designed the block, which is mounted outside a massage therapist's office. I loved the block's vibrant colors but also the combination of the modern design with a classic pieced Bear Paw quilt pattern.

A primary-colored quilt block next to the door and a matching totem pole in the yard marked our arrival at CAS, Child Advocacy Services. A large white dog lounged on the porch under the block, and I asked whether perhaps he might move so that I could take a photo. CAS director Rob Carlisle simultaneously held out his hand to greet me and encouraged me to consider allowing the dog to remain. He explained that Hayward is a Canine Companion and is symbolic to the CAS program. "If a dog can advocate for children, adults and children alike can advocate," Rob said. "Hayward sits with the children and goes to court with them. He is oftentimes more recognized in the community than some of our staff."

Elemental Balance

Rob went on to tell us a bit about Child Advocacy Services. One of the programs at the center is providing training for court-appointed special advocates, or CASAs, volunteers who speak on behalf of children who are in foster homes when they go to court. The aim is to help them find a safe and permanent home. Volunteers also help conduct forensic interviews when children are talking about sexual assault, working in eight offices in southeastern Louisiana, all designed to be child friendly so as not to retraumatize children.

Rob stressed the importance of talking about the subject. He said, "We get calls from people that see things in the community and they really are disconnected

from how to react to protect children. The training helps them feel confident and empowered in handling situations that we don't talk about every day." I was interested to hear that the program's focus is not to emphasize arrest and conviction, but instead to foster a supportive environment for the children. Rob said, "It's more empowering to see that there are others in the community willing to help. We focus on a total wholeness instead of on blaming or anger."

The buttons on the Never Alone Ever Again quilt block that Kim designed are emblematic of a special initiative at CAS, Buttons of Bravery. Each child who enters selects a button from a jar. The buttons are a recognition that "other children came before them courageously." Buttons come in all different shapes, sizes, and colors, so they are a great way to do that. "We started allowing children to pick buttons that matched them," Rob said. Each child takes one with them and places one in the jar. "It's impactful to see 570 children who gave these to us," Rob said. The next year, the buttons will be given to community members who have helped the organization. The Buttons of Bravery even appear on the agency's brochure.

The quilt block includes twenty fingerprints made by the hands that stand for the twenty years that CASAs have been active in the ten parishes, each of which is represented by a house. The black house in the background is the sadness from which the child came. "Of course the stitching is the thread that ties us all together," Kim said.

"A lot of people ask, how do you do such difficult work, but serving children is the easiest thing we do," Rob said. "Getting people to prioritize children is difficult. I know roads are important and we need infrastructure, but I put children at the forefront of all of that."

Glen and I had completed the first leg of our journey, and I had a New Orleans weekend planned. I had found an RV park right on the water not too far from the city. Glen and I toured the French Quarter, strolling in and out of shops full of antiques, art, and trinkets, perpetual window shoppers without the room or desire for any new possessions. We braved a chilly drizzle to stroll through a historic cemetery, hand in hand as we had been on our first date, when we walked among Civil War graves in Georgia.

I had chosen Commander's Palace for brunch after studying the menus of several award-winning restaurants and had already planned my meal. Fat shrimp wrapped in Tasso ham with pepper jelly and pickled okra were followed by grilled pork with savory wild mushrooms over stoneground grits. Glen chose to sample the famous turtle soup, and we agreed that the food and service were among the best we had experienced. When the trio of musicians visited our table and asked for a request, a favorite Nat King Cole tune came to mind. Swaying and waving my hands in time with the singer, I belted out "L–is for the way you look at me; O–is for the only one I see," and the smile in Glen's eyes told me that I had made his day.

Opposite:
Never Alone Ever
Again and Hayward

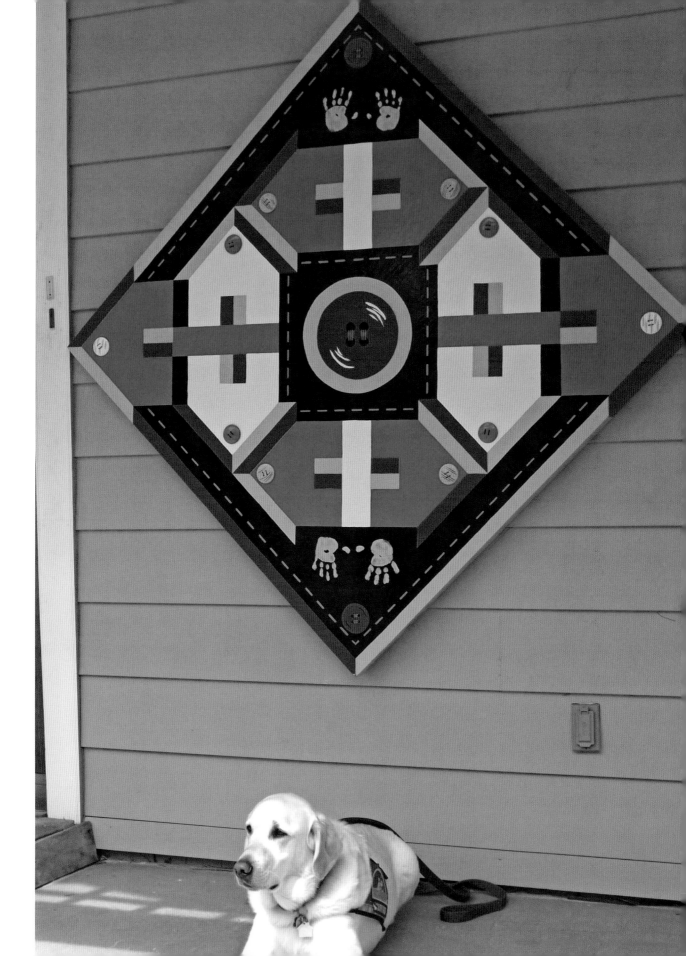

kansas

THE ROAD NORTH took us to Ajax, Louisiana, more of a crossroads than an actual town. The RV park sat just a minute or so from the interstate and miles from much else; a saw mill near the highway and a diner across the road were the only businesses nearby. We walked over for a pork chop dinner and took our time returning, overwhelmed by the sight of infinite stars in the blackest sky I had seen. I seldom accompany Glen and Gracie on their pre-bedtime walk, but that evening the three of us strolled along the fringes of the park, Glen and I in silent awe of the bits of light that were always there but so seldom visible to us.

I had been really pleased to find an RV park along the Arkansas River in Tulsa. Online maps displayed a wide span of river, and the reviews mentioned plenty of kayaking. I didn't let on to Glen but waited for the drive across the bridge near the campsite that would reveal the treat in store. The joke was on me, as the river had fallen victim to drought and had dried up completely, leaving a lunarlike landscape behind. Sensing my disappointment, Glen said, "Oh, you picked a perfect spot for some hiking, Sweetie!" At least he knew I had tried to make the long drive to Kansas more enjoyable.

Chris Campbell had brought the quilt trail to Kansas in 2010 and contacted me soon afterwards, so a visit to Franklin County was one of the first on our itinerary. Along with being a farm wife and mother, Chris is an avid quilter and quilt shop owner. A trip to the renowned Sisters Quilt Show in Oregon included a side trip to Tillamook County. "I was amazed at their farming methods," Chris said. She described an underground pipeline from a dairy to a cheese factory. "How wonderful is that?" One critical difference she noticed was the size of the farms.

New York Beauty/
Ohio Star

Chris said that in Oregon, a typical farm might be sixty acres or so. "In Kansas," she said, "an eighty-acre farm would be a hobby farm!"

Chris also saw the quilt trail in Tillamook and when she got back home, she kept thinking that somebody in Kansas needed to start the project. "That somebody became me!" she said. The county's first quilt block, which is mounted on Chris' Corner Quilt Shop, combines two patterns, New York Beauty and Ohio Star. I thought that the block, which Chris said combined her traditional quilting with the more modern quilting favored by her business associate Brenda Weien, looked pretty good, but Chris affectionately called the quilt block, "the first and the worst." Chris wasn't sure at first what type of board and paint to use, but she learned quickly and helped Kansas's first quilt trail grow to more than forty blocks.

One of the proudest barn quilt families is the Krambecks. Pat Krambeck greeted Chris and me sporting a Krambeck Farms t-shirt whose logo included their barn quilt. A number of quilt trail committees had created shirts decorated with quilt blocks, but this was the first I had seen for an individual farm. Pat had initially asked for the Double Wedding Ring, but that pattern was already taken, so a single wedding ring was designed to honor Pat's marriage to her husband, Chuck. The 1925 barn's ornate trim left no room for an eight-foot-square block, but a four-foot square would not have been visible on the large structure. A little

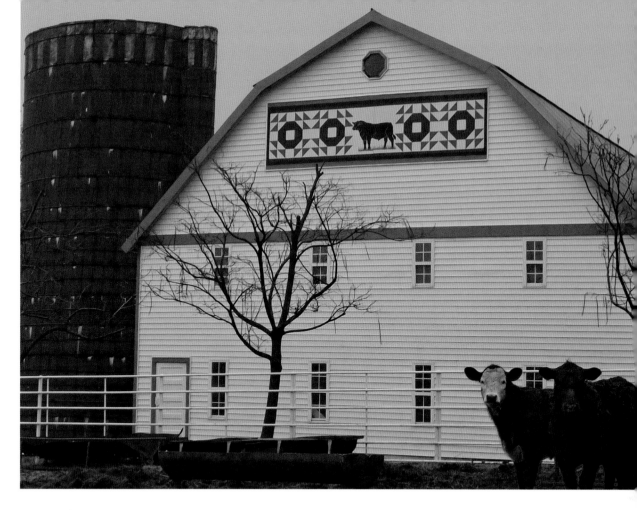

ingenuity resulted in the Krambecks' four-by-sixteen-foot painting; the rectangu-
lar arrangement makes quite a statement, with an Angus bull in the center, the
"boss" of the farm.

Pat began to talk about her family, which included ten grandchildren and ten
great-grandchildren. Her affection for them was evident in her smile, but each
time she mentioned her husband, Chuck, Pat's eyes shone even more. I thought it
was lovely that a great-grandmother would still have romantic ideals and hoped
that Glen and I would be similarly affectionate in decades to come. When Pat
shared a bit more of their story, I realized that she and Chuck were in fact newly-
weds, having met in Kansas City just a few years earlier. The two moved to the
farm after their marriage. "I love it," Pat said. "I didn't have any qualms about it."

Pat's eyes continued to sparkle as she talked a bit more about her husband.
She had found a news article about the Grand Champion Steer Chuck raised at the
age of twelve. Even at that young age, he had declared, "I want a lot of cows." Pat
went on to proudly share a story of Chuck's kindness. He had attended a hay sale
one recent Saturday, and one of the men who were waiting to purchase hay had a
seizure and was rushed home. Chuck bought the hay and delivered it to the

133

kansas

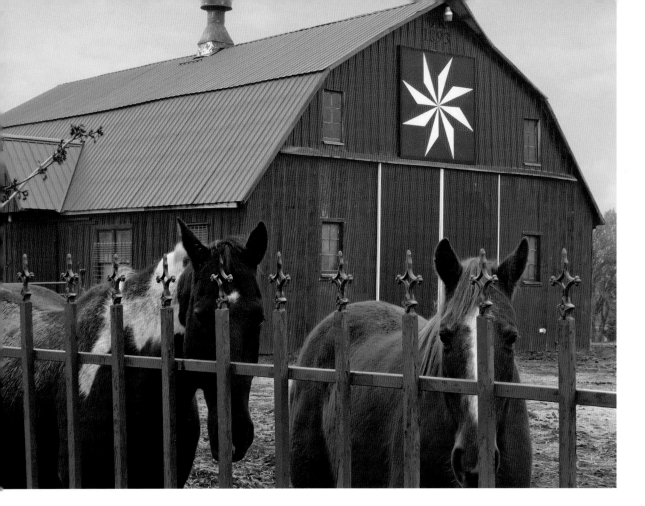

North Star

stranger's barn knowing that the animals still needed to be fed. He was surprised on his arrival to find that Jerry Olberding's barn had a quilt block as well.

The Olberdings' farm was actually our next scheduled stop, and their North Star quilt block was visible as soon as Chris and I pulled up. Reita Olberding told us a bit about the farm, which was purchased by her great-grandparents, James and Olive Herring, in 1893, and had been owned by the Herring family since. There was no barn on the section of land where Reita and her husband, Jerry, moved, so they designed and built one, laid out like the barns of the 1890s, with hay storage on two sides and room to drive through the center. The barn was constructed from pieces of several old barns from Axtell, Kansas, where Jerry grew up. The roof and two of the sliding doors are new metal, but the rest, including the windows and cupola, consists of reclaimed material.

Reita said that she and Jerry had built the barn, and I thought perhaps she meant that they had designed the structure and had others do the work, the way that many suburbanites "build" houses. I was astounded when she said that except for some of the work in the loft, with which their son and nephews helped, the couple built the barn themselves in about two months. The barn is home to their

134

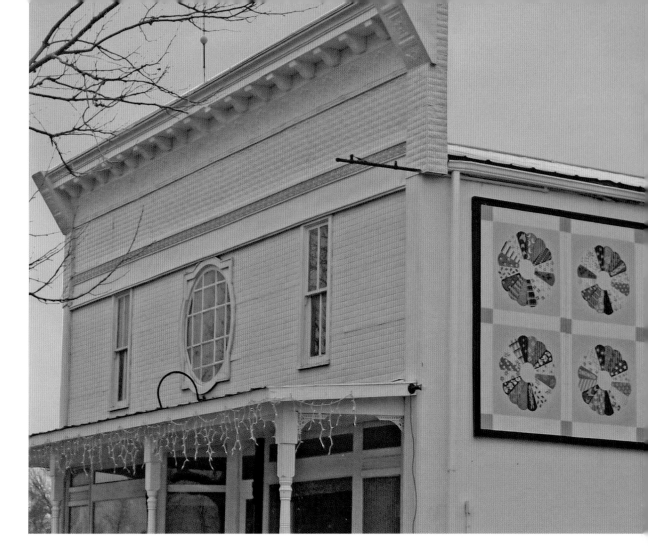

Angus cattle and to their riding horses, some of which were very pleased to greet Chris and me along the antique rail fence that day.

 The construction of the house was especially interesting. The one-foot-thick walls were built using ICF (insulated concrete form) foam construction. Reita explained that the walls included three inches of foam, six of concrete, three of Styrofoam, and then the siding, which greatly reduces energy use. The two did a great deal of work on the house as well—all of the wood, floors, and tile—driving back and forth from their home in Missouri, sometimes sleeping in a camper in the barn. Once the house neared completion, the Olberdings removed the fireplace mantel from their former home and brought it with them to Kansas to complete the move.

 The dozens of family quilts that hang in the home, the stained glass, and the kerosene lamps were evidence of the family's connection to the past. The home was a contradiction of sorts, with the latest in building materials blended with artifacts of earlier times in ways that complement both.

Dresden Plate

135

kansas

Our last visit for the day was not to a barn at all. Sandy and Russ Sylvester's Dresden Plate quilt block hangs on what was once the storefront of the Milford General Store. In the mid-1960s the town of Milford was set to be flooded and the Milford dam built. Russ's father, Wes, purchased the storefront, which was disassembled at the site and reassembled in Franklin County. The building housed Wes's collection of antique cars and tractors, some of which were still there for us to see. I wished Glen could have been along to see the centerpiece of the collection, a meticulously restored Thunderbird painted his favorite brilliant yellow.

"Wes appreciated his past and also wanted people to learn about new things," Sandy said. Those new things are part of an annual Day on the Farm that the Sylvesters have hosted for about fifteen years. Over three hundred third graders, along with their parents and teachers, visit the farm, where a petting zoo is set up. With the help of older FFA, 4-H, and FBLA students, the younger ones learn about soil conservation, grains, and dairy production. With any luck they might also get to see the windmill that sits out front of the store, grinding corn for the Sylvester's chickens.

That evening Glen and I joined Chris and her husband, Allen, at a hole-in-the-wall restaurant known only to locals, our first chance to enjoy Kansas barbecue. Gnawing the tender meat off of a rib bone with sauce oozing down to my wrists, talking and laughing in-between bites, I felt right at home a thousand miles from Georgia.

■

We made our way west, and those legendary Kansas winds swept in, buffeting Ruby from side to side like a ragdoll shaken by a child. I was relieved to arrive at our park in El Dorado in the Flint Hills region, a section of twenty-two counties that stretches from north to south in the eastern part of the state. The winds still pummeled the bus but at least we were no longer in danger of crossing into the wrong lane of traffic. A creek was visible through trees and brush behind our site, and as soon as we got settled, Glen unstrapped his kayak from the car and dragged it down a steep incline. I am not nearly as sure-footed as Glen, so I stayed behind with Gracie to watch, knowing that if I did make it down to the stream bank there was a good chance I would end up in the water rather than in my boat.

My first stop in the Flint Hills was at Pat Mitchell's home. Pat was waiting for me, and soon her daughter, Jonna, joined us. Pat's interest had been piqued by a news article about the new quilt trail. Jonna tracked down the information, and within a week of her delivering the boards, Pat had the extravagantly colored block completed. Pat designed the block on paper so that she could mix the colors of the eighty-plus triangles just so. She would paint a couple, then head back to the house to let those dry, just going back and forth until she had them all done.

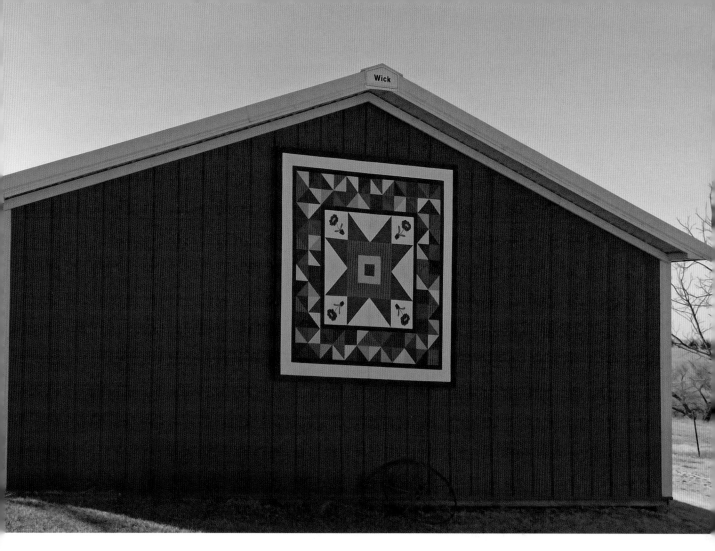

The project appealed to Pat as a way to break away from the cloth quilting that had recently occupied her time. Pat had stayed home for two years to care for her husband, Glen, who had Alzheimer's. During that time she made more than twenty quilts. "That's all I could do at the time," Pat said. "We all got a quilt that Christmas," Jonna added, with a bittersweet tone.

The Late Bloomers barn quilt was the perfect answer to Pat's need to escape the confines of home. I admired the fact that the octogenarian had painted such a detailed block on her own, with Jonna stepping in to help only when it was time to turn the large boards to reach another area.

As I visited with Pat, the infamous Kansas winds whipped around me once again. I was blinded by my whirling hair and barely able to stand upright to take photographs. I returned to the bus to find Glen wiping dust from his keyboards, the countertops, and every flat surface. The fine grains that rode on those fierce winds had infiltrated every corner of the bus. I had chuckled a bit when we arrived

kansas

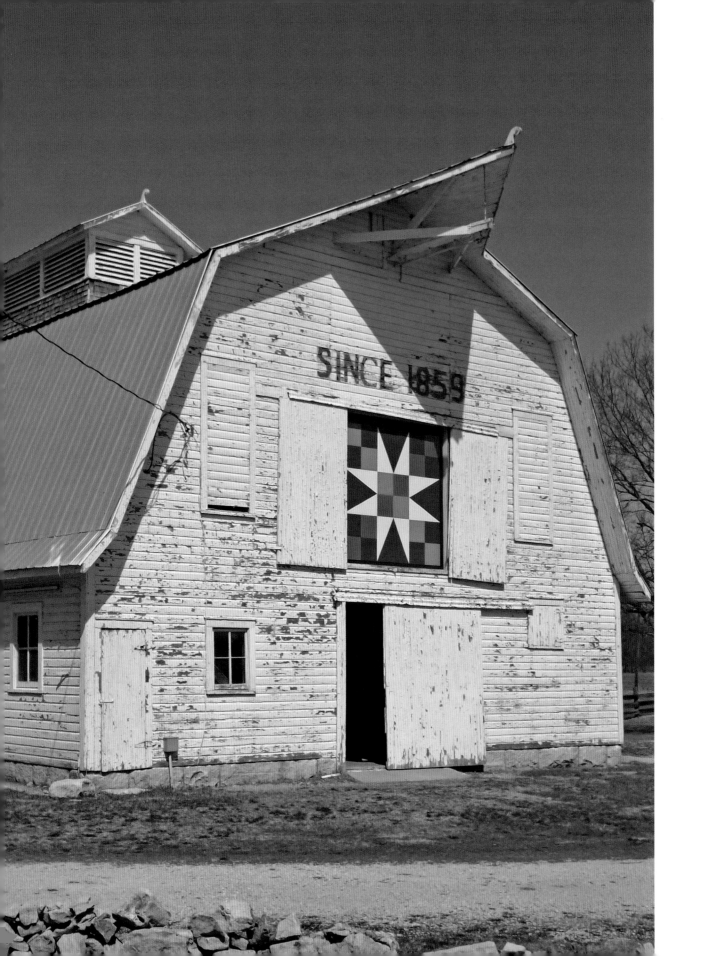

to see a tornado shelter dug into the side of a hill within the park and now was grateful for the peace of mind its presence brought.

The next day I traveled to Pioneer Bluffs, site of one of the first barn quilts in the Flint Hills. I was excited to visit the historic site and one of the few wooden barns I would see in Kansas. I enjoyed lunch with Lynn Smith, director of Pioneer Bluffs, along with Elaine Jones and Susan Hague, who have been avid volunteers at the site. Susan and Elaine had conducted a program for students at a local school, during which they talked about barns and quilts and how the quilt trail brings communities together. We were surrounded by crayon-colored quilt blocks hanging on the walls, as the third graders were due for a visit and were eager to see their artwork.

Lynn explained that the mission of Pioneer Bluffs is to tell the story of Flint Hills ranching. The history of the property began in 1859, when Charles Rogler, a young immigrant from western Bohemia, walked hundreds of miles from Iowa to stake his claim. The family survived the droughts and financial downturns that broke the spirits of so many other farmers, and the homestead was named Pioneer Bluffs by a later generation in honor of those whose spirit created the family legacy. The Roglers became pioneers in raising cattle on the tallgrass prairies, and by the time the property was sold in 2006, it was one of the largest and most respected cattle operations in the county, with over sixty thousand acres. The tract that included much of the original homestead as well as the farmhouse, barn, and other buildings was bought by investors to form a nonprofit for preservation. Lynn calls the new visitors to Pioneer Bluffs pioneers in their own right, as they work to preserve Kansas farming and ranch heritage and to foster respect for the land and its natural beauty. The Pioneer Star quilt block pays tribute to both sets of determined Kansans.

Elaine Jones had been involved with preservation of the Flint Hills and its tallgrass prairies since the early 1970s. "The more people come out here, the more they see that the Flint Hills are rare and beautiful and need to be preserved," she said. I was not certain why a tallgrass prairie was significant, so Elaine explained that the types of grasses and wildflowers comprised a unique ecosystem that had all but disappeared.

Lynn added that there were once four hundred thousand square miles of prairies but less than 3 percent remain. In most of the country, the soils were deep, so the land was plowed as settlers arrived, destroying the tallgrass ecosystem. The flint that lies just below the surface in the Flint Hills region made plowing more difficult, so some of the prairie has never been touched. Aha! Now I knew how the area got its name. The tallgrass is perfect for cattle farming, and for much of the year, the surrounding land is used for grazing. Again I was confused—where were the cattle? I hated to ask a silly question, but I honestly did not know. The cattle would soon be trucked in from Texas and Mexico, though some farms do have a cow-calf operation, which means that they raise their own cows.

139

kansas

Flying Geese
Variation

The conversation turned to the burning of the prairies that takes place each year. I was fascinated by those fires, whose flickering power held a certain beauty. Lynn explained that the old grass no longer contains nutrients, so it is burned to allow the sun to reach the new growth. The burning also gets rid of the tiny trees that have sprouted in the past year from seeds carried and dropped by wind or birds. "As my husband says, cows don't eat trees," Lynn said.

Susan added, "In a few months, it will be so green that it makes the pupils of your eyes contract." It was hard to imagine vibrant color spread across the khaki-colored expanses, but I made a note to schedule our next visit to the Flint Hills for a bit later in the year.

The Kansas Flint Hills Quilt Trail has spread across most of the region but is centered in Manhattan, a couple of hundred miles north, so Glen and I relocated. Glen had lived in Manhattan as a boy, and we stopped by the house where he and his family had resided and the elementary school Glen had attended just a couple

of blocks away. Though I had seen childhood photos of Glen in his mother's home, it was hard to imagine my six-foot-two sweetheart as a little boy walking down those sidewalks.

Manhattan is home to quilt trail organizer Sue Hageman, whom I had met when she and a group of friends traveled all of the way to Kentucky to meet Donna Sue and me at a book signing a couple of years earlier. Of course, seeing the Adams County, Ohio, quilt trail was a highlight of the trip, and the women left energized. Sue is a quilter, and she loves horses, which means she has been around barns all of her life. "When I go into a barn and smell hay, to me that is the best smell in the world," she said. Sue had seen the quilt trail in Franklin County on visits to her mother, so she consulted with quilt trail organizer Chris Campbell and was soon on the way to combining her loves of barns and quilting. With plenty of tips from Chris, Sue first painted a two-by-two-foot barn quilt "just to see if I knew what I was doing," and then a larger version of her Flying Geese Variation, the first quilt she made.

Sue and I had a fun day planned. I hated to leave Glen behind on the weekend, since he had spent five days hard at work. Few seemed to understand that he was not my sidekick or bus driver but the foundation of our lifestyle, that his talents were put to work behind the scenes in order for mine to shine. I was still strug- gling to feel worthy of Glen's generosity of spirit, and to understand that no quid pro quo was expected. This time we were fortunate, as we had met tourism direc- tor Marcia Rozell when I gave a talk in Manhattan, and she turned out to be an avid kayaker. Marcia and Glen had plans to tour the lake near our park, so no guilt tugged at me when Sue arrived to pick me up.

Sue and I visited with Connie Larson, the other force behind the Flint Hills Quilt Trail, in Connie's home. Connie's first foray into barn quilting had been when quilter Susan Kesl painted two quilt blocks, both in a pattern called Home Treasure, to be hung on the barn at Ag Heritage Park. The park is home to an extraordinary collection of household and farming artifacts, assembled by Con- nie's father, Everett Zimmerman, and her mother, Hazel. Dozens of pieces of farm machinery and implements can be found on the grounds. Inside, an array of everything from horse-drawn wagons to sewing machines to cider presses creates a picture of agricultural life from the earliest days to the present. It was quite an incredible collection, and I could have plundered all day.

When Connie saw her first barn quilts she embraced the concept. "I thought the blocks would be good for Ag Heritage Park, and soon realized that they would be good for the area as well," she said. Connie is not a quilter, but she loves fabric and color and enjoys the patterns. "I saw all of the ways this could connect to what people do and what they like, even their hobbies," she said.

Looking around the Larson home, I had a good idea of Connie's interests, and the pink camouflage cap she wore that day fit right in. Mounted animals watched

Arrowheads, Dagger, Hunter's Star

us from every corner, from heads of deer, elk, and caribou on the walls, to a magnificent deer standing next to the hearth, about fifty mounts in all. "Hunting is our life," Connie said. She has been bow hunting for about forty years and enjoys going on hunts with her husband, Dale, and son, Matt. Connie mentioned that she had even gone bear hunting in Alaska, but assured me that she wasn't as brave as it might sound, as a guide stood next to her tree stand to ensure her safety. The Larson's quilt block includes Arrowheads on one side and Hunter's Star on the other, perfect choices for this family. The center image represents Dagger, the deer that is the centerpiece of the Larson's trophy collection.

Connie and Sue had each started talking to Marcia Rozell and the tourism board about a quilt trail at the same time and it seemed natural that they work together. In addition to painting barn quilts and adding new sites to the quilt trail, the two also began a program that allowed hundreds of others to participate. In their "Barn Quilt 101" classes, the women supply primed boards, paint, and sup-

142

plies and conduct a workshop in which each participant paints a small quilt block to take home. The blocks are not formally part of the trail, but after thirty or more sessions, the number of quilt blocks in the Flint Hills easily neared four hundred. I am always asked how many barn quilts exist across the country, and on hearing of initiatives like the classes Sue and Connie organized, I know that any answer that I give will fall far short of the truth.

The Lancaster Rose quilt block on Chris and Ron Wilson's Lazy T Ranch in Manhattan was among the first in the Flint Hills. The block was patterned after a quilt made by Chris's great-great-grandmother, Maggie Thompson Beam, in Manchester, Ohio, where the quilt trail began. The quilt had remained in Adams County and was passed on to a woman who had married into the Beam family. While doing genealogical research, Chris located the quilt, and it was agreed that the heirloom should go to Kansas so that it might return to Maggie Thompson Beam's descendants. Along with the quilt, Chris showed us a photo of a very stern-looking Maggie with the quilt in her Ohio home.

Sue, Chris, and I walked around the property, where each building—even the chicken house—had its own barn quilt. The chicken quilt block was painted as a fundraiser to save a round barn nearby. The Wilsons bought the quilt block and hung it as a tribute to both historic barns and to the 4-H clubs whose fair exhibits they enjoy each year. Corn and Beans on the granary represents Chris's roots in Illinois where those two crops are grown so prolifically. Farmer's Daughter on the high tunnel greenhouse adds to the array, and Double Wedding Ring graces an arena building.

Also on the arena building is Sunbonnet Sue, with a few tulips in the background. This quilt block represents Chris's grandmother, Myrtle Beam Mosher, whose strength as a South Dakota homesteader had served as an inspiration. Myrtle was known to wear sunbonnets and was also an avid gardener, so the block is a perfect tribute. Chris added that the ranch hosts many family events where parents "celebrate their children," so the quilt block is also a reminder of those parents and their devotion.

The final quilt block on the farm is Wagon Wheel, which hangs on the building the Wilsons call the Cowboy Café, where the family hosts visitors to the ranch. Chris explained that pioneer women would often use the spare wheel from the wagon as a sort of loom to make rugs, which took on the round shape. On arriving at their new homes, they would have rugs already in hand. "From those strong pioneer women have come strong Kansas women in agriculture," Chris said.

As we enjoyed refreshments, Chris shared with us some of the cowboy poetry that her husband, Ron, had written. I wasn't sure what to expect from cowboy verse, but I enjoyed Ron's work, which was both humorous and imbued with reverence for the ranchers of the past and the more recent era. One poem described the marriage of a Hereford man to a woman from an Angus family, and another

143

Maggie Beam with
Lancaster Rose quilt

talked about a flock of unwanted sheep given as an unlikely gift. In one of my favorites, a young man explains to his rancher father the merits of the Internet. The father at once complains about his son's time spent with that "high tech stuff" and praises his son's newfound skill at roping.

> The boy said, "Our computer, Dad. It's made my roping good.
> Y'see, it helps my homework, just like Ma said it would.
> If there's a school project that requires a research line,
> I just find it on the Internet—I'm done in half the time."

I left Lazy T hoping to return sometime for one of Ron's performances and, of course, to bring Glen along.

Chris said, "Our clothesline of quilts is a tribute to Donna Sue Groves; her love for her mom; Adams County, Ohio; and all the quilters and farmers who have settled, grown, and worked the land and fed the nation." As Donna Sue would say, "She gets it," as do the many barn quilt owners along the quilt trail in Kansas.

Opposite:
Lancaster Rose

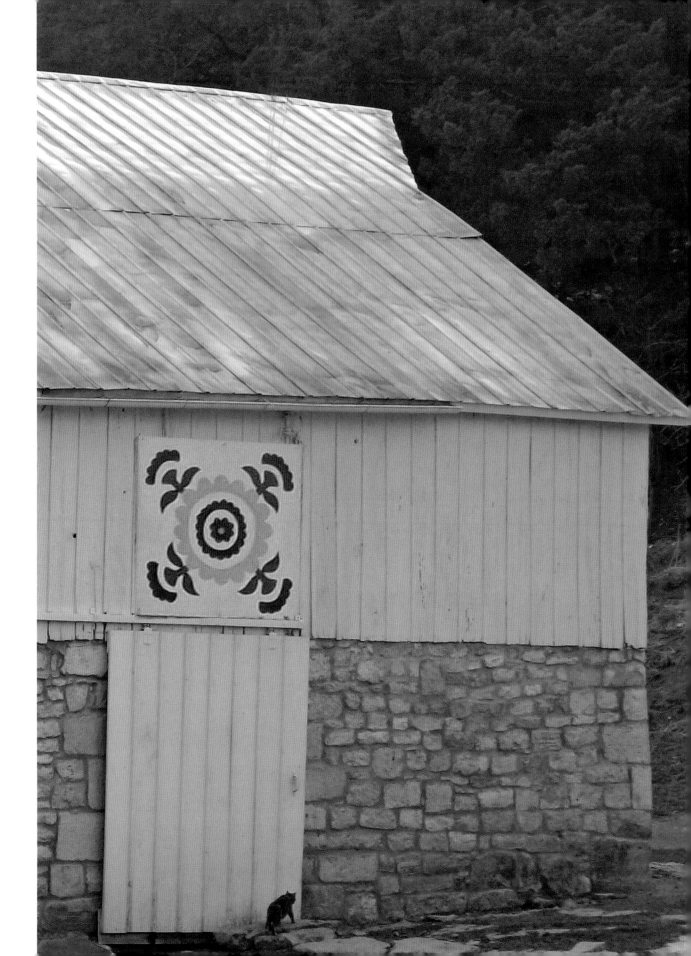

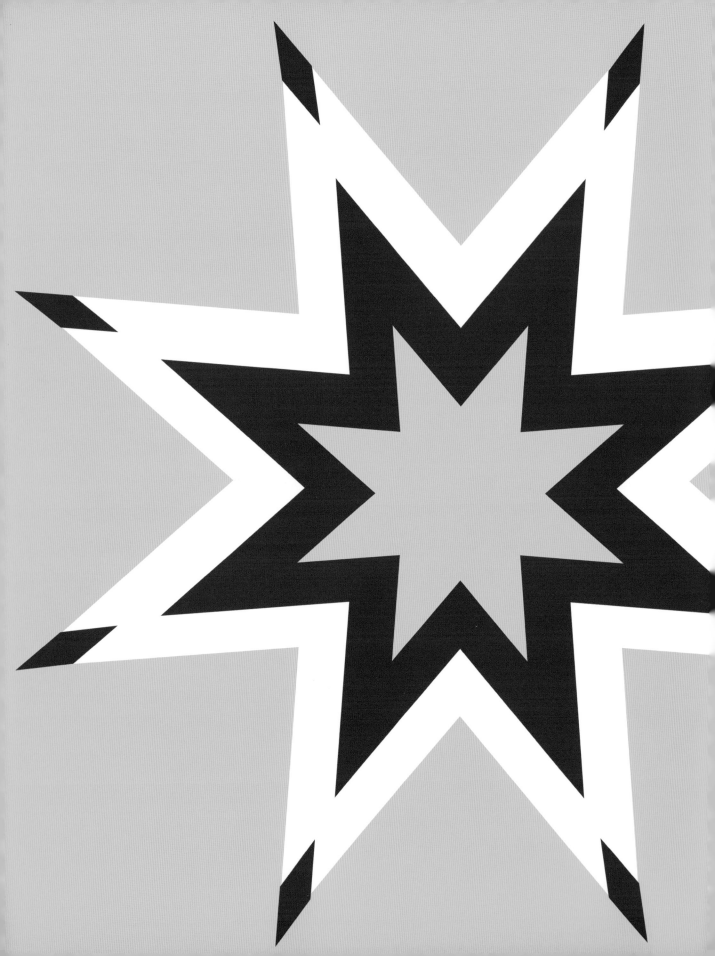

nebraska

RENAE KAMLER AND I had been corresponding for years, beginning in 2010 when her barn quilt was installed. Renae told me about life on the farm with her husband and children; I filled in with bits and pieces about my travels and my new life with Glen. As soon as I knew we would be traveling, Renae and Fillmore County, Nebraska, were added to the schedule. I was excited to see the barn quilts but also eager to finally meet a woman who had become a friend. Glen and I drove just a couple of hundred miles north to a tiny RV park in Geneva, Nebraska. I'd developed the habit of photographing the welcome signs at each state border, and as this one approached, Glen just had to say it. "Suzi, I've the feeling we are not in Kansas anymore."

"Hmmm, tell that to the wind," I answered. If anything, the dusty bursts were growing more and more fierce.

The next day, Renae and I set out to see the barn that she considers "the coolest barn in the county." I was equally taken with the Tatro barn and its row of what I thought were round windows along the front. On closer inspection, they were actually dark blue circles rimmed with white. The two red and white square cupolas atop the roof were much fancier than any I had seen in the past. Alice Tatro said they had been replaced more than once, most recently in 2012 when one blew off. "It took a brave soul to get up there and put those in place," Alice said. The number 19 is painted on the left cupola and 05 on the right, representing the date that the barn was built. On one end of the barn, an Evening Star is painted in matching colors to accent the ventilation louvers, with a Morning Star on the other. The barn's condition belied its age, as the shingles have been replaced multiple

4T

times. After a couple of paintings, the sides of the barn had been covered with steel, but the original look remained in place.

Alice and her husband, Ronald, who passed away in 2008, had spent about fifty years on the farm, and the barn was their pride and joy. It was constructed using pegs without a single nail. I asked about those circles, and Alice thought they might have been open at one time but were in their current state when the Tatros bought the property.

When asked to add a quilt block to the already picturesque barn, Alice was pleased, and the choice of pattern was an easy one. The 4T is a quilt pattern that I had seen before, but it is also the registered brand of the Tatro farm. Each of the T's was one of the four Tatro daughters, who used the barn for their 4-H lambs. The barn quilt served to grab the attention of travelers and created awareness of the burgeoning quilt trail. "That barn really put us on the map," Renae said.

Renae and I left Alice and drove through the county; there were several miles between towns, so we had time to talk about Renae's barn quilt and the quilt trail. "My husband, Pat, thought I was crazy," Renae said. Pat reluctantly approved of the quilt block but was adamant that nothing pastel was going on his barn. In fact, he had definite ideas about the colors. Renae said, "It needed to be red to go with the barn, and blue to go with the silos, so something patriotic is what it had to be."

148

Renae wanted a simple pattern for her first block, so Fourth of July was the perfect choice. Daughters Madeline and Malinda helped with the painting and went on to help their mom with another patriotic design—American Pride—in honor of the town of Shickley's 125th celebration. Both barn quilts fit the town's theme, "Home of the free in a big little town."

Renae had initially wanted to create a barn quilt to honor her grandmother, Matilda Quandt. Renae remembers walking the block to her grandmother's house from school each day for lunch. Unless Matilda had guests, she was always gardening and quilting. She was partial to Log Cabin quilts and pieced one each year, whether for her own pleasure or as a lap quilt for her church. The children also went to Grandmother Matilda's after school. Everything was moved from the den once her grandmother had a quilt top pieced. "Out went the desk and chair, the little fold-flat couch, the treadle sewing machine to the dining room. We set up some chairs with the quilt frame on top, and she would work her way around the quilt sitting on the kitchen stool." Renae's mother was a farm wife, so the afternoon pickup at Grandma's eased the crunch of driving several miles to school to retrieve the children at a particular time, something Renae didn't truly appreciate until she became a farm wife and mother herself.

Some months after my visit, the seventh-grade class at the local middle school painted a Log Cabin barn quilt for the Kamlers, dedicated to Renae's Grandmother Matilda. Under the guidance of teacher Rebecca Jorgenson, the children applied the solid colors and then added layers of patterns to make each log in the block look like fabric. Grandmother's Quilt block was hung on a corn crib on one of the Kamler's sections of land where Renae gets to see it daily.

The quilt block has become a tribute not only to Grandma Quandt but also to Renae's mom, Lavilla, and Lavilla's mother, Christie Olson. Renae said, "I learned many, many things from those women. Cooking, cleaning, canning, sewing, gardening, butchering, all aspects of farm life. This heritage of the women in my life is a lesson I need to keep sharing with my two girls, because they come from a long line of strong, capable, hardworking, faithful farm women, and it is a line that they need to continue. I see and feel all of that when I look at that block on the corn crib."

I love a large barn quilt mounted on a smaller building so that the entire surface is plastered with brilliant color, so the South Dakota Star quilt block on the Ozenbaughs' granary grabbed my attention right away. Katrina Ozenbaugh agreed that the large block has a great impact: "Whichever side I pull into the horseshoe driveway, it's the first thing I see. Wham! I love it!"

Katrina was born and raised in South Dakota but came to Nebraska for college and remained once she married. Her quilt block honors her mother, Donna, who Katrina says, "was the one who taught me to be a lady and do my sewing and all of the things a good farm wife needs to do." Donna went to college to be a

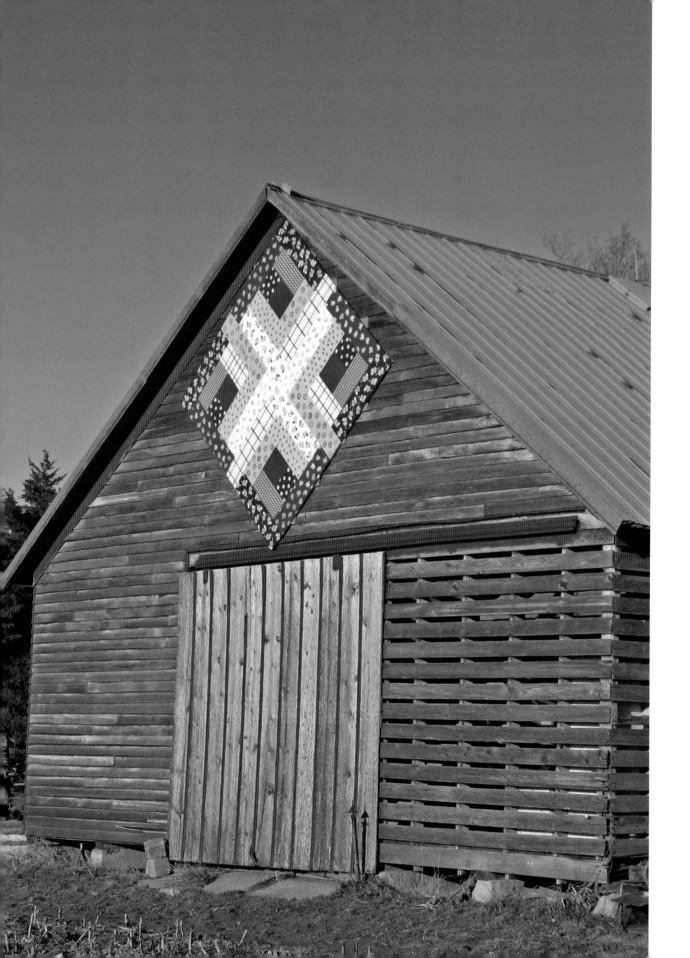

South Dakota Star

home economics teacher and shared that passion with her children. Katrina grew up learning to cross-stitch and can jelly and pickles and raise a garden; she also learned how to embroider a tea towel for a quick gift. The family did not participate in 4-H but Mom always made sure they would complete a cross-stitch project or sewing project each summer to enter in the county fair. "She is a super-cool woman, such a strong person," Katrina said.

The quilt block was actually the second one painted with Katrina's mom in mind, as Donna had received a Blazing Star barn quilt from her husband as a surprise gift. That quilt block represented two strong women: Donna's grandmother, who started the horse ranch where they lived; and her mother, who was born in that house and rode her horse to school each day.

In 2013, Katrina's husband, Mitchell, followed in his father-in-law's footsteps, with the barn quilt a surprise birthday gift for his wife. Katrina got a text message

Opposite:
Grandmother's Quilt
Photo by Renae Quandt/Kamler, Fillmore County Barn Quilt Committee

151

on the morning of her thirtieth birthday letting her know of the gift that awaited, and she and Mitchell drove up to South Dakota to get the square and haul it back.

The South Dakota Star is the perfect pattern to represent the connection between Katrina and her mother, who Katrina says taught her the importance of giving and volunteering and instilled a belief that family and faith are above all else. "It's perfect because it is South Dakota, of course, and then because it is a star. Even though we are in separate places, we are still under the same sky."

The next day Renae and I had just a few quilt blocks to see, but I was concerned that I had fallen behind on some errands during a hectic week of travel. Renae willingly added a couple of stops to our route, but we found the post office closed for lunch. I was already late getting the books into the mail but, of course, I understood that we needed to move on. Renae solved the problem with small-town ingenuity. We crossed the street and enlisted the help of Renae's friend Evelyn, who works nearby; she agreed to mail my packages and then delivered the change for my postage when she came to my talk in Geneva that night. Such an act of kindness to a stranger.

Alice Tatro attended the event that evening as well. I mentioned my frustration that the wind had kept me from being able to prime the boards that I desperately needed for an upcoming barn quilt painting workshop. Without hesitation, Alice informed me that the church social hall was at my disposal, that I could just stop by and get the key when I was ready to paint. Once again I was amazed and touched by the generosity we encountered in the small towns along the quilt trail.

At the edge of Wilber, Nebraska, I was greeted by a sign that read, "Vitame Vas, Welcome to Wilber," and by another that proudly claimed Wilber's status as the Czech capital of the United States. White-painted benches adorned with Czech phrases lined each row of red brick shops and businesses, and polka music played from speakers along the sidewalks, creating a festive, almost celebratory, mood. Of course, I was visiting Wilber because quilt blocks are part of the décor. White planter boxes were sprinkled throughout the tiny downtown on street corners and in front of local shops, with a colorful quilt block blossoming forth from each one.

The front of Nancy Linhart's home is decorated with wooden cutouts of hearts, along with a heart with the house number on it. After hugs, Nancy explained, "I put a heart on everything I do because the Czech Republic is the heart of Europe." Nancy's home is also at the heart of her life, as it was where she was born and raised.

Nancy and her friend Shirley had visited the nearby fairgrounds in Gage County, where they saw an array of quilt blocks. She contacted Donna Sue Groves and was inspired to bring the project to her hometown. The flower boxes had

Planter box, Wilber, Nebraska

been downtown for years, having been purchased by area residents. The tradition of decorating the planters with seasonal and holiday colors suggested that they might be a fitting home for small quilt blocks. Nancy drew the designs and the twenty-one blocks were painted in Nancy's cabin over a month's period. The Czech colors of red, blue, yellow, and green predominate and serve as another means of extending a welcome to the charming town.

Nancy sent me on my way with a dozen of her homemade kolaches, a traditional Czech pastry. She said that there was always some debate as to how to spell the word, but without a doubt they were delicious. Ten out of the twelve made it back to the bus, where Glen pronounced them, "mighty tasty."

I spotted an article online whose headline read, "Barn Quilt comes to Friend Residence." I thought that Friend was an interesting surname and went on to read through the article about a quilt with dozens of names embroidered onto it. A couple of months later, I heard from Carla Cross, who began to tell me about her quilt block. I realized that hers was the quilt about which I had read—and that Friend was a community in Nebraska rather than a family.

A quick look at the map revealed that Friend was not too much of a detour as I returned to the bus from Wilber. As I turned past the "Cross Farms" sign, I saw the large metal barn and the barn quilt. Carla was on the front steps before I got out of the car, ready to share the rich story. The tale was not only that of the quilt but of the incredible journey on which Carla has embarked to uncover its history. Carla spoke excitedly as she recounted her purchase of an ugly blue flannel quilt at an estate auction. She had a business selling furniture and collectibles, and the quilt looked like something that might be used as cushioning for her goods as Carla drove to various markets. It was a few months before Carla would realize just what a bargain her five dollars had bought.

The quilt was purchased in October but was laid aside until the first of the year when Carla was getting ready to go to a show. She gave the comforter a much-needed washing, and as she held it up to fold it, she could see a circular shape in the light that shone through. Her curiosity was piqued, so Carla used scissors to cut a few stitches on one edge. Peeking inside, she saw a signature embroidered on cloth. The next four hours were spent ripping those stitches until the Dresden Plate quilt was revealed.

Each block of the pattern had four signatures stitched onto it. Soon, Carla and her husband, Ken, were going square to square listing the names. "Now I know them all," Carla said, and she explained how that came about.

Carla placed an article in the local newspaper to locate anyone who might have information about the quilt. She hoped to trace its origins, and she was especially puzzled by one thing: "I wanted to find out why it was covered." Carla then

Agnes Bena
Friendship Quilt
Photo by Carla Cross

began searching online for each of the names, but some were difficult to discern. She remembered, "We would be looking at names and wonder, 'Is that an E or an A?'" One unusual name stood out, and when an article about the one hundredth birthday party of Velzoe Brown appeared in a California newspaper, Carla got in touch with the reporter who provided an email address for Velzoe's neighbor; as soon as Carla heard from her, she knew she had found one of the original quilters.

"Velzoe has talked about that quilt for years," the neighbor said. "She wondered what happened to it." Soon a friend of Velzoe's was located to help with phone contact, and an elated Velzoe had a request. "Can you come to California?" she asked. "I have to look at the names on that quilt before I die."

"Who was I to say no?" Carla asked, and her husband said that if visiting Velzoe meant that much to her he would fly her out for Valentine's Day. When he suggested that Carla check online for ticket prices, she admitted that she already knew exactly how much the flight would cost. In February 2011, just four months after purchasing the quilt, Carla set out for California.

Velzoe turned out to be quite an interesting figure. She played piano, drums, and three other instruments and had traveled in an all-girl band at the age of sixteen. The baby grand piano in her music room was testament to her place as an early pioneer in women's music.

On seeing the quilt, Velzoe got out her magnifying glass and carefully looked at each block, telling stories about each woman whose name she read. "This one was my mom's friend. This one was a teacher. That one was married to a banker." Velzoe told Carla that the quilt had been made in 1936 for Agnes Bena when she was sick. Each of her friends made one square and embroidered her name, and then Althea Rusk McIntosh put the quilt together.

Carla and I watched the video of one of their meetings. "This is a world-shaking thing, like finding Noah's Ark or King Tut's Tomb," Velzoe declared. A photographer from the local paper was on hand to document the event, but Velzoe was having none of that. "There's a story here," she told him. "You get your boss on the phone." Carla said that a call to the paper's editor had a reporter on the way immediately to record the moment in history.

Carla's meeting with Velzoe took place just a few weeks before Velzoe's 101st birthday in March 2011. Velzoe passed away that May, and Carla was glad that she had insisted on making the trip when she did.

On returning to Nebraska, Carla began her quest to find out more, and she continued to work to trace the names on the quilt. Carla was able to locate only one other of the remaining ninety-seven quilters still living. The name May Thirtle on the quilt led to May Thirtle Alback, whom Carla visited in her home in Omaha.

Agnes Bena's daughter, Helen Bena Weber, shared her knowledge of the quilt and its makers with Carla and helped fill in some of the blanks. Helen didn't remember any discussion of the quilt after Agnes received it from her friends and

Opposite:
Friendship Quilt

Agnes Bena Friendship Quilt 1936

unfortunately she cannot answer Carla's pressing question. She simply has no idea how it came to be covered in the ugly blue flannel.

As she walked sections of the family farm each day, Carla's mind kept returning to the quilt. "I need to honor it," she thought. Carla believed that local art teacher and muralist Greg Holdren would be up to the job of painting the barn quilt, so Carla asked for another special gift. Husband Ken asked for a price quote and of course Carla had it at the ready. The quilt block was hung in February 2013, and Carla continues to add to her information about the Friendship Quilt of Ponca Hills.

About a month after my visit with Carla, national news reported devastating tornadoes had struck Beaver Crossing, Nebraska, and I recalled that was just a mile from Carla's home. When I contacted her, Carla reported that the family was safe. I hated to ask, but to me one of the mangled buildings looked like the one that had been host to the barn quilt. I was correct, Carla said. The barn had been destroyed and the quilt block ripped away. A couple of days later I heard from Carla again. She had spotted a piece of her barn quilt in the burn pit on the farm; it had been blown almost two miles away and returned among the debris. Carla insisted that no one risk injury by trying to retrieve the piece of wood, but hoped that of the four the only piece that had returned to the farm would be the most special. Sure enough, Carla said, "It was Velzoe's square. She wanted me to see it to know she is with me."

When the family relocated to property nearby, Carla made sure that Velzoe and the quilt would not be forgotten. She again engaged Greg Holdren to create a replica of the earlier block so that she is reminded daily of Velzoe Brown and the Friendship quilt.

The women of Pender, Nebraska, had corresponded with Donna Sue since the beginning of their quilt trail project. I knew that theirs was a barn-less trail and that it had been created as part of the town's 125th anniversary. I looked forward to a stop in Pender, especially when Glen discovered that the tiny town was home to the Blue Ox Company, whose equipment we use to tow our car behind the bus. It was a great opportunity to add a factory tour to our travels, something that Glen dearly loves.

Our travels centered around the quilt trail, but when possible I tried to incorporate Glen's interests into our route. In Kansas, we had driven over to Wichita to hear George Strait in concert, and we already had tickets to see Vince Gill during our upcoming visit to Michigan. Though I scheduled those activities with Glen in mind, along the way, I had learned to appreciate the merits of both manufacturing and country music.

Pender quilt trail committee member Susan Strahm picked me up at the bus in the morning and we headed to Maureen Wenke's home. Maureen had in her

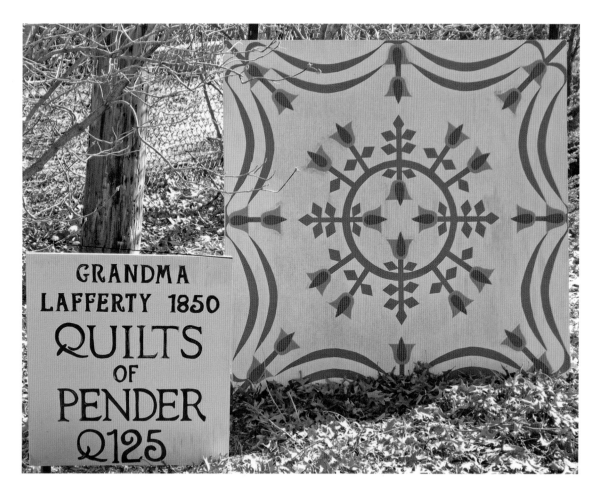

possession a family quilt that is at least 120 years old. The quilt was made in Pennsylvania by Maureen's great-great-grandmother Anne Isenberger Lafferty. The pattern doesn't have a name, but it is said to be typical of a wedding quilt that would have been made in that area in the 1860s and '70s. The quilt was a wedding gift to the quilter's daughter, Ida, on her marriage to Samuel Bressler in 1886.

Samuel had homesteaded near Pender the year before, so soon he and his bride moved to the Nebraska farm, with the wedding quilt among the few possessions the pioneer couple brought with them. They raised seven children, among them Winnie Mcquistan, who passed the quilt on to her granddaughter, Maureen. The quilt had been registered in the Nebraska Quilt Project and can be found on a rocker in Maureen's home.

Susan and I took a driving tour of Pender, where I was overwhelmed by the dozens of quilt blocks on posts, porches, and fences. My head turned quickly from one side of the road to the other like a spectator at a tennis match. At many points, two, three, or more quilt squares were within sight all at once. I had seen hundreds of painted quilts over the past several years but never this many in such a

Grandma Lafferty,
1850

Anna's Quilt, cloth quilt

Anna's Quilt

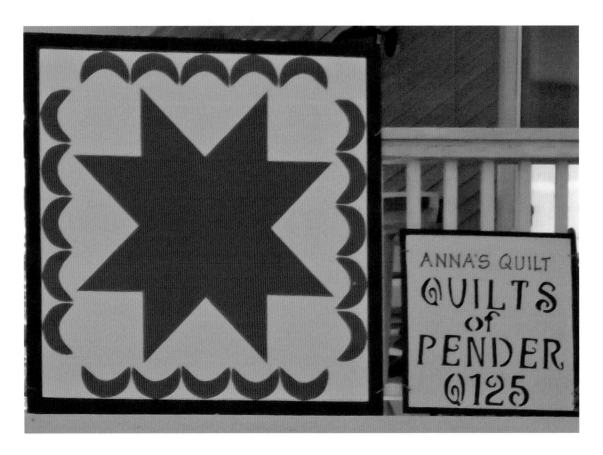

small area. I could only imagine the pleasure of living in Pender and seeing all of those quilt squares every day, maybe taking a different route to work and back in order to see new ones.

A group of women had gathered to meet us at a local restaurant. One was Marceline Tonjes, whose barn quilt is Family Ties. Her husband Floyd never left home without a tie, so over the years he had quite a collection. Marceline had made five quilts from those ties, and the wide variety of colors and fabrics are represented in the painted quilt.

Cindy Janke tearfully told us about her patriotic quilt block, which was dedicated to the memory of her brother, David Lefler, who had served in Vietnam with the Iowa National Guard. "He didn't return," Cindy said. "We still miss him."

Mary Ellen Olsson was on hand, and she had brought an heirloom quilted by her great-grandmother, Anna Vodica, who immigrated from Czechoslovakia at the age of eighteen. Mary Ellen has fond memories of Anna, who she and her sister called "Noni." Mary Ellen recalled watching Noni crochet the many doilies, tablecloths, and furniture covers for her home. "She always amazed me how she was able to rapidly crochet," Mary Ellen said, "Not even looking at what she was doing, but entertaining a conversation." Anna also stitched simple red and white quilts, including the one that Mary Ellen had with her. No name is known for the pattern, so the quilt is simply called "Anna's Quilt."

The barn quilt idea came to Pender by way of Debbie Christiansen, who was asked to help with beautification for the 125th celebration. Debbie had seen barn quilts in Iowa when on a covered-bridge tour with friends, and the idea seemed to fit. What began as a group of eight expanded to dozens within town, and then on to include over two hundred. The painters are especially proud that they were asked to install quilt squares at each of the four entry roads into town, marking Pender as a town blanketed with quilt blocks.

nebraska

minnesota

WHEN ASKED WHETHER we had any surprises in our travels, Glen always mentions Minnesota but quickly adds with a laugh that I was the only one surprised. "I was born in Nebraska, lived in South Dakota and Kansas, and attended graduate school in Pennsylvania. But this Southern girl thought she knew more about snow than I do!" When he noticed in January that we were scheduled for Minnesota in April, Glen immediately told me it was likely to snow. I insisted that he was wrong and fervently hoped that he was. The good news was that I had never seen more than an occasional dusting in Atlanta, so the eight inches that fell on that April night in Minnesota were magical to me.

To his credit, Glen was not angry, but he has teased me since then about my stubbornness and shares the story any chance he gets. He leaves out the fact that the frigid weather meant frozen sewer pipes under the bus and an unpleasant cleanup job. I had never expected to be part of a relationship in which daily chores were divided along traditional gender lines, but on that cold morning, shopping for groceries and doing laundry were quite appealing tasks compared to what Glen had to endure.

I had arranged with Carver County quilt trail organizer Naomi Russell to spend the day together. The snow had melted, but the day was overcast and a bit drizzly. Still, I was excited to see my first Minnesota barn quilts. As we drove into the countryside, the land was mostly developed, with sprawling new subdivisions lining both sides of the road. We found the Degler farm all alone among the acres of modern construction like a single sheep left behind when others have gone to pasture.

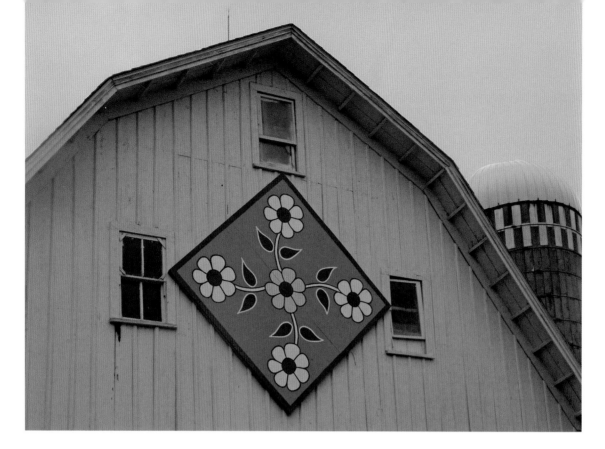

Daisies

Daisies quilt

Controversy often arises when a barn quilt's pattern is not a traditional geometric design. Donna Sue and I agreed that it was not our place to determine what is and isn't a quilt, but we still find some puzzling. Is that horse a quilt? What about that college logo? Some of the more intricate designs could be sewn into an appliqué quilt, but it is doubtful whether they would be. I stood in the chilly mud studying the floral design on Lois Degler's barn, umbrella in one hand and camera in the other, wondering whether this was another such case. But sure enough, Lois had the quilt on hand and disproved my notion that her daisies were not quilt-able.

Lois made the Daisies quilt about 1945 as a 4-H project. The quilt looked remarkable for its age, especially since it was used as a bedspread when Lois got married. "That was the end of quilting for me," she said. "I was busy raising a family and being a farmer's wife." Lois met her husband, Dean, through 4-H when both of them showed cattle at the state fair. Dakota County, where Dean lived, is situated next to Carver County, and by the time the fair had ended, romance had begun. The couple married and bought the eighty-acre farm in 1946. Dean had moved to be with Lois in Carver County, but the herd changed from her Brown Swiss cows to his Jerseys.

Son Gayle was a county commissioner, but he still had a hand in farming. The crops that once fed the cattle on the last dairy farm in town were now sold to others, but Gayle still rented land on which to grow corn, alfalfa, and soybeans. Speaking of the encroaching development, Gayle said, "I'll grow crops on it until they build a house on it!" He acknowledged that he would most certainly be the last generation to operate the family farm. The lack of open land nearby and his sons' choices of careers in teaching and engineering told the tale. For the time being, the two young men are on hand when it is time to bring in the hay, but "the clock is ticking," Gayle said. Lois pointed out an aerial photo of the property from some years past. I had seen many such photographs proudly hung in farmhouses across the country. In the photo, the Degler farm was surrounded by nothing but lush green. I shuddered to think what a more recent image would reveal—those hundreds of houses in neat rows like so many teeth in mammoth jaws.

Janet Fahey was pleased when her application for a barn quilt was approved, but almost immediately a problem arose. After much thought, Janet had decided on Double Wedding Ring for her barn quilt, with one of her grandmother's quilts to be used as the model. Unfortunately, Double Wedding Ring had already been claimed by the Kelzer family, as part of a fiftieth anniversary celebration. Naomi urged Janet, "You need to pick something else—quickly!" as the first round of barn quilts was set to be painted. Janet turned to the samples that had been provided, and when she saw the Triple Tulip pattern, she said, "Well, hello!"

Janet can trace her ancestors back about 150 years when they immigrated from Echt, Holland. The land that they worked so hard to clear on which to make a living is precious to Janet. The barn was built in 1961 from hardwoods on the

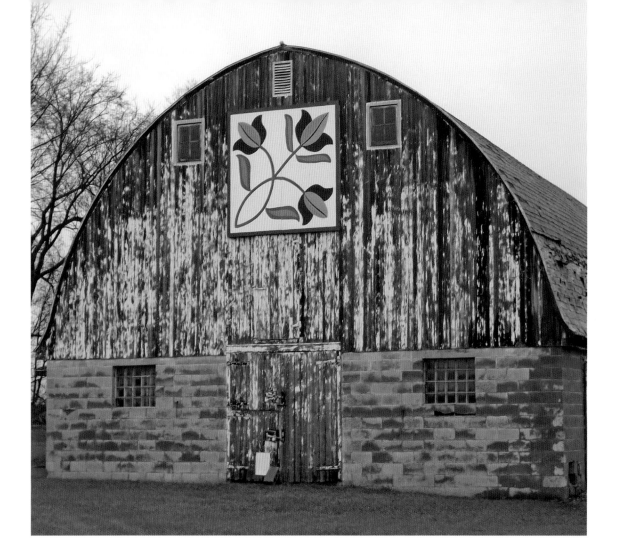

Triple Tulip

property. The trees were cut and taken to nearby Cologne to be milled; then Janet's dad, four carpenters, and a group of neighbors built the entire structure in just four days. The barn quilt was starting to create a new appreciation for the farm in the younger generations, as Janet's nieces who helped paint have a lot of pride in the block.

I have seen many a metal-sided barn in my travels, and, of course, I understand that the owners spend a great deal of time and money to have siding installed to preserve the wooden structure. But sided barns had never possessed the same charm as wooden ones—until I saw Lori Kramer's barn. Lori said that the farm had been in her family since 1899 and proudly stated that she was the fourth generation on the property. The barn pre-dated her family's arrival, so its age is unknown other than being greater than 112 years. Lori doesn't remember the barn being wood, but her sister who is just a few years older does. When her dad decided to side the barn, he used sheets of tin, creating a patina finish that Lori said

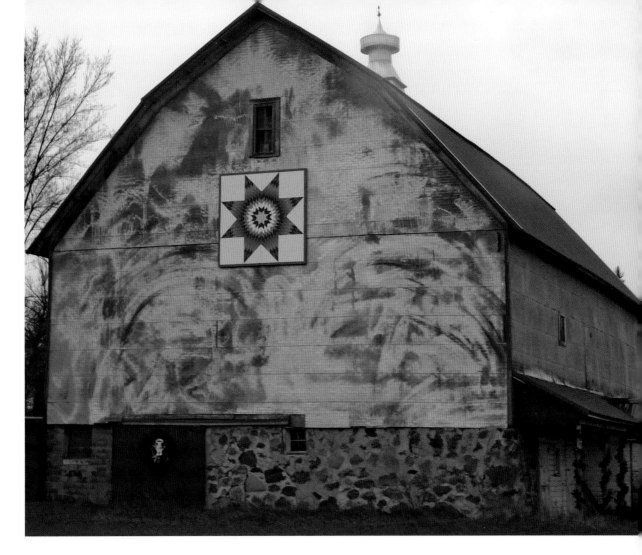

looked most impressive on a dreary day. It seemed that I was lucky to be standing under an umbrella after all.

The Lone Star barn quilt is patterned after a family quilt that Lori's maternal grandmother created. She learned to quilt the pattern on a visit to relatives in Montana and on returning home made quilts for each of her children. In addition to the Lone Star quilt, Lori has her grandmother's baby quilt, which is about 145 years old.

The barn sits closer to the road than most, and Lori shared the reason. It seems that the original owner, a Mr. Vogler, discovered that the road was going to be moved and would come very close to the house. He borrowed nine hundred dollars to have the barn built right away and placed close to the road to thwart the plans. The barn was recently used only to load cattle, and Lori admitted that she was "still trying to justify restoring that barn."

167

minnesota

iowa and illinois

A S MUCH AS I had enjoyed my first real snow, I was eager to warm up a bit. I am very much a Southern girl, after all, and anything below fifty degrees means being trapped indoors. The forecast suggested that a quick detour would bring higher temperatures, and though I had not planned to visit Iowa, our schedule for the next week was flexible, so we veered south.

Barn quilts popped up along the road frequently during the three-hour drive, and soon Glen and I began an impromptu contest, each shouting out when we spotted a quilt block. Glen had learned the names of most of the more common barn quilt patterns, and he often added, "Isn't that Ohio Star?" or, "Ooh, nice Log Cabin." He was at the wheel but still managed to find more than I did. I was reminded of Donna Sue's childhood story of counting barns in the car with her brother, Michael, and wondered how many families made use of barn quilts as a way to keep kids occupied.

The brilliant greens of my past Iowa summers were months away, and the untilled ground was a dull and dusty brown. Still, the barns and their quilt blocks in Delaware County were plentiful, and I was determined to see as many as I could. More than one motive had driven my desire to relocate. I left Glen and Gracie behind one morning with a promise to return before lunch. I had only a couple of hours, so I drove quickly, the car skittering along those gravel roads like a bug on the surface of a lake, at times barely avoiding a ditch.

I realized very quickly that planting was approaching. Gigantic farm machines crawled every road along the way, mechanical monsters that too often blocked my path and took up my already scarce time. Still the flurry of activity fascinated me.

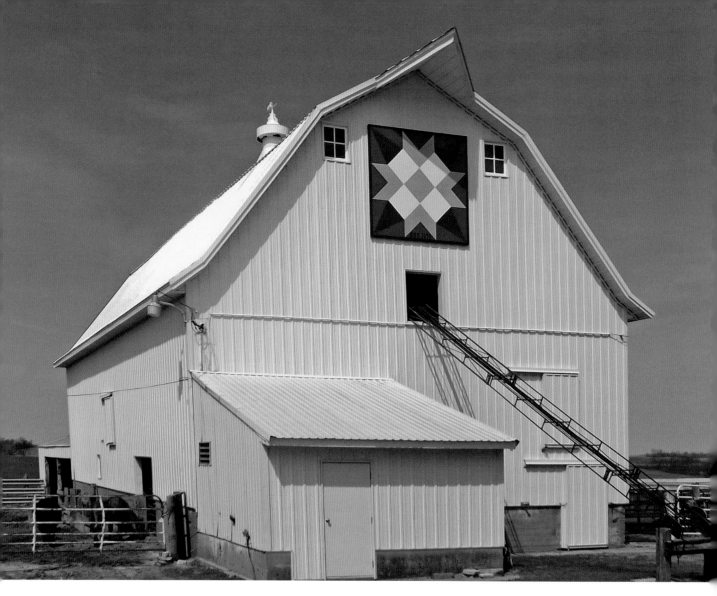

Prairie Queen

I had ventured out without appointments hoping that luck would intervene. A white barn with a brilliantly colored quilt block along an out-of-the-way road appeared to be a working barn, as a handful of cows observed my arrival, and a hay lift was positioned in front. The barn quilt faces the house, so I parked along the driveway for the best view. The wind was picking up, so before I had time to snap the first photo, the front door opened. Susanne Reiter had seen me pull into the drive and before asking why I was there, immediately invited me inside.

Prairie Queen was Susanne's choice for the barn that overlooks eighty acres of pasture. Volunteers were available to paint the quilt block, but Susanne asked, "Could I try?" The green shade of the background blends with the fields that create a visible backdrop. The corn was not yet growing, but the grass was already brilliant.

following the barn quilt trail

The barn itself is about seventy-five years old. Susanne's husband, Gene, bought the property in 1970, and the barn was later resided and reroofed. "We want to keep it another seventy-five years," Susanne said. The two were pleased to continue farming, though Susanne said, "It's not the most profitable."

The back side of the barn was home to another barn quilt, called Bright Side. The quilt block, visible across the fields from nearly a quarter of a mile away, was chosen by Gene because it seemed to resemble an Indian blanket. I had seen barns with multiple quilt blocks and even quilt blocks on opposite ends, but His and Hers was a new twist.

■

Glorious warmth and spring sunshine continued, matching more closely what I considered proper weather for April. Of course I was ready for more barn quilting, and our proximity to Butler County, Iowa, gave me a chance to visit one of the state's earlier quilt trails. Many of the blocks were unusual, with jewel tones included along with the standard primary colors, but one that stood out the most was painted in just red and white.

I hesitated to drive up to the Wagner barn, as it sits back from the gravel road quite a bit, but a barn quilt and a somewhat unusual barn structure beckoned. Barbara Wagner said that the family barn is of a single-story construction with the haymow in the center and room for livestock on the sides, quite different from the usual arrangement with hay storage above. Barbara's barn quilt is unique as well.

Barbara wanted a quilt block for the barn where she grew up but just could not find one that suited her. As a quilter, Barbara saw that not as a problem but as an opportunity. "I wanted a single color," Barbara said. "For me, if you use too many, it's harder for the pattern to be seen." Since the barn is situated a fair distance from the road, Barbara chose solid red to provide the needed contrast against the white barn. Working with an Eight Pointed Star and its center square as the basis, Barbara first created a design on paper and then transferred it onto the board.

Once the quilt block was on the barn with the W for the Wagner family added, Barbara realized that each corner appeared to have a crown in it. She said, "I did not intend for those to be there; when you are painting you can't stand back from it and look. As soon as it was on the barn, I saw those crowns." She considered the name King's Corners but settled on Center Stage, as family is most important to her.

The Wagner family enjoyed the barn quilt, and Barbara shared the pleasure of touring the quilt trail with others as well. She works at the nearby Lutheran home, and when she found that many of the senior citizens who lived there were unfamiliar with barn quilts, a road trip was in order. Of course the barn that the residents were most eager to see was the Wagners'. "They are like a second family," Barbara said. "They can't picture you going home until they know what your home looks like."

iowa and illinois

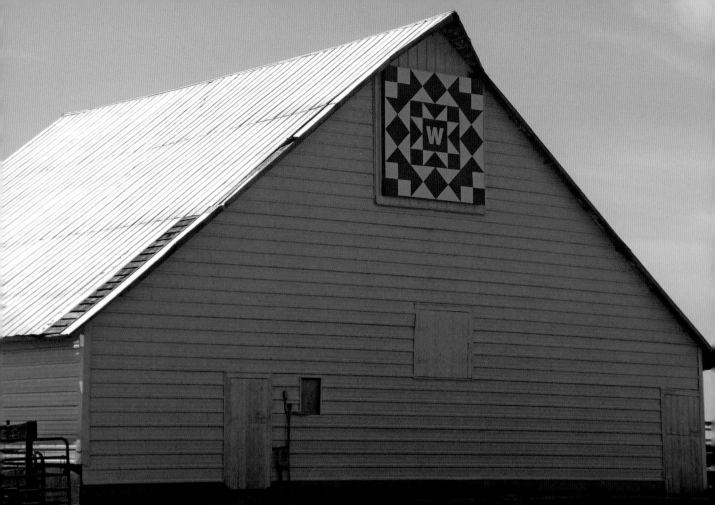

Illinois

My upcoming speaking engagements were scattered across Indiana, Illinois, and Wisconsin, and the closest I could come to a central location was Garden Prairie, in northern Illinois. I drove the car to each event, sometimes a couple of hundred miles, so that we were able to stay put for two full weeks.

In our latest temporary home, Glen and I adopted the Friday-night fish-fry habit, lining up with the locals at the VFW post or church hall each week to feast on crispy cod and hushpuppies. I got to know the local postmaster, who bemoaned the fact that he worked in the same building as a bar, which was so noisy at times that he had to shout to be heard by customers. Glen established an early morning bicycle route that took him through miles of flat roads each day where he raised a hand in greeting to farmers along the way.

following the barn quilt trail

The RV park was situated on the banks of the Kishwaukee River, and we yearned to kayak through the surrounding farmland. When paddling with friends, we would park one car at a riverside takeout spot and drive together back to the launch site, but that was not possible with only one vehicle. Glen came up with a solution. Saturday morning, as I pulled on my quick-drying kayak shorts, he asked, "Are you ready for a bike ride?" We left the kayaks at the riverside in the park, drove the car to our destination, and returned by bicycle to the RV park, where we launched our boats and paddled down to the waiting vehicle. Life with an engineer does have its benefits.

Of course a new location meant the call of nearby barn quilts; I inserted one or two from the map into each foray into town and encountered some Illinois beauties. One afternoon the last address proved difficult to find. As I crept along down a narrow tree-lined road, my GPS announced, "Your destination is on the left," but nothing was visible except a house behind a thicket of trees. I turned around and retraced my path; now the mechanized voice insisted, "Your destination is on the right." I had to be close, as the barn quilt was on the Perkins barn, and I was on Perkins Road. I pulled into the nearest drive to inquire and spied the barn with its starry quilt block peeking out from behind the home.

I had long before lost any fear of knocking on strangers' doors. After all, spontaneously pulling into an unknown yard had started me on my quilt trail journey some eight years earlier. Appointments are convenient, but sometimes stories are best told when the teller isn't expecting to be asked. That seemed the case when I visited with Donald Perkins, who greeted me with enthusiasm and told me that yes, he had a quilt story to share.

Donald proudly stated that he was the fourth generation on the family farm, which was settled in 1870. He was interested in preserving the history of the area and as such was active in the local historical society, having served as its president at one time. The quilt Don brought out to show me, which is called Mr. Lincoln's Stars, was created in his honor. In 2004, the Heritage Quilters of the McHenry County Historical Society began work on the quilt, which was to be raffled as a fundraiser for the society. A label on the back of the quilt states, "It is only fitting that this patriotically named quilt be dedicated to a McHenry County Veteran of World War II."

"I had a lot of medals," Don told me. "I don't know where they are or even which ones I had, but I know I had several. I was a marksman, and it was harder back then. There are so many fancy things on the guns right now." Speaking of the newer generation of military men in the family, Don said with a grin, "I'd like to show these younger fellas what I did." Don thought he might contact the government to check his record, and I hoped he would.

Daughter Gail said that the family hoped to purchase the quilt that was created to honor her father, but they had a difficult time doing so. Family and friends

bought loads of raffle tickets, with the promise that whoever won would give the quilt to Don. Their efforts were in vain, though. Luckily, the woman who won the prized quilt understood its importance to the family and was willing to sell it to them.

Gail went on to say that her mother had expressed interest in having a quilt on the barn. Sister Deb took the lead in having the barn quilt painted as a Christmas present, but their mother passed away that fall before the project was completed. "It means a great deal," Gail said. "It was such an honor to have the quilt dedicated to Dad. Now we have a constant reminder, and we are just so proud."

The label stitched to the back of the quilt describes Don's importance to the community and closes, "There is no better storyteller, enjoyer of life, or uplifting person to be around than Don Perkins. He and Abe Lincoln would have found each other 'right smart company.'" I don't know about Mr. Lincoln, but I found Mr. Perkins delightful.

Opposite:
Mr. Lincoln's Stars

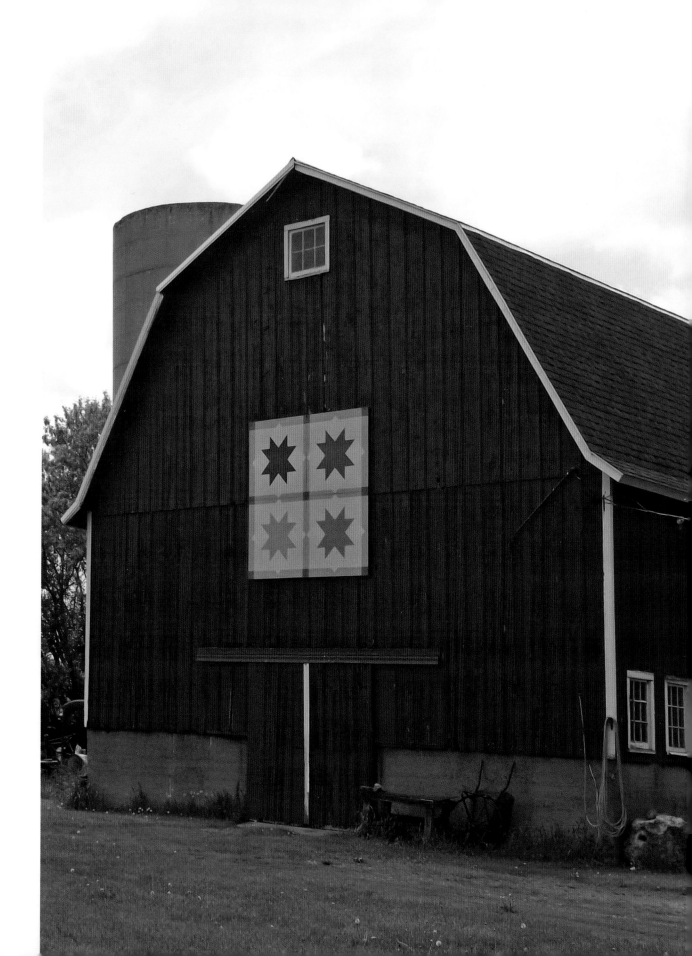

wisconsin

G LEN AND I made a leisurely northern migration into central Wisconsin. Our RV park's pool and miniature golf course, combined with the lack of bus repairs or other worries hovering over us, added up to a three-day vacation. I took the opportunity to meet a barn quilt enthusiast who had shared with me dozens of photographs of Wisconsin barn quilts over the years. Yvonne Bennett and her husband, David, drove over from Milwaukee to join Glen and me for a kayak and canoeing trip. We gals jabbered about barn quilts and broke the quiet of the river in doing so, but a riverside picnic with someone I had known via email for years was a welcome treat.

On a lazy afternoon, I laid out a route for a quick foray into the nearby countryside. Wisconsin barns are some of my favorites, and I wanted to devour as many as possible. Of course an hour's driving became longer when photos were added in. Just when I thought I had better head back, I rounded a curve and was facing straight into one of the most charming barn quilts I had encountered. Almost the entire side of the barn was covered with a mural featuring seven quilts on a clothesline.

I found Larry Vance outside, and he walked me to the house where I met his wife, Judy, who was pleased to meet a visitor and eager to tell me about the quilt mural. She said that the idea of a mural had come about more than thirty years earlier when the farm was purchased, but with raising children, the cost was too great. The original plan was a wildlife mural with some water running through it, but "the theme has changed many times," she said.

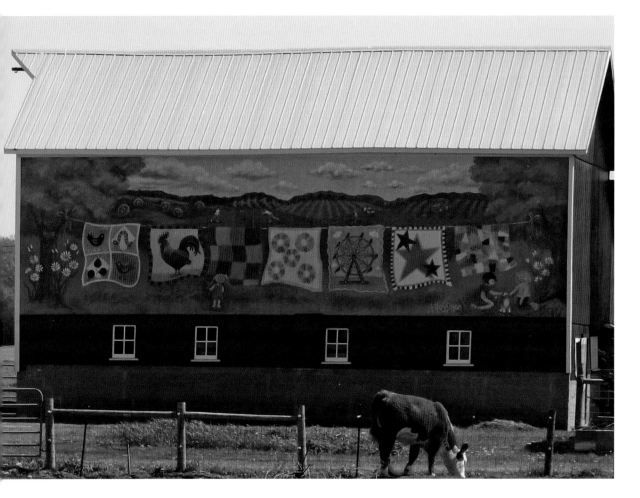

Vance Quilt Mural

At the same time, barn quilts were becoming popular throughout the area. After a dozen or so went up the first year, the Vance barn was on the list for the second year. The barn quilt was installed on the gable end of the barn facing the house. "Everyone else in the family calls it Bullseye," Judy said, "but my husband and I thought 'Kaleidoscope.'"

Judy went on to say that shortly after the barn quilt was hung, the barn was repainted in red—with the quilt block carefully covered, of course. At that time, the long side of the barn facing the road was painted almost all in white, so that a mural could finally be added. Artist Amy Mossman was hired to do the painting.

"I wanted as many quilts as she could get in that space," Judy said, "and I had a lot of ideas." One of the blocks is a Ferris wheel, which represents the fair where Judy worked for twenty-five years. Another is a four-patch with a bird in each of two blocks, with ladybugs in one square and a worm in the other to represent the things those birds might eat. The most unusual quilt is a rooster, but I had an inkling as to why that one was chosen. I had walked through Judy's kitchen and

following the barn quilt trail

noticed that the décor featured all manner of roosters. Sure enough, her favorite was the model for Amy's rendition.

All six grandchildren are worked into the painting as well. A young girl in the pasture leading a cow along represents the granddaughter who shows Herefords. The two boys playing football nearby are two young grandsons, and the other two granddaughters are shown stroking Judy's cat, Elvis. The pigtailed toddler with her teddy bear standing in front looking at the quilts is their youngest, and Judy's dad is represented by a John Deere tractor. He was the John Deere mechanic for the county, and his presence "really represents us all," Judy said. The other farmer in the mural is her husband, Larry.

Each year, Larry and Judy enjoy being part of the barn quilt tour. Larry is usually outside to greet barn quilt enthusiasts and to share the story of this unique piece of barn art, one of the finest I have seen along the quilt trail.

Sunday found us in the hills of northern Wisconsin at a small family-owned campground tucked into the rural countryside. When Glen backed Ruby into our assigned site, we realized that we were indeed in the midst of farm country, as a half-dozen cows observed our approach from a hummock about ten yards away. A few years earlier, such close proximity to other animals would have sent Gracie into a prolonged barking frenzy. I was both relieved and saddened that our geriatric pup was oblivious to the sounds and scent of our bovine neighbors.

I had watched the incredible growth of the Shawano County, Wisconsin, quilt trail for a couple of years and was eager to visit. The project comprises more than three hundred barn quilts, all the large eight-by-eight-foot size, making it the largest single-county quilt trail in the country. I set aside a couple of days and contacted Jim Leuenberger to plan a tour. Jim and his wife, Irene, had painted most of the quilt blocks in Shawano, so Jim had favorites in mind. I had gleaned a few potential gems from the quilt trail's website as well, so between us we easily had two days' worth.

A sunny sky dappled with clouds provided the perfect backdrop for barn quilting. Our first stop was a unique barn quilt whose story I found compelling. Jerry and June Erdmann greeted us with incandescent smiles, and June's bright red, white, and blue clothing further set the mood. After a quick tour of their home and a collection of dozens of pieces of salt-glazed pottery, we settled into the task at hand.

I have known many men who served in Vietnam, but their stories remained untold; a sort of unwritten law made questioning them about their experiences in the war unacceptable. Books and films had given me some inkling of what they had witnessed and endured, but none volunteered to share their experiences. Now, the subject had finally arisen when asking those questions was appropriate. Jerry needed no prodding, as he had told his story many times.

179

wisconsin

After a year in training, Jerry was sent to Vietnam in 1969 as the leader of a ten-man squad. One day that October, it was his squad's turn to take the point position to watch for enemy in the area. As they approached the hill, artillery shells from the American base camp flew past, but one of the shells fell short. "No one walked away," June said. Jerry added that out of the eleven men, only four survived. He recalls the medic clamping off the veins to his shoulder, as his jugular had been cut by shrapnel. His life was saved, but most of his right arm was lost.

June showed us a scrapbook that included photos of a young Jerry taken in Vietnam. It was difficult to connect the young man in fatigues posed against a brushy backdrop with the man who sat next to me. June also had put together a large oval frame in which Jerry's honors and awards were arranged. Included were an Expert Marksman's badge and Airborne Jumper's wings and other insignia, along with a Vietnam Service Medal and National Defense Medal, and in the center, the Purple Heart. June had such pride in her husband, whom she married a few months after his return. The two live on June's home farm in a new house situated next to the original barn. The old farmhouse is still in use, though, having been sold and moved five miles away. "That's what you call recycling," June declared.

Jerry uses his experience to inspire others by speaking at Memorial Day services and at schools on Veterans' Day. "People generally don't see anybody that looks like me. I represent what veterans go through," he said. I braved the question that tugged at me: What about a prosthetic? Surely with today's technology, the government could make life easier. June laughed and said that yes, Jerry has an arm, but it is forty-three years old. Jerry added that the arm can flex and has a claw that will open.

June added with a grin, "Oh, yes—he used to clamp onto the wheelbarrow and get pulled over!"

Jerry said, "The doctors asked if I wanted a new one, but I said they ought to save that for the new fellas." He displayed no bitterness about his fate. "I have no complaints," Jerry said. "I would do it again. That's your job. They do it today; you are called to serve. One generation after another steps up."

The design for the barn quilt began with the Stars and Stripes in patriotic colors, to display the couple's patriotism, with the Purple Heart added to represent Jerry's sacrifice and honor in his military service.

The day had begun with such a powerful interview that I could hardly imagine moving on to another visit. But our next stop was just across the street, so I set aside my admiration for Jerry Erdmann and headed to the Polzin farm, where I was greeted by my favorite quilt pattern, Grandmother's Flower Garden. This was the first quilt I had ever sewn, and I had incorporated fabrics from my maternal grandmother's scrap bag into the top. My sentimental attachment to the pattern extended io barn quilts as well.

My excitement grew when I realized that Kathi Holm Polzin's quilt block was based upon a family quilt. Kathi brought the quilt out for us to see; it was made by her husband Tom's Grandma Sorenson and passed down to him. Having a replica of Tom's family quilt hung on the farm where Kathi's grandmother once lived created the perfect tribute to both families.

Kathi's barn quilt has a bit of added meaning, as each color in the quilt has significance. The yellow center is Tom's favorite color; the blue is her own. The dark green signifies the evergreen trees that Kathi loves and the white where Kathi's late husband is now. "He talks to me a lot," she said. Finally, the outer blue represents the sky and Tom's fascination with aviation and World War II.

Jim, Irene, and I left Kathi and embarked on a photography tour of the county, during which Jim and I shared our enthusiasm for "just the right angle." A stop to capture a barn quilt with horses grazing in the foreground required a bit of wading

181

wisconsin

through a roadside ditch and crab-walking side to side. Jim settled in for a shot, but I slipped and tumbled backwards, whacking my head on the car. Poor Irene jumped out to see what the noise had come from and thought I certainly had a concussion. I assured her that I was fine and joined Jim along the fence, not letting on that the horizon was spinning just a bit.

We ended the day with a visit to Jeff and Holly Schmidt and their striking Diamonds Are Forever barn quilt painted in blue and corn gold, the colors of FFA. On seeing us arrive, Holly called Jeff in from his work in the fields. I knew that every moment away was precious, so I wasted no time. Jeff said that FFA has played a central role in the family's lives. I thought that the initials stood for Future Farmers of America, but Jeff told me that there was so much more. The organization still includes agricultural education but now focuses on leadership skills and subjects such as parliamentary procedure, along with management and business.

The Schmidts' children are the third generation to be part of the organization, having held leadership positions at the state level and won national awards. The farm itself is home to its fifth generation of the family. Son Dylan said that it was difficult to find help on a small family farm, as the cows are still milked in the

Diamonds Are Forever

Opposite:
Kathi Holm Polzin with her Grandmother's Flower Garden quilt and barn quilt

183

barn. Father and son were debating the subject but had not ruled out the possibility of adding robots to their farm labor. I couldn't help thinking that the business and leadership skills learned in FFA were being put to good use.

I had only a couple of days to visit the Shawano Quilt Trail, which certainly would have taken a week to see in its entirety, but Jim Leuenberger had chosen well. The fall colors of an Indian Paintbrush barn quilt perfectly accented an unusual brown barn that started our second day. Jim and Irene had been delighted to find out that Jana and Donald Dreier, with whom they were already acquainted, owned the barn that they thought would be a great addition to the trail. "We both liked the idea and wanted to contribute to Shawano County," Jana said.

On the porch at the Dreiers' lakefront home, Donald shared some amusing memories. Area residents spent summer days swimming at a spot called The Rock, near a series of waterfalls on the Red River. Donald and his college friends went down the river on inner tubes one afternoon. "We got pretty banged up in the Novitiate," Donald said, referring to one of the larger rapids, "and we could hear the next fall just ahead. We decided there was no way we were going to continue." My affinity for rivers led me to later research, which revealed that those falls are considered highly dangerous even to skilled kayakers. I cringed at the thought of those inner tubes crashing through the rocks.

The young men left the river and took off through the woods, eventually finding an old farm trail. The farmer spotted the boys and offered drinks and a place to dry off. At the time, Donald was taken with the property and asked the farmer, "Would you contact me if you decide to sell it?" Some forty years later, his wife got a call from the family stating that the farm was up for sale. "Two days later I owned it," Donald said. He now owns about a half mile along the river near the falls that frightened him and his friends so much all of those years ago.

Jim, Irene, and I toured the countryside past dozens of barns, some quilted and just as many not. As is often the case, each time a new barn quilt would appear, the three of us would declare simultaneously, "Oh, that's pretty." Then another quilt block would appear and the same adjective applied. I suggested that three educated people ought to be able to come up with a more descriptive term, and the next few sightings were met with deliberate pronouncements of "lovely, vibrant, beautiful, or scenic." After a long drive between barn quilts, the next one appeared, and before we knew it, all three once again called out—"Oh, how pretty!" We gave up on our English lesson for the day and continued on to the home of Jim Starks.

I had met many Civil War buffs over the years, but when I spotted the cannon in Jim Starks's front yard, I got the feeling that he might be a bit more avid than most. Jim's great-grandfather, Samuel H. Starks, was in the Twenty-Seventh Wisconsin Infantry and left behind his papers along with his weapons. The mementos

Opposite:
Indian Paintbrush

Never Again
Photo by
Jim Leuenberger

186

passed to Jim's grandfather and then to his father, but until recently were stored among other family items in the attic.

About twenty years ago, Jim's interest was piqued by a movie about Gettysburg. He said, "It just snapped in my head." He joined the Civil War Preservation Trust and began to learn more about the battles. Jim was inspired by "the men and the times they lived in, how tough they were." Over time, he had his great-grandfather's papers framed and hung in the house and purchased a gun safe so that the weapons could be stored downstairs. I know little about weapons but found the intricately carved blade of Jim's great-grandfather's sword an impressive work of art.

Even more impressive was the artwork on Jim's arms. At the age of fifty, he had a tattoo of his great-grandfather's likeness inked on his shoulder. His mother was not too pleased, so Jim did not get another tattoo for a while. Then on a visit to Vicksburg, he took home a fitting souvenir—a tattoo of a sword that runs the

length of his arm, with "Samuel Starks Vicksburg 1863" inscribed below. Jim said that his mother wondered why he always wore long sleeves when he came to visit, but she did not press the issue.

Jim's barn quilt, Never Again, honors the military men whose dedication and heroism he admires so much. Jim said, "I want to leave something behind, something people can look at."

Michael and Janice Van De Yacht's barn quilt displays to the rest of the world the beauty that the couple enjoy every night. The farm with its 1907 barn sits on the edge of the Navarino Nature Center, and their favorite scene is the view of the landscape out back as the sun sets. A tree pattern was the natural choice for their quilt block, but the couple wanted different colors in the tree—not just one shade of green, but the many shades that a real tree would have. The design also incorporates the varying shades of the setting sun as they grow gradually darker. "I was afraid that after we put all of that into it, it wouldn't look like a quilt," Michael said. "But it's definitely a quilt."

Jim Leuenberger laughingly said, "I risked my life for this barn quilt!" Michael and Janice had come to workshops in the basement of the Chamber of Commerce to come up with the design for the quilt block. Storm warnings came, and the wind began to pick up, but the three were so engrossed in their project that they did not want to leave. When thunder shook the building, Janice realized that they ought to get home to check on their dog. "If not, we would have stayed," she said.

Jim drove to his home on the Wolf River with flying branches and debris battering the car and tornado sirens going off all around. "I have never been more scared in my life," Jim said. But all three agree that their adventure was worth it. The farm is known as Rocky Valley Farm, so the family named their barn quilt Sunset in Rocky Valley.

Our sojourn in the midst of dairy country demanded that Glen and I sample some acclaimed Wisconsin cheese. The local market offered an overwhelming array, and I spent a good half hour choosing and then rejecting one and then the next, uncertain of the difference between the various labels. We love nothing more than a good experiment, so I grabbed a two-year-old chunk and a nine-year-old, doubtful that the latter could be worth the four-fold cost. A blind taste test revealed the dry, flaky texture and layers of intense flavor of a well-aged cheese to be superb. By the time we hit the road a couple of days later, we had made a substantial investment in nine-year-old cheddar.

In nearby Oconto County, I met with the barn quilt committee at New View Industries. Director Lynn Jones explained that New View provides life skills training and job support to adults with disabilities. When librarian Kay Rankel was

looking for a partner to paint barn quilts, Lynn and the clients at New View were eager to participate. Two evenings a week, volunteers visit the facility and work side by side with New View's clients. The volunteers include retired math teacher Donna Baird, who told me that it lifts her spirits to see challenged people so happy. Retired teacher Les Schultz added, "They aren't afraid to work."

Indeed there was a lot of work going on throughout New View. In the warehouse area, a group worked in assembling and packaging for a local company, readying products for sale. Lynn explained that being able to work in a sheltered environment both allowed participants to generate income and also fostered responsibility and pride, a focus on ability rather than on disability. When asked about the barn quilts, client Billy F. said, "It's really cool when people can see what people with disabilities can do. It's like 'WOW!' we know what we're doing. It makes me feel really good."

Scott B. added, "I really like to help decorate the community."

Lynn took us on a tour of the facility, which includes a wood shop where barn quilts are created and a large open room for painting. Today's project was not barn quilts but colorful checkerboards, lined up in a row, each in different colors. Before we left, we stopped to see the Guiding Star quilt block on the outside of the building, a shining example of the fine work done by the painters at New View.

I wanted to spend more time at New View, but of course we had some barns on the agenda. Lynn, Kay, and I drove to the town of Chase to see the first barn quilt in Oconto County, erected at the Chase Stone Barn. The red, white, and blue Pinwheel is an unusual block, as it is a full eight-by-eight-foot size, mounted on

Pinwheel

Opposite:
Sunset in Rocky Valley

189

wisconsin

posts, as attaching it to the barn itself was out of the question. The barn was built of local fieldstone and mortar in 1903 by a German immigrant. It fell into disrepair but was purchased by the town of Chase in 2007 and is being restored, as it is one of the last surviving all-fieldstone barns in the country. I had been in many barns by this time but never one made entirely of stone. I enjoyed the opportunity to tour the landmark building with its massive arched doorways and red-trimmed doorways.

Volunteer Norb Reinhard informed us that the barn was sixty feet wide and one hundred feet long with walls that were two feet thick. The tin roof is original, as are the beams that hold up the roof. I noticed fire marks on the beams and asked about the cause. Norb told me that they were reminders of the Peshtigo fire, which burned more land and killed more men than the famous Chicago fire that occurred on the same day in 1871.

It was a dreary day, and the whimsical Dairy Cow quilt block overlooking the Brock farm's muddy yard was just the lift we needed. Owner Russel Brock greeted us wearing a grin and a black-and-white spotted cap that matched the hides of his cows. I knew right away that he had a sense of humor. The barn was clearly new, but Russel shared a bit of the history of the property.

Russel's grandfather, Peter, the son of Danish immigrants, was born and raised in Oconto. In 1904, at the age of twenty-one, he bought forty acres just a couple of miles from his home place and set about building a house. He was questioned as to why he would build a house when he didn't have a wife or even a prospective wife with whom he would share the home. Peter replied, "If I build the house, the right woman will come." It is said that Rena, who was new to the area, drove past and asked, "Who is building that nice house? I want to meet him." A year later, Peter and Rena were married and the Brock family farm was begun.

As Russel tells it, when his father, Peter's son Raymond, was to be married, he needed to finish his house. He was still plastering the day before the wedding, as Peter had told him, "You are not going to bring her to my house tomorrow!" Raymond added 120 acres to the farm, and a full-time dairy operation began. The farm has since grown to over six hundred acres, and ownership is being transferred to the next generation—son Bryan, who already operates the dairy with his wife, Johna, along with the fifth generation of Brocks.

Russel believes that family farming still has a bright future. "Otherwise, I wouldn't be selling the farm to my son," he said. Farming methods have changed from generation to generation, but one thing remains constant. "If you take care of your cattle and land, they will take care of you." When new technology comes along, the first consideration is the positive impact on the cattle and the land. "Those things come first," Russel said. "Then the rest of life will fall into place."

I continued to follow the progress of the Oconto County quilt trail, and a month or so later, I heard from Lynn Jones, who said that her clients at New View Industries had decided to use my tour schedule as the basis for their geography

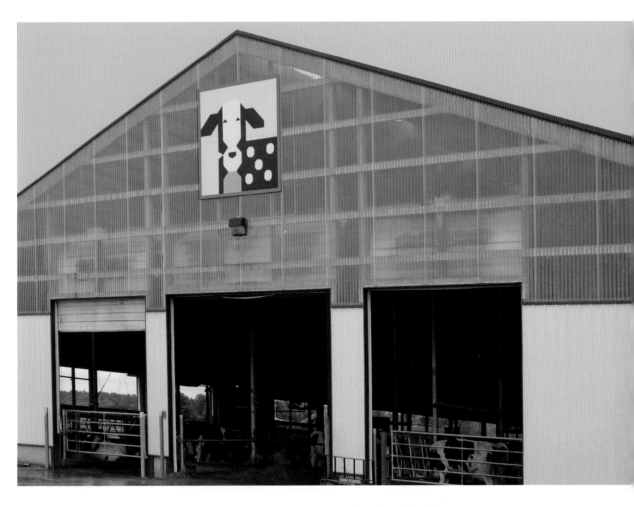

Dairy Cow

lessons. Every month or so, a new set of questions arrived: "Did you kayak in the ocean? Was it scary driving through that tunnel? Did Ruby make it up the mountains? What kind of food do you cook?" When the weather turned cold, the group sent advice: "Be sure to wear a hat and gloves in that snow!" I responded to their questions and shared photos not only of the barn quilts in each locale but also of the changes in landscape and of our activities. Before too long, Glen got into the act. Giant California redwoods, Arizona cacti, and sand cranes strolling through our Florida campsite prompted him to say, "Hey—let's get a photo of that for New View." Our correspondence continues, and I know that when we return to Wisconsin, a visit with our friends in Oconto County will be a highlight.

wisconsin

heading west

I DIDN'T EXPECT to like South Dakota. My mind's eye portrait was of a bland expanse of land, an obstacle to be hurried through on our way to greater things. South Dakota proved a delightful surprise. Rolling green expanses of prairie were punctuated by the occasional stand of trees and farms in the distance. I wondered what it would be like to live in one of those farmhouses, within view of the highway but remote from the nearest town. The intrusion of billboards along the roadside annoyed me, and I vowed not to visit a historic drugstore as retribution because their dozens of signs ruined my view.

We left the highway to cruise through the Badlands and felt transported to another world. A couple of cowboys moved a small herd across the two-lane, appearing at just the right time as if sent straight from a Hollywood lot. Glen actually set forth that perhaps they were faux cowboys who traveled back and forth to delight tourists, but they certainly appeared genuine to me. The bus glided between layered, red rock formations, and slabs and spires of gray. Massive cattle along the roadside, sleek and silky black, were so strikingly different from the dairy cows of the Midwest that they, too, marked our western progress.

Mounds of white fluff littered the roadside along the entrance to the RV park, as if a gigantic pillow had been ripped open and the contents spilled out. "They must have some huge dandelions here," I said, and Glen burst out laughing. "That comes from those trees," he said. Haven't you ever seen cottonwood?" I was skeptical, as Glen likes to pull my leg on occasion, but he pointed out the clumps of cocoon-like material still hanging from nearby branches, and I was convinced.

We set out to see more of the Badlands and relished the chance to walk through the formations, scrambling over rocks to gain distant views. The bright sun and clear air provided the tonic we needed to revive us after a couple of days' long drive. We spotted bison in the distance and chuckled at the antics of a colony of prairie dogs, and I was reminded of my visit a few years back when Gracie ran frantically from one hole to another convinced that she could make a capture. Dinner was fry bread, a kind of puffy, flat dough topped with meat and cheese, cooked by a Native American woman at a walk-up stand.

When we left the next afternoon for the Black Hills, my ebullient mood had disappeared. Glen's manager, Cliff Hebert, had always been generous with our schedule, not minding if Glen began work early, drove a couple of hours at lunch, and then resumed his workday. But Glen's agenda included midafternoon teleconferences that could not be moved to a more convenient time. I had promised when I put together our whirlwind itinerary of six days from Wisconsin to Washington that I would drive if needed, and now I had to do so. My stomach churned as Glen drove the half hour or so to the interstate, when it was time to swap seats.

I found driving far above the ground as horrible as riding at that elevation had been luxurious, and I clenched the wheel until my hands cramped. The prairie grasses that I had found so beautiful the day before danced furiously, heightening my awareness of the gusts of wind that I could feel pushing the bus from side to side. Glen sat behind me at his desk, keys clicking away, and then engaged in conversation with his colleagues. I ground my teeth and avoided the impulse to wipe the single tears that occasionally ran down my cheeks, as doing so would mean momentary one-handed driving. An hour passed, then two. The Black Hills rose ahead, but my eyes focused on the white line along the shoulder, my guide for keeping the unwieldy vehicle on the road. Glen's work was completed, so he offered to take over once we turned off the interstate; when the GPS registered ten miles to go, I began the excruciatingly slow countdown. Eight miles, then down to five. My hands began to tremble as I realized that indeed I was going to make it. I was proud that I had endured and ready for my sentence to end.

Glen took over and made the turn onto the two-lane that took us into the hills. My shaken mind was still fighting to relax when Glen shouted with delight, "Barn quilt! Did you see it?" I had not. One drawback to bus travel is that it is impossible to stop along the roadside when something interesting appears. A spontaneous barn quilt sighting was exciting, and though the forest that surrounded us was beautiful, there was no doubt that I would make the drive, We were twenty-odd miles from our campsite, which would mean a long round trip, so as soon as we were settled into the park in Custer, I set out.

I passed the farm where the barn quilt was hanging once, as the quilt block was obscured by trees as I drove north. Red and blue flashed by, and I quickly turned around. I took photos of the small barn before approaching the house, hoping

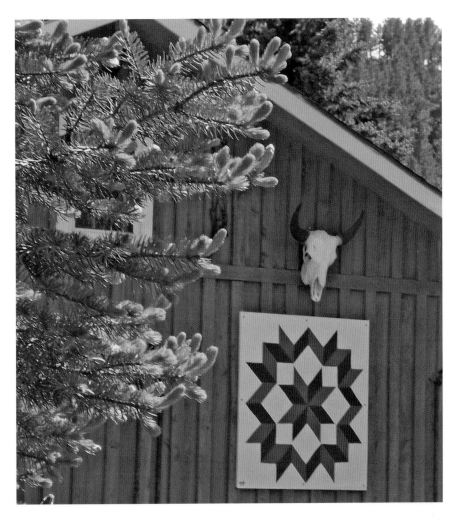

that once they knew that I wasn't selling anything they would be pleased to have me visit. Here I was disappointed, as no one was home. I left business cards asking for a phone call, and by the time I had made my way back to Custer, Beth Haug had left a message.

The barn quilt was not just the only one in the area, but Beth said that it had been mounted just four days earlier. The serendipity of our arrival was incredible to us both. Beth went on to explain that her husband, Reed, had seen barn quilts along the way to a draft horse sale in Iowa. He liked the idea of adding one to their farm and asked a local muralist to do the painting. The Carpenter's Wheel, or Tumbling Blocks, pattern was chosen among those the Haugs found that were said to represent Scandinavian heritage.

Reed grew up in South Dakota and the family had been in the Black Hills for more than thirty-five years. "With the weather and the surrounding environment, it's the best place in the U.S. to hang out," he said. The Haug's farm is home to a team of draft horses but is mostly a hobby farm, with gardens and rabbits.

heading west

Reed also told me about the Crazy Horse Memorial, where he was employed, and invited us to visit the next day. It wasn't on our agenda, but at Reed's suggestion, Glen and I headed there the next morning. The enormous ivory-colored carving, though still decades away from completion, was stunning. We rode to the top and walked upon the great chief's arm, a precious shared experience. The unexpected addition was one of our most treasured times of the cross-country trek, a bit of magic associated with our only South Dakota barn quilt sighting.

Wyoming is home to a few barn quilts but no organized quilt trail, so our focus was on the natural scenery near Buffalo. With a map of recommended drives, we explored the countryside, where deer and elk stalked through high grass stopping to peer at us suspiciously. Up a hill almost too steep for the car to climb, a meadow of lavender and yellow wildflowers offered tremendous views of snow-topped mountains and a chance for Gracie to romp and sniff. We wound our way down narrow clay-packed Forest Service roads through a hidden canyon and hiked a waterfall that appeared just along the roadside. We could have stayed a month, but for this trip we had a short couple of days to take in our glorious surroundings. I was dismayed to know that we were only a couple of hours from Yellowstone but knew that we could not make the trip and still reach Washington on schedule.

Glen and I were enchanted by Bozeman, Montana. The mountains seemed to enclose the entire town, and on the outskirts they starkly contrasted the collection of chain department stores and restaurants. When I headed out of Bozeman to visit with Jane Quinn, mountains stood unobstructed straight ahead. The long driveway into the property afforded a view of the historic barn, with just enough sheep grazing in the foreground to create a bucolic scene.

Jane showed me the interior of the rustic barn, where some bark still clung to the logs. The notches that held the logs together looked familiar to me; sure enough, she said that the method was the distinctive style of Tennessee, some 1,700 miles away. It turned out that a Southerner had homesteaded the land and built the barn. James L. Patterson was a Confederate officer in the Civil War who returned to Tennessee after spending time in the prison camp on Rock Island, in Illinois. He married his wife, Eleanor, in 1868, and four years later traveled by train and then by wagon to Bozeman. "I can't imagine how all of those Civil War officers existed here together," Jane said.

The farm was the Patterson's home, and James acquired a good deal of property. Jane cited a city directory from the time that listed his vast land holdings, crops, and livestock, which amounted to wealth far surpassing others in the area. Jane and I both found Eleanor Patterson particularly interesting. Here was a woman raised in the South who became prominent in a land so different from her own. Eleanor was a leader in both the Daughters of the Confederacy and the WCTU. I

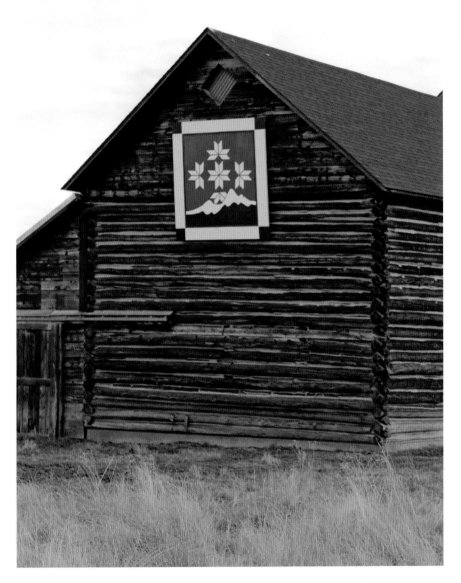

pictured her as a fiery sort, but Jane shared one piece of sadness. Eleanor's only son died when he was nineteen, and she mourned him for the rest of her life, wearing a brooch with his photo even on the finest occasions.

The property passed through two more generations of Pattersons before being willed to a nonranching family and eventually being abandoned. By the time Jane and her husband, Bill, began looking for a place to move from town, the house and outbuildings were in disrepair. Jane was drawn to the farm, and waited until the house was offered by auction with only twenty acres. Soon, the couple

197

heading west

found themselves in a bidding war for the property. "I told the owner I was an Iowa farm girl and had always wanted to raise hogs," Jane said, "and we just clicked. He thought we would be good for the property."

The couple moved to the farm in 1984 and have been working ever since, relocating and renovating some of the smaller buildings, including the bunkhouse, which became Jane's quilt shop. As a quilter, Jane was taken with the barn quilts she saw on visits to Iowa, and she wondered why Montana didn't have them. My visit to Bozeman included a painting workshop, appropriately enough held in the historic barn. Jane was occupied with work that day, but a couple of months later, she created her own barn quilt. The pattern she chose is derived from the logo of the now-defunct Quilters Art Guild of the Northern Rockies, of which Jane had been a member. She called the pattern Snow Crystals over the Rockies.

That winter, when cold weather descended on the mountains, Jane reflected on the quilt block. "It is snowing right now and about zero. Standing here in the kitchen, I can see the barn quilt with fine snowflakes coming down, and it's wonderful."

We left Jane and Bozeman behind and drove west toward Missoula. There was a small quilt trail to see, and I looked forward to more of the scenery with which I had become smitten. The mountains were steep, and Ruby chugged along, straining and lurching to make it up each grade. I didn't worry too much; after all, large trucks labored at twenty miles per hour groaning and rumbling just as the bus did. Glen coached Ruby, "Come on; you can do it!" as he monitored the temperature gauge, and when the needle crept up a bit, he pulled over to let the engine cool down. Getting Ruby started up a slope from a dead stop was no easy feat, but we fumbled along. Soon a roadside sign marked the Continental Divide, quite a milestone in our trip west.

This time I was the one who noticed. "Do you smell gas?" Glen did not. "Seriously," I said, "you know how it smells when you pump gas and it spills all over you? That's what I smell." We climbed a bit farther, and before long the odor reached Glen's side of the bus. He took advantage of the next pullover lane. We weren't sure what it meant, but fuel was pouring from the engine compartment in the rear. At least it was daylight, and the tow truck driver was fast this time. We landed in the parking lot of a truck repair shop in Missoula, where we plugged in our electrical connection to spend the night.

I was too angry to cry. We had treated that bus with such care, having her transmission rebuilt and the radiator fan replaced just a few weeks before, and she had let us down yet again. We were headed to California, already unknown territory, and I had no stomach for additional surprises. By the time Ruby was towed into the repair bay the next day, I had already packed. We had to be in Washington in two days, and there was no way we were going to get there in that bus. One mechanic after an-

other offered his best guess as to what was going on, and the only thing that they could agree on was that we had a big problem that was going to take a while.

I had scheduled a stop in Missoula to visit the quilt trail there, and despite my downcast mood, I wanted to see some of those quilt blocks while we waited for news of the bus. I meandered for a couple of hours photographing the barns and scenery and especially loved the fact that the quilt blocks were painted directly on the barn surfaces. When I later caught up with project director Kris Crawford, she shared some of the local history. The barn quilt trail grew out of an Eagle Scout Project renovating a 1907 schoolhouse. "The old-timers shared so many stories when we were working on the renovation. It is a very unique neighborhood but history is disappearing," Kris said. Once the Boy Scout project was finished, people in the community got involved in preserving the stories of Target Range, so named because a butte in the neighborhood was used as a target-shooting area for nearby Fort Missoula.

The barn quilt trail began in 2010 as a way to preserve both some of the local buildings and the stories behind them. A volunteer organization, Threads of Montana History, with Kris at the helm, gathered the stories of the homesteaders and those who have been in the area for decades. I loved the name of the organization—quilt blocks stitched together with history. And there was a lot of history to gather.

One of the most striking locations on the trail was the Pomajevich Ice House, home to an Apple Blossom barn quilt. Icehouses were not all that uncommon, as after the second milking of the day, farmers would take the milk to the train, where it would be packed on ice to be sent to a creamery. The Pomajevich Ice House is different, as it was family owned. The Pomajevich family used the icehouse to store white fish and meats and also herbs and produce from their truck garden that were being readied for market. The building was set for demolition, but instead is now being renovated and its history preserved. The walls are filled with sawdust for insulation, and the seven-hundred-pound door, typical of an icehouse from the early 1900s, hangs on iron hinges.

Once residents heard that the icehouse was being restored, old-timers who recalled when it was actively used came forward to share their stories. Some area residents spoke of attending school with the Pomajevich children and told of Mrs. Pomajevich's home-cooked meals. Sometime in the 1930s the building no longer served its original purpose and began use as a storage facility; as such it became a repository for local artifacts.

"The inside had layers of items that unfolded a story decade by decade in the sawdust-filled floor and walls," Kris said. Some of the artifacts included local brewery bottles whose labels were long forgotten, a 1940s *Saturday Evening Post* magazine, and saws and cleats that would have been used when harvesting ice from the river nearby.

heading west

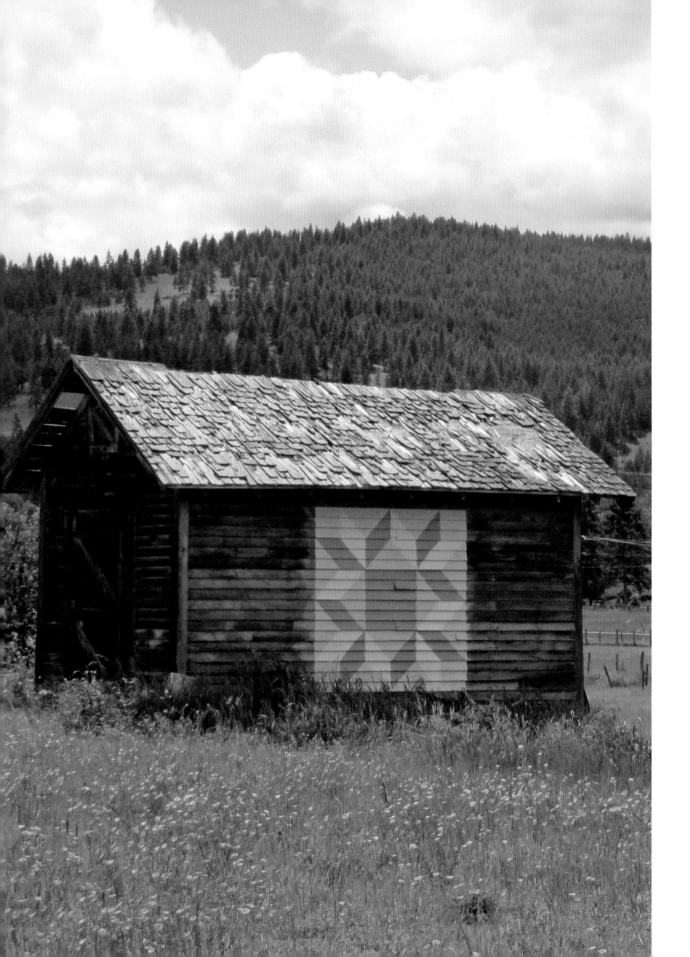

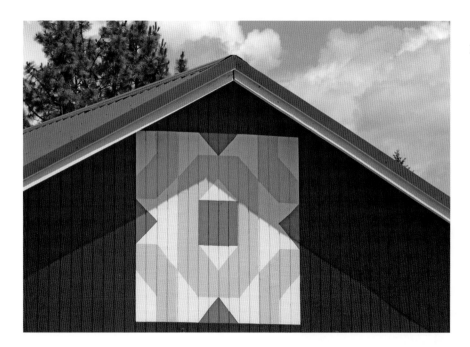

Word of the icehouse restoration project spread, and the family gathered in front of the icehouse for a photo as part of a family reunion the following summer. Kris Crawford said she could not have been more pleased. "Prompting the inspiration for family gatherings and preservation of local history is such a wonderful result of these quilt barn trails."

The Kelly barn is decorated with an Irish Chain quilt block. The pattern itself dates to 1877, so it was doubly appropriate for the location. The family chose the pattern because it not only honored their Irish heritage but was also tied to the era when the land was first settled. Kris completed an incredible amount of research on the property and actually found the original land grant. I had seen such a document only once before, in Tennessee, so this was pretty exciting. The document was signed by President Ulysses S. Grant in 1874 and established ownership of 160 acres in the "Helena Montana Territory" to one Terrence McMurray, whose family owned the property until it was purchased by the Kelly family in the 1930s.

The quilt trail includes markers that provide a bit of history of each site so that visitors experience more than just driving by a mural. Area residents have incorporated the quilt trail into their lives: A group of troubled young women added the barn quilts to their walking path and said that the beauty of the murals and the connection to history had a profound effect on them. Commuters have altered their routes, and groups of scouts and schools have visited. Kris said, "It makes us feel good to know that we are having an impact on people's lives. "It really is a trail that makes an imprint on your heart as it takes you from barn to barn, and one story to the next."

Opposite:
Apple Blossom
Photo by Kris Crawford,
Threads of Montana
History founder and
president

201

heading west

washington

SOON AFTER LEAVING Montana, we got the bad news. Ruby's engine had blown and it would have to be replaced, an expensive repair that would take at least two weeks. We put the decision on hold and crammed everything into the car once again. I scrambled to cancel our reserved campgrounds and replace them with a series of motels. I had been proud to have each location along our route to California booked more than a month in advance but was now chagrined at the slew of lost deposits. Our little family set off for Washington overwhelmed with dejection; I could not draw a cheerful breath. But soon we were passing through landscapes that were new to us both, and by the time we reached the Idaho panhandle, the thoughts of our predicament had been pushed aside.

We had driven through hundreds of miles of mountains by now, but here the peaks were different—sheer, almost vertical, walls with rows of evergreens cascading down like luxuriant dark green tresses. I glanced over a bridge from time to time, but the rivers were too far below for any assessment of paddle-worthiness. The car just did not afford the same vantage point as the bus when it came to stream spotting. Washington brought farmland, mostly fields of potatoes growing close to the ground, then gentle mountains where the roads curved through and into valleys.

The only quilt trail in Washington is located in the Kittitas Valley. Quilt trail chairperson Jacky Fausset had said that the main crop in the surrounding area was hay, and I expected to see the neat rolls that were scattered among fields and

Log Cabin

stacked in front of barns in other parts of the country. Instead we saw what had to be thousands of bales stacked to overflowing in massive white-tented warehouses. For fifty miles, acres of freshly mowed fields looked to be overtaken by an enormous church revival.

The next morning, I was ready to tour the valley with Jacky. Visiting with one of the hay farmers might be tricky, as I had arrived at the peak of the harvest, but there were plenty of other barns to visit. Jacky could not have chosen a better location for our first stop, Sweetwater Lavender Farm. I am not one for perfumes, but for me the scent of lavender is at once soothing and invigorating, a perfect balm for a tired traveler. Sheryl and Michael Grunden had moved to the property in the 1990s and wanted to plant something that would last through the winter and also withstand the fierce spring winds without being uprooted. A few lavender bushes grew out front, so they planted a couple of rows of Munstead. I was confused; I thought we were talking about lavender. As it turns out, there are many

204

varieties, and Sheryl discovered that Munstead is self-propagating. "As the wind blows, so goes the lavender," she said.

Ten varieties of lavender grow on the property, and as we strolled through the masses of fragrant spiked blooms, Sheryl pointed out some of the differences. Some have longer stalks, and some plants are narrower than the rest. There are many shades of color as well, from an eggshell white to a deep purple. When some varieties grow to maturity, they become woody at the bottom and are replaced with other varieties. Some will only last two or three years, "When it hits minus twenty that is about their limit," Sheryl said. Beginning in June, a sign at the roadside invites visitors to stop in the evening and cut the stalks, and of course to see the Log Cabin barn quilt. I left with Sheryl's gift of a huge bunch of rich purple blossoms, which freshened the air in our motel rooms for weeks to come.

A multicolored block with a horse in its center hangs on the barn at Spirit Therapeutic Riding Center. Evelyn Jones explained how the center came about: "I was going through a rough time in my life and volunteered at a therapeutic riding center about two hours away. After three lessons I discovered that I was empowered by the riders." Since she grew up around horses, working with them in this context seemed natural to her, and soon Evelyn was job shadowing some of the instructors. She said, "I jumped in with both feet not knowing what I was getting into, and then it became a dream to open a center here in the valley."

Evelyn's husband, Dave, joined us and I asked what attracted him to the idea. He answered firmly, "Her. It's a package deal." He continued, laughing, "It's a big package."

Evelyn continued, "Poor Dave. When we met I told him, 'This is my plan; this is my dream. Take it or leave it.'" Soon the two were hard at work creating an outdoor arena with a mounting ramp, which opened in 2006. The center provides equine-assisted activities for people with disabilities; Dave listed autism, brain injury, Down Syndrome, and MS. Evelyn added chromosome disorders, Cerebral Palsy, and also emotional disabilities and said that clients ranged from five years old to their forties.

Each of the facility's twenty-five or thirty clients visits for one hour per week. Each will groom and tack their horse as they are able, then exercise before riding for thirty to forty minutes. Dave went on to explain that some of the clients may have weight on their arms, some may carry a sensory ball, and some will stand in the saddle. "Each lesson is to their abilities." The riding gait simulates how our pelvis moves, so the movement gets those muscles to fire and helps riders develop flexibility and core strength. Those with mental or emotional disabilities form a relationship with the horse that leads to increased confidence, patience, and self-esteem.

With all of the wind in the area, there were days when lessons in the outdoor arena had to be cancelled. Dave said, "These kids love coming here, and it

Rail Fence/Horse Head

devastated them. One day we had to cancel a bunch and I suggested that we build an indoor arena. I never heard a quicker yes in my life!"

The five-year-old facility includes an area with the gear for each horse labeled and at the ready. One important feature is a lift system that allows riders in wheelchairs to safely mount a horse and makes it possible for those with severe mobility problems to ride. The nonprofit center has a pool of about seventy-five volunteers, as each rider starts out with three. As riders become more independent, they may require fewer volunteers.

The methods employed at Spirit are provided by PATH, or Professional Association of Therapeutic Horsemanship International. Evelyn credits the organization with providing the methods and guidelines followed at the center. "We are just providing the vessel for that to happen." Volunteering at Spirit has its rewards also. Evelyn said, "I ask volunteers to leave whatever they have going on in their vehicles once they get here. A lot tell me that they are able to decompress once they get here. When I volunteered I didn't know who benefitted more, myself or the riders. They teach me something every day."

By far the most incredible story I heard was of a pair of conjoined twin sisters who ride at the center. One of the girls rides sidesaddle, and the riding helps them both to become stronger. Evelyn said, "When you have a bad day, it puts things in perspective. With everything they are up against, they try."

Ellen Walton grew up near the Rose Bowl in California, but she always wanted to farm. Her great-grandfather settled in Northern California with two thousand acres and ten children; the Jensen Ranch was the family place for holidays and summers. Ellen remembers chickens and hay and horses doing the work and said, "I know they must have had dairy cattle, too, because all of the family recipes seem to consist of sour cream."

It wasn't until decades later after her children were grown and she met her new husband, Pat, that Ellen was able to realize her dream of farm life. Pat had grown up in the country in England with a cattle-farmer grandfather and steeplechase-jockey father. His background was enough for the two to begin looking for a farm.

The couple looked at every piece of property in the valley but kept coming back to one. Then they walked in and said, "Oh, my gosh, this is the worst house we have seen yet!" There was so much wrong with it. The interior was in poor condition, and there wasn't even a bathroom upstairs. "We were so ready to love it, but we couldn't at first," Ellen said. But Pat had confidence in his skills, and soon the renovation process began. Ellen said, "This two-year mark has been huge. When we pull in we don't see falling-down fences. There is a lot that needs to be done but it doesn't stand out so much. We have made a lot of headway."

The barn had been spruced up a bit as well, with a newly rebuilt floor and fresh paint on the front before the Churn Dash barn quilt was put up. The pattern

was the first quilt Ellen's grandmother made. Ellen said, "I don't think I would have done a barn quilt if I didn't have a quilt that had meaning to us. Especially in an old home here—it's nice to have a bit of barn history."

Opposite:
Churn Dash

Ellen said that she and Pat are "are just the current caretakers of this house," and as such they thought the neighbors ought to weigh in as to whether a barn quilt was appropriate. "They lived here a lot longer, so I left part of this decision up to them," she said. When Ellen explained that the quilt was from her family, both neighbors said, "Oh, yeah." Ellen said, "I did not ask for permission, but if they said no, I would have taken it more as a bit of wisdom. We wanted to be good guests when we moved into the house."

I had learned about lavender and therapeutic horses and had visited a beautifully restored barn, but I just couldn't leave the Kittitas Valley without finding out about hay farming. Kathi Brunson attended my talk in Ellensburg and encouraged me and Glen to stop by her home, site of a quilt block that is a combination of Evening Star and Bear Paw, and one of the valley's oldest family-run hay farms.

The farm was founded by Dan W. Brunson in 1912 and has been in the family since. When so many others were losing their homes and farms during the Depression, Dan served as an auctioneer at farm sales, supplementing the farm's earnings and ensuring his family's security. Dan's grandson, Tom, who currently operates the farm, credits the "dedication, hard work, and love of the land" that began with Dan as keys to the Brunson farm's continued success.

The Brunson farm progressed through crops and livestock and was a dairy at one time, but these days the focus is the Timothy hay for which the Kittitas Valley is renowned. The valley is ideal for the crop, which is grown on approximately thirty thousand acres. The warm days and cool nights are perfectly suited to growth, and the persistent winds help to cure the hay, resulting in a shorter drying time and allowing the hay to be baled with a minimum of bleaching. With plentiful and cheap water created by snowpack from the mountains nearby, the perennial crop can remain in the same field for multiple years.

I was surprised to learn that the largest buyers are the Japanese, who purchase the hay for the horse industry. "The Japanese place great importance on the Timothy hay having a dark green color and being clean of other grasses," Tom said. "Many Japanese buyers personally come over and look at the hay within weeks after harvest." I was astonished to hear that hay was shipped overseas from Seattle in such quantities and equally surprised to learn that horse racing was big business in Japan.

Kathi Brunson grew up in a rural environment and remembers her parents' hard work at the vegetable farm along the Columbia River. Kathi said, "They opened that ground from sage brush and grew twenty-three different kinds of vegetables

209

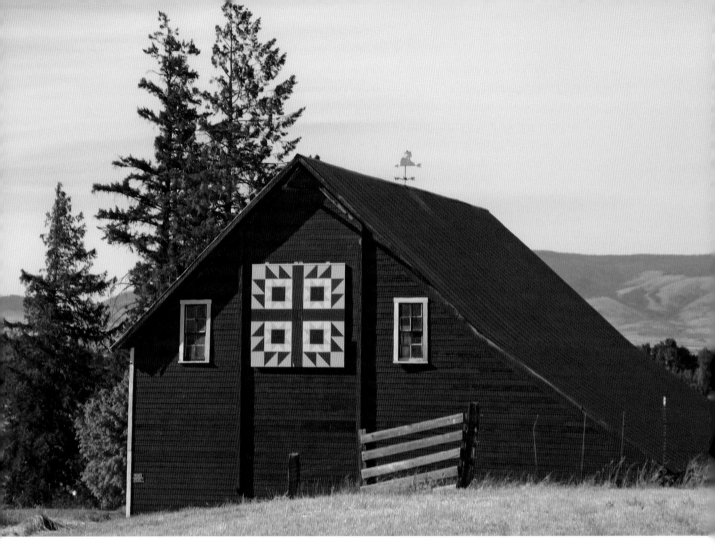

Evening Star and
Bear Paw

for over sixty years." Of course Kathi had to do her share. "As a teenager, I resented having to work during the summer when school was out and friends were having fun, going swimming and playing and staying out late. Well, we could stay out late, but had to be ready to work at the crack of dawn! Looking back, however, I have fond memories of growing up in this rural environment and feel fortunate for that safe and healthy surrounding. I feel this same way now about having raised our children and living on this farm."

Tom said, "It is comforting to know that this farm, after three generations and one hundred years in the same family, will continue to be farmed by my son-in-law and grandson and won't be lost to development." I had seen so many farms across the country teetering on the verge of extinction or giving way to subdivisions and shopping centers, so I also took some pleasure in the fact that the fourth and fifth generations were ready to keep the Brunson farm intact.

210

following the barn quilt trail

Our respite in Washington had allowed Glen and me to discuss what to do about Ruby. The repairs would cost more than she was worth, but surely then she would be set for the thousands of miles of travel to come. We had already replaced so many parts; this had to be the last. Our love for that bus was beyond reason. She was the emblem of our leap of faith that we could live together happily on the road and a twenty-ton symbol of all that we had shared. We both had doubts, but neither felt strongly enough to advocate abandoning the bus. The discussion carried on for hours and ran into days before the decision was made—we would have Ruby repaired, and Glen would fly back to Montana and drive her to California when she was ready for the road.

california

REACHING CALIFORNIA WAS cause for celebration. I had never visited the state, and of course the West Coast marked a huge milestone in our journey. Glen and I spent a couple of days making the drive down the coast taking in the sights. Redwoods National Park was an awe-inspiring first stop, and the cool shade allowed us to take Gracie for a hike of more than a mile, a treat she seldom enjoyed at her advanced age. We detoured to visit a drive-through tree, where a crowd of nervous onlookers waited for someone to give it a try. Glen slowly idled through, then urged the others, "Come on, now. I made it with kayaks on top of the car and bikes on the back!" After a few minutes with no takers, we continued on. Along the coastal road, overlooks provided views of whales breaking the surface in the distance; we clambered down to the beach where I dipped my toes into the Pacific for the first time.

There was still a lot of territory to cover, so Glen and I added a new enhancement to our travel—Spanish lessons. We found a basic course on CD, and soon we were driving along parroting the instructor's phrases. Glen asked "Perdón, Señorita, Entiende Español?" I replied, "Si, Senor, Entiendo un poco de Español." I was proud at how quickly I had learned to understand his question and to answer that yes, I did understand a bit of Spanish. But being called Señorita at the age of fifty-four grated just a bit. We had passed the three-year mark in our relationship, and I was ready to become a Señora. We had talked about getting married, but Glen wasn't quite ready, and I didn't press the point. If nagging wouldn't change his habit of driving in the right lane just slightly below the speed limit, it certainly wasn't going to convince him to set a date for a wedding.

I have to admit my disappointment that not all of California was scenic, particularly during a drought. The hills in the central part of the state were covered with scraggly, dry brown grass, which I was informed by many a resident was actually "golden." A Sacramento motel became our headquarters for a couple of weeks, and the temperatures of more than one hundred degrees made just short walks with Gracie unpleasant. Fortunately, I was invited to speak in Napa, where we enjoyed a brief respite from the blistering heat at a guest home nestled in a vineyard. We woke in the morning to the sound of women singing as they worked among the grapes, and the three of us strolled among the vines at sunset. The rolling green landscape was covered with rows of vines, planted first one direction and then at right angles on the adjacent hill, like hair that had been parted with a gigantic wide-toothed comb.

Glen and I kayaked the Russian River through Sonoma County, a tree-lined stream that reminded us a lot of home. We played tourist in the Bay Area; our bike ride across the Golden Gate to Sausalito was both terrifying and exhilarating, with high winds buffeting me from each side as local riders zipped past in the narrow lane. The Fourth of July found us savoring Dungeness crab on a balcony overlooking the ocean, then braving a chilly sailboat tour on the choppy bay to watch fog-shrouded fireworks. The shops on the glittering piers held all kinds of local treasures; we purchased a cable-car-shaped loaf of sourdough—an edible postcard of sorts for faraway family—that Glen's mom, Anna, found both amusing and tasty.

It had been a month, and Ruby was finally repaired. Glen flew to Missoula, retrieved the bus with her new motor, and made the thousand-mile return trip to Sacramento in just a day and a half. I was a bit perturbed with him for driving such a distance without sufficient rest but also eager to be back in the bus.

Lake County, California, was the destination that had fueled my desire to reach the West Coast, the guidepost that had determined the rest of our itinerary. We had crisscrossed the state enough to know that traveling any distance in California meant crossing mountains. Our last high-altitude trip had been catastrophic, and Glen admitted that Ruby had overheated while crossing the gap from Nevada into California, so we made our way gingerly with an eye on the thermostat until reaching the shore of Clear Lake. We parked just a couple of yards from the water, ready to explore the lake and glad to be at home.

After so much time away, I was eager to return to the quilt trail. Committee member Marilyn Holdenried picked me up in Kelseyville and, on the way to our first appointment, we toured the town, where barn quilts adorn many of the local businesses. We sped away to view quilt blocks at a couple of wineries and then headed down dusty roads into a less populated area of the county.

Marilyn was eager for me to visit the Hilton barn, but as it came into view, I was a bit disappointed. I had, after all, asked to see historic barns, and this one looked brand new. Still, the barn owner was awaiting our visit, so after a few

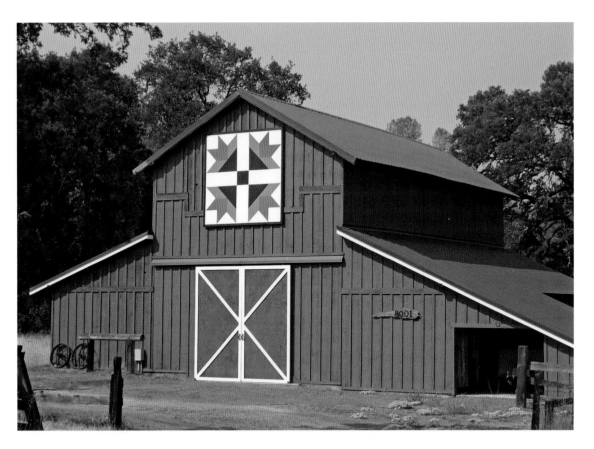

photos, I joined Marilyn and Lyn Hilton in the courtyard of the house nearby. Seated at the picnic table surrounded by artfully landscaped greenery, Lyn explained that she and husband Jim had purchased the house as a weekend home and moved there ten years later, in 2008. A complete restoration of the century-old farmhouse allowed them to live there comfortably, but they had no plans to farm. After all, Lyn said, the deer ate her rosebushes—imagine what would happen if they planted grapes.

Once the Hiltons got the barn quilt bug, a massive restoration began, and within six months, the barn had been returned to what looked like new condition.

I was surprised to learn that the Turkey Tracks barn quilt, inspired by the wild birds that frequent the property, was painted without benefit of tape to mark off the lines. "We didn't know," said Marilyn. "I kept saying to myself, 'If I breathe, I'll go out of the lines.'" Soon thereafter, the group took up the method used by many others and found that a bit of tape and a few deep breaths made barn quilt painting much more enjoyable.

The area is known for growing pears, and the harvest was underway, with the orchards filled with workers on narrow ladders filling enormous crates of fruit.

Turkey Tracks

215

california

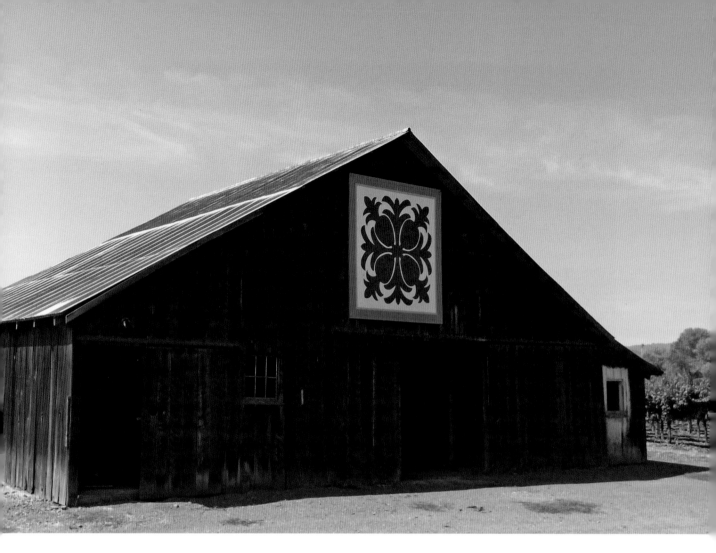

Hawaiian Pineapple

The Pear Basket quilt block that Connie Wright and her sisters chose hangs at an agricultural business at the intersection of the street where her dad, Leroy, grew up and the land where those pears were grown. "The pear industry was our entire life," Connie said. Connie mentioned that she and her sisters had worked on the family ranch, and I asked why a California farm was a ranch. The term usually brings to mind Texas and horses and cattle. Neither Marilyn nor Connie had any idea other than, "That's what we have always called them."

Connie shared vivid memories of the frost alarms that would alert each farmer to the drop in temperature so that smudge pots could be placed in the orchards to prevent freezing. I remembered seeing those pots in the orange groves in Florida when I was a child. As young girls, Connie and her sisters would make a game of running down the rows extinguishing the smudge pots the day after a frost. As she grew older, Connie shared a more adult chore. She would sit in the office waiting

216

for the alarm or for a call from a nearby farmer whose alarm had sounded already. Sometimes the vigil would last all night.

I couldn't help thinking that pear growing was tough business for children, but Connie revealed that the kids did enjoy one advantage when they went to school having been up all night. The teacher always allowed those with smudged faces to put their heads down for a much-needed rest.

The dark-wooded barn where Debra Sommerfield's barn quilt hangs is a perfect backdrop, similar to the black barns of Kentucky. Debra saw the barn at Rooster Vineyard on her path to work each day and felt that it was "crying for a quilt block." The owner agreed, and soon a Hawaiian-themed quilt block was created to fill the vacant space. Debra explained that the quilt was dedicated to her mother, Jacqueline Myers, who was born in Hawaii. She was an artist who kept Hawaii alive in her Bay Area home through sketches and drawings of Hawaiian flowers. Jacqueline's favorite color, purple, was used in the Hawaiian Pineapple quilt block. The pattern reflects the appliqué style of quilting for which the islands are known and represents the warm welcome of the islands transported to California.

That evening, Glen and I were invited to the Holdenried ranch for dinner with members of the quilt trail committee and their friends. It turned out to be an unforgettable evening, with a catered meal featuring locally grown produce, fresh fish, and wines from the vineyard that surrounded us to accompany each course. As the twenty attendees shared their barn quilt stories in turn, I recognized the names of those with whom I had corresponded over the years and was glad that we had made the journey.

The next morning, Marilyn and I headed across the street from her home to meet with Madelene Lyon, whose Clark's Star barn quilt honors the family who founded the ranch. As we entered the farmhouse, Marilyn settled in at the table with the ease of a longtime friend, and Madelene told me about her family's history on the property. Her dad arrived in San Francisco in 1917 and mom in 1924, and the two Swiss immigrants married soon after meeting. The property had been a dairy and later grew pears and prunes and in the midsixties transitioned to grapes after Madelene and husband Walt moved to the ranch. Marilyn remembered that time well: "They were preparing the fields, and I just knew that dust was going to get on my new baby," she said with a grin.

Madelene went on to talk a bit about the transition from one type of grape to another, and the information surprised me more than a little. I had always thought that different grapes meant different plants. Madelene explained that the variety of grape might change to meet demand but the shift didn't involve planting seedlings. The roots stay in place and cuttings from the desired plants are grafted on. The budding-over process allows the new variety to produce a full crop in just two

217

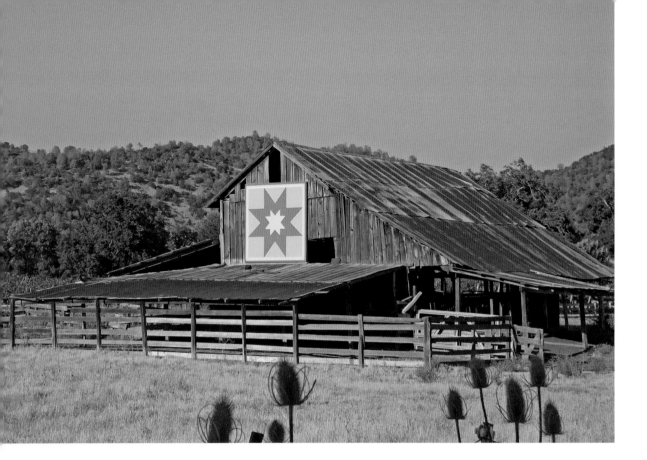

Clark's Star

years. It sounded like magic to me, but both women assured me that operating a successful winery took a lot of hard work. "You can say all you want about farming," Madelene said, "but in the end it's worth it. You make your own decisions; you work your way through the ups and downs."

"It's such a feeling of success," Marilyn chimed in, and I couldn't help thinking that the two had discussed the matter over many a cup of coffee and counted themselves blessed.

Marilyn and I drove along the lakefront to our last destination, and arrived at Ely Stage Stop just in time for lunch and a chance to learn a bit of Lake County history. The simple wooden house had been moved to its location when it was clear that a highway project would cause it to be demolished. "It was one of the first wooden structures in Lake County," docent Suzann Schutz told me. The docents who worked at the museum greeting visitors and sharing the history were all volunteers.

The house had been part of a ranch that was founded in 1859 and was not only a family home but also a public house and a hotel. The ranch was sold to Benjamin Ely, whose family operated a stagecoach stop where travelers might rest and enjoy a meal while horses were changed. In its time the building served as a post office, a bar, a gas station, and a home for wayward boys. The rich history of

218

following the barn quilt trail

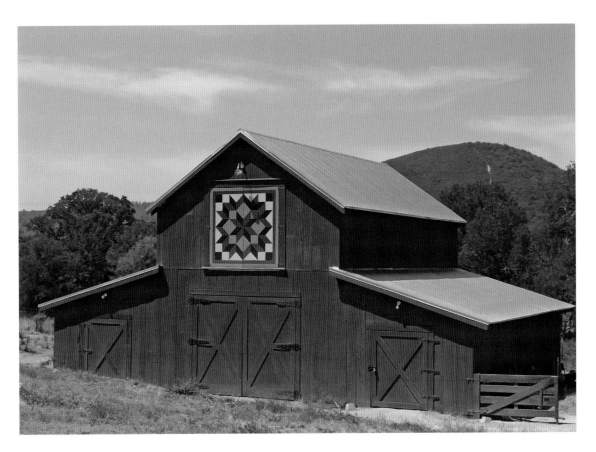

the building inspired the Historical Society to move the structure to land that had been donated by a local vineyard so that a county museum could be created.

Carpenter's Star

The museum included artifacts such as furniture, kitchen implements, and china that might have been in place when those travelers stopped by. The stagecoach on the porch looked very real to me, but building manager Bill Lane explained that it was in fact a three-quarters-size replica built locally. The grounds of the museum also contained historic farm machinery and a cable car from San Francisco, and, of course, a barn.

Once again I was introduced to a barn that appeared brand new but was only, as Bill put it, "in its latest incarnation." Bill had incorporated his love of history with his skills in the construction industry to oversee the project. The boards were gleaned from an 1800s barn and moved to the spot for the two-year construction process. The Carpenter's Star barn quilt was chosen by vote of the docents and seemed very fitting as an acknowledgement of all of the volunteers' work in building the barn and museum.

The quilt trail in the town of Quincy, in Plumas County, is a small one of only ten blocks, but they are located so that it takes only a few minutes to drive from one

219

california

to the next. So many times I have visited a quilt trail to find the blocks scattered at such a distance that the trail is not really viable for a traveler. Here it was possible to drive at a leisurely pace, stop for photographs at each site, and still finish in a couple of hours.

My tour guide, Carolyn Kenney, and I visited with Janet Shannon, whose barn is decorated with a Double Pinwheel barn quilt. Here was a great story, an actual forty-niner who had farmed in Plumas County. Janet's great-grandfather Samuel Lee was born in Ireland in 1832 and at the age of twelve stowed away on a ship bound for New York. Over the next few years he made his way to California and took up mining.

In 1850, Samuel struck gold at his mining camp, and he used the proceeds to purchase part of the property that would later make up the one-thousand-acre homestead. He married, and with wife Elizabeth raised two children on the ranch, which was mostly used for cattle. The mortise-and-tenon barn was built sometime in the 1860s and though the siding and roof have been repaired, most of the original structure remains intact.

Janet shared some of her memories of the farm. The large garden provided both fresh fruit and vegetables during the warm seasons and produce to be canned for the winter. The family did keep milk cows and separated the milk so that they had fresh cream, whole milk, and skim milk. They also made their own cottage cheese and churned butter.

The house where we sat was the one where Janet's mother was raised and where Janet grew up as well. "Mom loved this house," Janet said. The home is no longer occupied but remains a home base for Janet and her siblings when they visit the area.

Glen and I left the quilt trail behind and headed to Southern California, where I had several speaking engagements. I had found an RV park right on the beach in Los Angeles, where we could walk ten yards to the sand. We had a glorious week as temporary residents of our own Los Angeles beach house. We dove headfirst into the waves and tumbled blindly onto the shore, swam out beyond where we could stand and bobbed as each wave crested, then dropped onto the sand and let the foam kiss our toes. Over the weekend, we made a trip into the city to see those famous names in the sidewalk and took the obligatory drive into the hills for a glimpse of the Hollywood sign.

We didn't have a house to go home to, but we still wanted to spend the holidays in the South near friends and family. On departure day, everything was stowed and secure, but when Glen turned the key to start Ruby, a weak groan issued forth instead of the vigorous rumble of the diesel. How that bus broke down while parked in one place is still a mystery. A mobile mechanic determined that the parts needed for the repair might take days to arrive. I had a talk scheduled in Arizona in just a couple of days, and I knew the organization there had spent a lot of time preparing, so

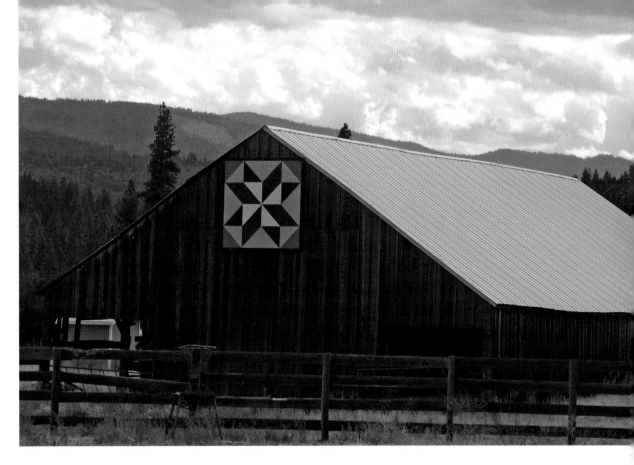

I just could not cancel. I sobbed in frustration and anger as I drove the six hours to Phoenix but was relieved the next morning when Glen called to say that the parts had been located and the bus was running. We were to meet in Needles, California, and continue on to the Grand Canyon as planned to enjoy Labor Day weekend.

Double Pinwheel

It was not half an hour before Glen called to say that the bus's transmission was refusing to shift; he was stuck in Los Angeles on the freeway and limping along in low gear. I made my way back to California, and this time the decision was clear. Ruby had to go. She had sapped us of time and energy and had depleted our savings. She had made us wary of travel and unable to commit to a schedule. Neither of us wanted to make the move from that retro rock-star bus to a run-of-the-mill RV, but it had to happen. A week later, we left California in our new home on wheels, a 2006 Alfa See Ya motor home, a spacious RV with tall ceilings and loads of storage that was said to be perfect for those who make RVs their full-time home. We had joined the ranks of everyday RVers, but we had faith that we would make it to Texas and beyond without mishap.

We crossed into Arizona, glad to be headed east, loudly singing a Beatles favorite with tambourine accompaniment: "Ob-la-di Ob-la-da . . . La-la how the life goes on."

221

california

texas

THE DRIVE FROM Los Angeles to Texas took a couple of days, and along the way we adjusted to our new home. Bus owners snobbishly call RVs "sticks and staples," and for the past year Glen and I had turned our noses up at those whose homes on wheels did not seem as sturdy as ours. But that first night parked with the slide-outs open that turned our living area into a spacious room, I felt liberated. "I think I could learn to like this," I said tentatively, hesitant to bring up a sore subject.

"I just wish we had made the change months ago," Glen answered, "and I hope this Alfa turns out to be reliable. No more uncertainty."

We might not be trendy, but we were comfortable. Half a dozen large windows allowed natural light to pour in during the day. Gracie had a place to lie down without being stepped on; after a year of bus life, the poor dog must have thought that her name had changed to "Move" or "Get Out of the Way." And I was able to cook dinner without having to vacate the kitchen if Glen needed to pass by.

I had just about given up on cooking, as the narrow aisle on the bus was barely large enough to open the pantry and so poorly lit that I could seldom find what I was looking for. Now, I had plenty of room and light, loads of storage space, and a real oven. The repetitive motion and resonating sounds of chopping herbs and grating citrus, the smell of vegetables roasting in the oven, even the clatter of dishes in the sink were harbingers of home. Cooking for Glen had always been a caretaking practice for me, a comfortable means of expressing love without words that I had sorely missed.

Texas was one of the few places that looked exactly as it should. Oil derricks in constant motion stretched to the horizon, and all manner of heavy machinery was strewn along every roadside. At night, the refineries were lit like city skylines, visible from miles away. It was my turn to drive again, as we could not cross half of the state in a weekend, but after piloting the behemoth Ruby a few hundred miles, an RV of the same length was easily manageable. Sometime into the second hour I found myself daydreaming just as I might on a highway drive in the car. I seldom volunteer to drive, but since my daylong Texas jaunt, I have always felt confident when it's my turn to take the wheel.

I had never thought of Texas as the South, but when I visited with the first group of quilters, the hugs and easy smiles that Southerners share on greeting flowed, and an unfamiliar state felt like home. In the South, a long *i* sounds like ahh, so every sentence carries with it a measure of comfort. Texas was the perfect place to shake off my misery, all at once like a dog coming in from the rain. Fort Worth offered a chance for Glen to visit colleagues in a manufacturing plant nearby; it does him good to get away from the desk for a while to exchange ideas face to face. For me, a visit to a quilt trail was in order. It was no accident that we were near Fannin County, home to the second of only two quilt trails in Texas.

I love connections between barn quilts in different parts of the country, and Jane Gehalo had just such a story to share. Jane lives in Telephone, Texas, whose unusual name refers to an earlier time when the only telephone for miles around was located at the local general store. Jane is originally from Miami County, Ohio, where I had spent two summer days touring the quilt trail a few years earlier. All of the quilt blocks are painted directly on the barn surface, and the trail comprises over one hundred barns. Jane's Ohio Rose barn quilt is a reminder both of her home state and of the original painting in Miami County, Ohio, after which it is patterned.

Jane explained that she returns to her childhood home in Troy, Ohio, every year, and on each trip she takes photographs of barn quilts. Her father, Carl, loved to travel the area by car and would name each barn and who might have lived there. "He knew every road in several counties," Jane said. The barn quilting trips enriched Jane's visits to family, as she and her dad were able to share theit common interest.

The circle expanded when Jane suggested that barn quilts would be a good fit for Fannin County, Texas. Resident Patti Wolf, my host for the day, had taken Jane's suggestion and worked with a group of local volunteers to create a quilt trail. One of Patti's favorites is Judy's Hope, an original design that Patti painted for Judy Keene. As we approached the property, the barn looked a bit wobbly, but Patti assured me that the boards on the one-hundred-year-old barn were in fact so solid that mounting the quilt block had been very difficult.

I was surprised when Judy's husband, David, whose family settled the property, said that the oak for the barn had actually come from Oklahoma. David reminded me that the farm is only five miles from the Red River, which was used for

Opposite:
Judy's Hope

following the barn quilt trail

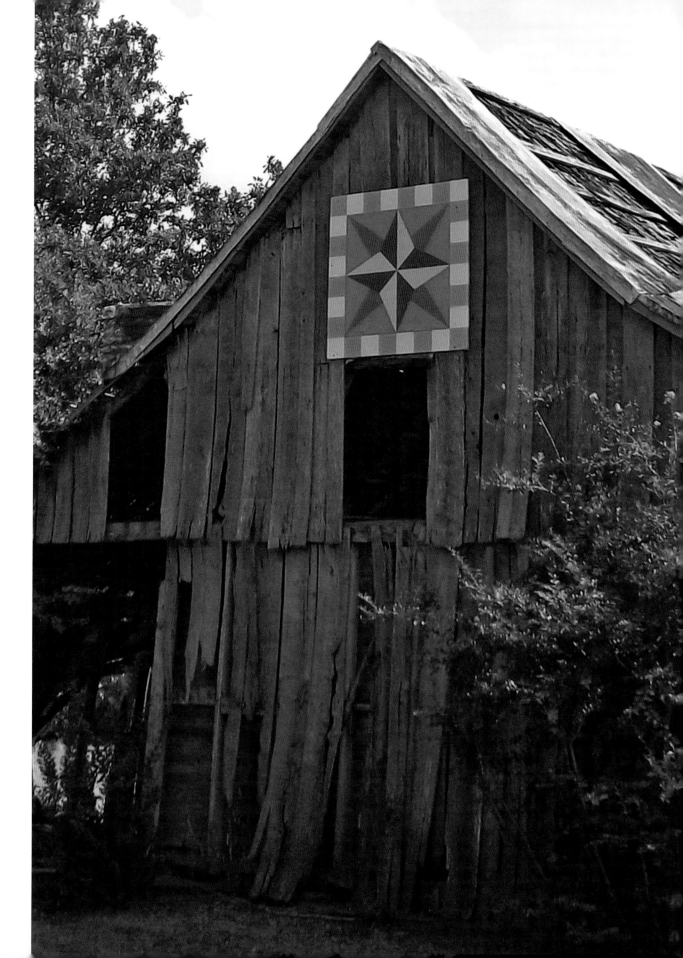

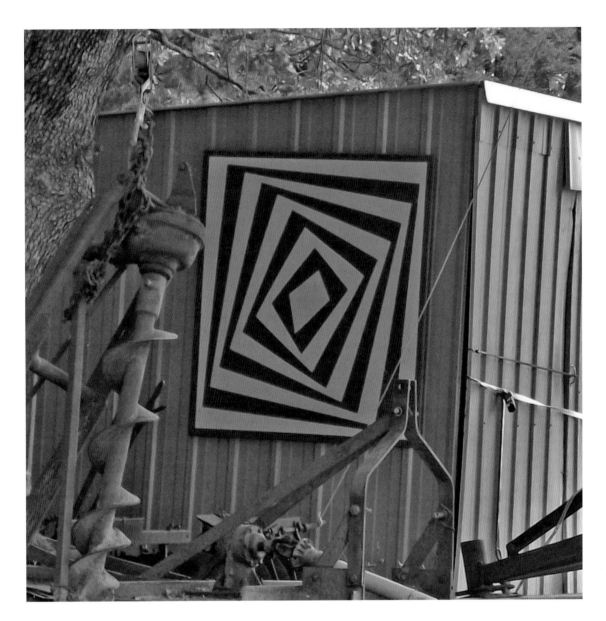

transportation of the building materials. I then recalled from the map I had used to stake out possible kayaking locations that the river constituted the nearby state border. David also shared the fact that a family of vultures nested in the barn and raised their young each year. It seemed that just about anyone could inhabit a barn.

Judy volunteers at the chamber of commerce and had helped put together a list of the area's barn quilts. When Judy brought the list to Patti Wolf, she shared during the conversation that she had been diagnosed with breast cancer. The two soon discovered that they live behind one another and have since become very close. Patti honored her friend by painting a quilt block for the barn, which she

called Judy's Hope. "Every time I come and go I am thankful that I survived and it gives that message," Judy said, "and I am happy for my wonderful new friendship with Patti."

My final visit for the day was to the offices of the local newspaper, where I found Connie Estes and Tim Meek hard at work on the latest edition. Connie remembered having lunch with Patti and hearing about the quilt trail. "I'm so in," she had said. Connie's brightly colored quilt block is unique because it contains a hidden element. Though I had visited earlier in the day, I hadn't noticed. The young woman who was painting Connie's quilt block had an idea, "Let's hide something in your square." Connie agreed, and since the family has three horses, they chose to place a horseshoe in the quilt block and paint over it. The same was done with the Mariner's Compass that was the second barn quilt on the property. Sure enough, when I looked back at my photographs later, I could make out the outline of those horseshoes. I thought it was an ingenious idea. "It's just like a big huge smile in my backyard," Connie said.

Tim Meek was hard at work at the desk adjacent to Connie's. Patty and I had stopped by to see his barn quilt earlier, and it was certainly unlike any I had seen. Tim explained, "In junior high school I just didn't listen very well, and during class I sat and doodled. That design was one of my favorite doodles that I would draw over and over again." Tim didn't give the pattern a name until recently when he once again drew the design in pencil—this time on the eight-by-eight-foot board. I couldn't help thinking that a jumbo doodle, which Tim named Infinity and Beyond, had to be a lot more fun to draw than an exacting quilt pattern.

I had noticed an unfamiliar word, "Rivendell," on the crossbars leading into his property, and I asked Tim to explain. Tim was born in the area but had moved to Fort Worth. When he got married, a small town seemed a better place for the family, so he returned to Fannin County and commuted to work forty miles each day. Tim didn't mind, though, as the peace and quiet at the end of the day was worth the drive to Rivendell, named for the place of refuge in *The Lord of the Rings*.

I left Connie and Tim to their work and headed back to the RV. It seemed odd that I had commuted from the city to the country to work for the day, the opposite of the routine Tim had described. I enjoyed sharing with Glen the photographs from my tour and surprising him with the news that I had stopped by Rivendell. It is not too often that one of Glen's favorite books and movies is part of my day's work.

kentucky

CALLOWAY COUNTY, KENTUCKY, lies on the path between Atlanta and Paducah. I had stopped off a number of times on my way to the National Quilting Museum and had watched the quilt trail grow from a few blocks in 2012 to a trail of thirty in 2014. This time I set aside a day to visit with Judi Little, who had painted most of the barn quilts, and local resident Posy Lough, who had taken an interest in barn quilts and the quilt trail and via phone and email had become my long-distance friend.

With Judi at the wheel, we traveled winding byways where tobacco barns appeared frequently along the roadside. I had always admired those barns, but my timing had never allowed me to see them in use. October is cutting and curing season, so this time the crop was abundantly displayed. I am not sure why, exactly, but to me, the cut tobacco had a certain beauty. Posy expressed the same sentiment: "I love to see every stage of it, to see it all on display." When we arrived at the Kelly farm, we were rewarded with the full array.

"Oh, my goodness—Look!" Posy and I exclaimed in unison, as the bright green quilt block came into view. Soon we were chattering excitedly as the racks of tobacco—some green and ready for hanging, some dried and prepared for transport, and some in the barn itself—were revealed. Joetta Kelly joined us in front of the barn, and as we watched the workers transfer tobacco, she told us a bit about the farm. Her husband, Jim, had worked at the family dairy, milking cows alongside his grandmother. When it came time for him to take over, Jim moved into crops such as beans, corn, hay, and, of course, tobacco. The farm operation includes about a dozen barns, but the one where we stood was the only one that

Shamrock

faced the road, so it was the natural choice for the four-leaf clover. The Shamrock represents the Kelly family and also Joetta's memories of searching for four-leaf clovers as a child.

Our timely visit allowed a chance to find out more about the drying process. Joetta explained that the barn itself actually held two different types of tobacco—the open sides were burley tobacco, whose leaves are larger and heavier and slightly yellow. Burley would be naturally air-cured, with the resulting product used for cigarettes. The rich green dark-fired tobacco would be cured inside the barn with smoke and then used for snuff and chewing tobacco. The idea of fires being deliberately set inside barns intrigued me.

According to Joetta, smoldering rows of wood were laid across the bottom of the barn and then covered with sawdust to keep flames from starting. "It's an art," she said. My imagination was piqued; I just had to see inside one of those barns. Joetta agreed to take us to a barn with an active fire, and I trotted to the door with the excitement of a child on Christmas morning. The farmhand who opened the

230

door was both puzzled and amused as I peered past his shoulders, where I was able to catch a glimpse of the smoldering mass that ran the length of the floor. A blanket of acrid smoke rushed out, thick and stinging, and after only a moment I retreated to clear my eyes and lungs, choking but pleased at having seen those embers in place.

Everything about the Norsworthy farm looked remarkably new, but the barn quilt and its moose mascot looked so distinctive against the tan-colored barn that I was drawn to the scene. Despite its modern appearance, this property had a long history. The farm had been in Bob Norsworthy's family since 1890 and had passed to the oldest son in each generation since. Bob and his wife, Connie, had made their home in Connecticut, but Bob always said that they would move back when his turn came. "I still don't believe it," Connie said. "I thought we would come back just for a while, and now, here we are."

The moose silhouette that had caught my eye earlier is a nod to the Norsworthys' years in New England. It was already in place on the barn when the decision

Pine Tree

231

kentucky

to add a quilt square was made. Connie thought it only fitting that the moose have a tree, "a destination," as Bob called it. Judi Little worked from the pine pattern that Connie chose to create a scene that adds just the right touch to the family farm. As for the continuing family legacy on the property, Lee-Clark Norsworthy, Connie and Bob's only child, will be the first woman to own the property.

Clarkie Butterworth said that the property where their home and barn are located is adjacent to her husband Jackie's home place and only five miles from her childhood home. The barn had been used to dry tobacco and was certainly worth preserving, so the couple thought they might have it moved behind the house where they could keep it in good condition. On a trip to Florida, the couple came upon a barn whose center had been widened so that the driveway ran through. They immediately decided that their barn should not be moved but rather altered so that it fits its current location. The charming "drive-through" barn became quite the conversation piece, even more so after it became home to one of the county's first barn quilts.

Glen and I had visited the area a year earlier and had been delighted by the unusual structure; we had each posed for photos inside the doorway, with the car positioned in front as if ready to drive through. When I heard that it had burned, I felt a sense of personal loss. One stormy night, Clarkie and Jackie heard a lightning strike but upon checking saw that the house was unharmed. Soon after returning to bed, they heard the sirens of approaching fire trucks and realized that the current had traveled to the barn and started a fire. The firemen couldn't save the structure but managed to contain the blaze.

Clarkie said that they got so many calls and even sympathy cards from neighbors after the barn was lost. Others reported to her that students on the way to Murray State University used the barn as a mileage marker, as it stood just about four miles from the campus. The Butterworths simply had no choice but to rebuild on the same foundation, and this time the drive-through was part of the design. The newness of the structure is somewhat startling, and the patriotic-themed barn quilt is slightly different, but both are similar enough in style to evoke fond memories of the historic barn.

The Penner barn with its patriotic barn quilt and the flag waving in the glimmering sunshine captured my attention right away. As we walked up the steps, I began to realize that the family's expression of patriotism wasn't limited to the barn. A white wicker chair held pillows with flag and star patterns that complemented the woven rug nearby. A wooden shutter painted with stars and stripes added to the folk art theme. When I saw a small plaque that read, "Proud Army Family," I thought I might just have the key to the Penners' enthusiasm for flag and country.

Jamie settled in among the stately eagles, red and white quilts, and richly woven blue carpet inside the home to talk about her family. Jamie's father served in

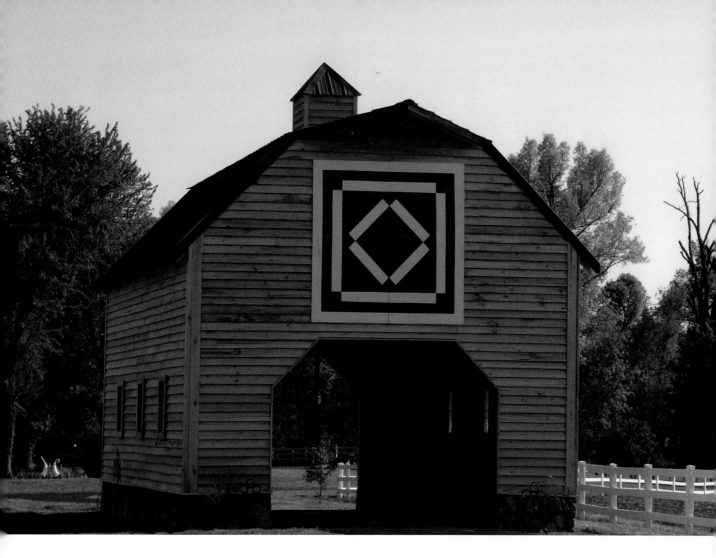

World War II and her mother was very patriotic as well; she was proud of the fact that her husband had served. "She taught me to love the flag," Jamie said. Husband Jerry is a retired Army colonel, and his twenty-nine years of service reinforced Jamie's already strong affection. Jamie described attending military funeral services, where the flag is so prominent. "If you weren't already a lover of the flag, you can't help but become one."

Tears rose in Jamie's eyes as she talked about her mother, Margaret: "She loved Kentucky, and she would have loved that barn!" Margaret was a quilter who worked by hand well into her eighties. The barn quilt Jamie chose is Mother's Fancy, in honor of a dear mother—in red, white, and blue for a cherished father and love of the flag.

The day closed with a visit to Posy Lough's home in Murray. I had already heard the story of her barn quilt. Posy's husband, Tom, and son, Kyser, came up with a plan to create a special celebration for Posy's seventieth birthday. Her sister,

kentucky

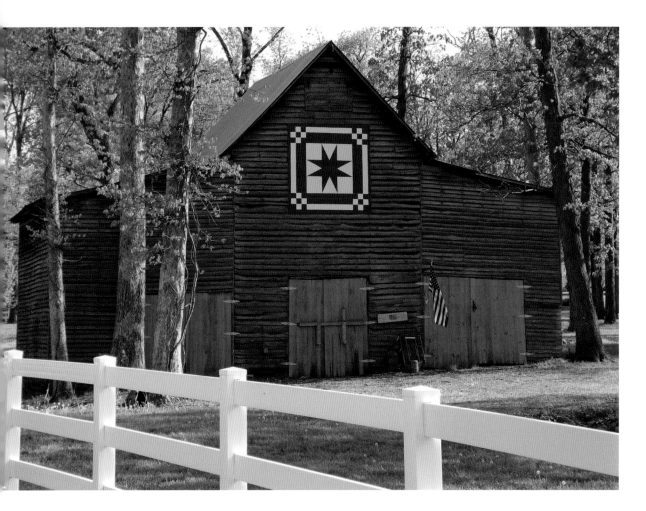

Mother's Fancy

Ceil Humphreys, created a simple Tulip pattern—a Posy—on cloth, and with Tom's help sent an outline of the flower to over two hundred friends and family. Each was asked to color in the flower and return it to Ceil, who stitched all of the pieces into a quilt. I loved the idea and marveled at the fact that so many had collaborated on the quilt. Kyser completed the package by creating a barn quilt in the same flower pattern. The quilt block hangs over the garage, a daily reminder of the love of friends and family for aptly named Posy.

Gracie and I were left alone for a week, as Glen was called out of town for work. I didn't mind too much; we lived in such close quarters that it was probably good for us to spend a few days apart three or four times a year. If I had to be left alone, Kentucky was the perfect place, as I could keep myself occupied with a bit of additional Kentucky barn quilting.

234

Daviess County quilt trail organizer Jackie Snow asked me to meet her at Reid's Apple Orchard, and I was taken aback. An apple orchard in Kentucky? Sure enough, as I drove along the curves leading to the parking area, I passed about a dozen families among the rows of trees picking their favorite varieties. I asked owner Billy Reid what types of apples would be found on the property, expecting a brief response. Billy named Red and Yellow Delicious, Jonathan, Winesap, Pink Lady, and Fuji before I gave up trying to jot them all down. The family is busy year round, with spring strawberries, summer vegetables and peaches, then apples and pumpkins in the fall.

I asked whether the tobacco barn on the property had ever been used for its namesake crop, and Billy replied that he had spent just a single year as a tobacco farmer. He soon realized that the constant bending involved in caring for the crop led to intense back pain and that he preferred growing strawberries. It seemed to me that growing a crop at ankle level would be even more difficult, but Billy answered, "I want to either stand up or be on the ground—not all of that up and down."

Jackie and I, along with volunteer barn quilt painter Lelia Gaines, drove into the Kentucky hills and an invigorating early fall chill. As we approached the Bosley home, I glimpsed a white barn that featured two of my favorites—the Grandmother's Flower Garden quilt block and tobacco drying below. Philip Bosley started out of the house to greet us, but I was already scrambling up the hill in back to capture the scene. On the way I passed a small patch of cotton, and Lelia stopped for a closer look. Soon Philip was headed to the shed nearest the house for clippers to cut a branch containing a bunch of drying bolls for Lelia.

Joining Philip and his wife, Beverly, inside their brick home a few minutes later, we settled into easy chairs in front of the parlor fireplace, where Philip quickly shifted from host to storyteller. He began with the central facts: The property had been in his mother's family since the 1820s; the house in which we sat was built on the foundation of the Bosley plantation house, which had burned. Philip recalled his grandmother Ruddle, whose husband, Isaac, had built the home in 1914. I asked Philip for his grandmother's first name, and he replied, "I just told you; it was Ruddle." Soon a story as to the origins of that most unusual name ensued.

Philip's grandmother had a half-brother, Chapman, whose fiancée, Ruddle, was very dear to the family. When the family's first daughter was born, she was named after the young woman who was to be her sister-in-law. Philip told the story of "Uncle Chap" returning from the Civil War, where he served in the Confederate Army, so that he could see the baby. In order to avoid the Home Guard, who were on the hunt for Confederate soldiers, Chap slipped into the stable before dawn. When the farmhand arrived to milk the cows, Chap exchanged clothes

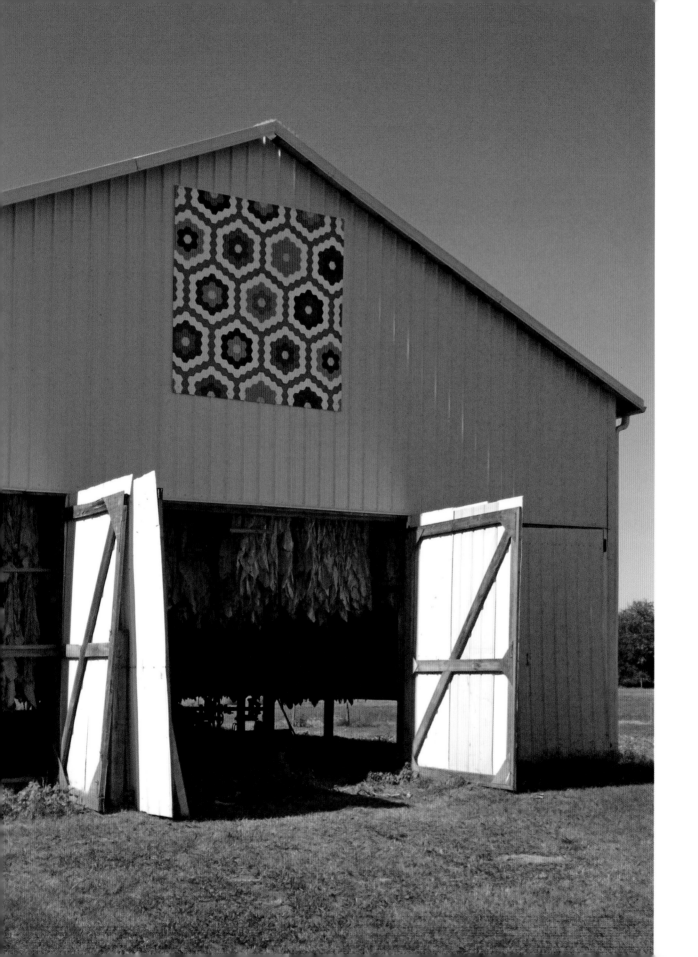

with him and carried the milk into the house so that he could visit his new sister. I couldn't help asking whether the fellow in the barn was wearing Chap's uniform or waiting in his skivvies, but the answer wasn't part of the family legend. The legend continued that Uncle Chap was killed at a country store in Tennessee where he stopped to get a sandwich. A group of mounted Union soldiers demanded his horse, which Chap knew could gallop very quickly. He jumped onto the horse to escape, but as Philip said, "A bullet is quicker than even a fast horse."

A great story is second only to a beautiful quilt block in my mind, so my visit with this red-haired raconteur was a highlight of the day. Finally the discussion turned to the barn quilt. Beverly told me that she has a quilt in the Grandmother's Flower Garden pattern that was pieced by her paternal grandmother and then finished by her mother when Beverly and Philip married. The quilt was already a favorite and the pattern took on even more meaning after Philip's mother passed away. The couple was cleaning out the house when they came across a quilt they had never seen. Sure enough, its pattern was Grandmother's Flower Garden, which now seemed a natural choice to adorn the barn that overlooks Philip's cotton patch.

We ended our day with a visit to Norma Lashbrook and the Harvest Sun quilt block that honors her husband, Don. Don wanted to be a farmer but soon realized that raising a family on an uncertain income might prove difficult. The industrious young man purchased a milk truck and rose each morning before dawn to travel to seventeen area farms to collect the one-hundred-pound cans. He transported the milk to the local dairy, and when snow piled up, Don pulled a trailer behind his tractor to get the job done. Norma's admiration for her husband was evident as she spoke. "On Sunday, he would have his shoes ready, and I would have the kids ready. As soon as he came home, we headed straight to church and Sunday school."

As Norma spoke of life on the farm and in the surrounding community, her eyes shone with enthusiasm. She talked about the one-room school that she attended in the nearby community of Habit, where her father owned the general store. When the school was consolidated with the one in nearby Philpot in 1937, the community wanted to upgrade from the lanterns and outhouses of the older buildings. School started in October that year because the electricity was not yet in place. The entire town turned out at eight o'clock on the appointed night and cheered when the lighting that signaled a new era came on.

Norma was especially proud of the braided rugs she and her mother created while Don was out quail hunting with Norma's father. The rugs, made from strips cut from woolen army blankets, scarcely looked worn, and one covered an entire room. "That one took two quail seasons to make," Norma said. Jackie had earlier pointed out the little quail family painted on the bottom of the barn quilt and visible only up close. The birds represented not just a husband who loved to hunt but also the connection between generations on the farm. "I have been here since my

237

kentucky

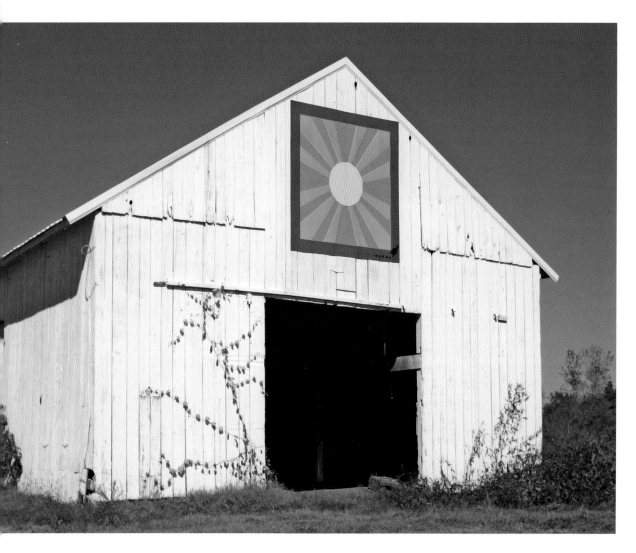

Harvest Sun

family moved to this property in 1929," Norma said. "I was eleven months old. I hope to spend the rest of my years here; it's been a good run."

In neighboring Webster County, Mary Ellen Wagner's barn quilt was mounted on a small farm building overlooking a pond but somehow the modest building added to its charm. Mary Ellen shared with me the family story that went with the quilt block. The quilt that the square is based on was pieced in 1889 by her great-grandmother, Martha Freeman Scarborough Jones, in Norene, Tennessee. When she was pregnant, Martha pieced a quilt for the child soon to be born. The pattern Churn Dash, which Martha had chosen for her daughter, Elsie Jane Jones, turned out to be the perfect choice, as Elsie Jane began churning butter at the age of five and loved the job.

238

following the barn quilt trail

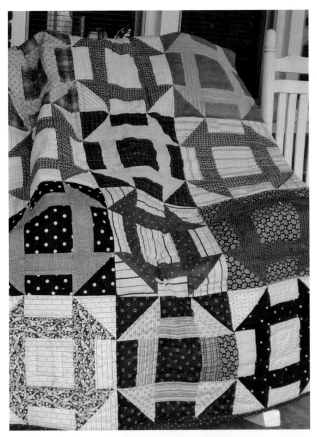

Churn Dash, cloth quilt
Photo by Mary Ellen Wagner

Churn Dash
Photo by Mary Ellen Wagner

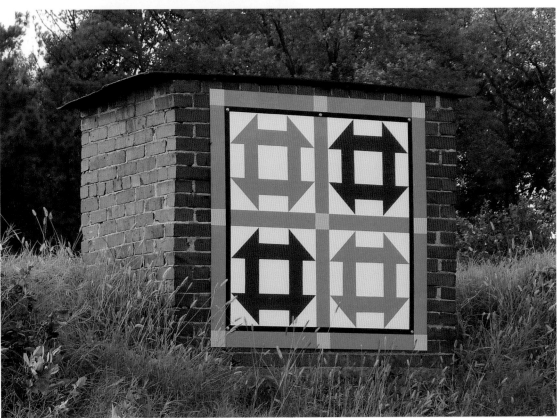

The quilt is a true scrap quilt, made from her daughters' dresses and the shirts that Martha's husband, John Bernard "Dock" Jones, wore when he played the fiddle at dances in Lebanon. It was given to daughter Elsie Jane when she was ten years old and was then passed to her daughter, Nina Jo Jones Qualls.

Nina Jo did not know her grandmother but heard a lot about her. "Everyone around her in Tennessee said she was one of the kindest people they ever knew. If anybody was sick, she would fix chicken soup or sandwiches; she would sit up with babies in the community when they got sick." And of course, Nina Jo heard about her grandmother's quilts, especially that Churn Dash.

Nina Jo's mom kept the quilt in a drawer because she didn't have a lot of storage space with five children. "I loved that quilt so when I got to be ten she gave it to me. I rolled it up and just held it in my arms. I was so tickled to get it," Nina Jo said. Just as her mother had, Nina Jo kept the top unquilted. "I thought it should be completed, but it was easier for me to keep just as a top so I could fold it up." It turned out that its being folded saved that quilt. In 1944, the dresser in which the quilt was stored was removed from the house during a devastating fire. Had it been quilted at the time, the family treasure would most likely have been destroyed.

More than a century after the top was stitched, Nina Jo decided she wanted the heirloom quilted. Niece Mary Ellen Wagner, who would later host the quilt block, belongs to the Onton United Methodist Quilters. The group hand quilts, and they were pleased to have the opportunity to complete the project. Mary Ellen had a photo of the ladies at work, and I could only imagine how pleased they must have been in having the privilege of finishing it. "I never knew my grandmother or great-grandmother, so it was very neat to work on this," Mary Ellen said.

Mary Ellen not only helped to quilt; she also painted the quilt square and is very pleased with the result. Mary Ellen showed me photos of the quilter, the quilt itself, and her aunt with the quilt. One photo, of the headstone on Martha Freeman Scarborough Jones's grave in Tennessee, was particularly touching. Along with the inscription there is a fiddle on the tombstone, for the husband and great-grandfather "Dock." Opposite is a small Churn Dash quilt block, a reminder of a beloved seamstress. The grave had previously been unmarked but now pays tribute to three generations of women.

■

Debbie Tichenor wanted a barn quilt and stopped by the Woodford County extension office to ask who might be painting them in the area. Debbie couldn't find anyone who was actively painting, but she did find out that Donna Sue Groves was putting together The Gathering, a barn quilt conference in Adams County, Ohio, in the spring of 2011. There, Debbie gleaned a lot of helpful information and also met Don and Sarah Hart, who had painted many of the barn quilts in nearby Madison County. I had visited the Harts a couple of years earlier, and I knew that

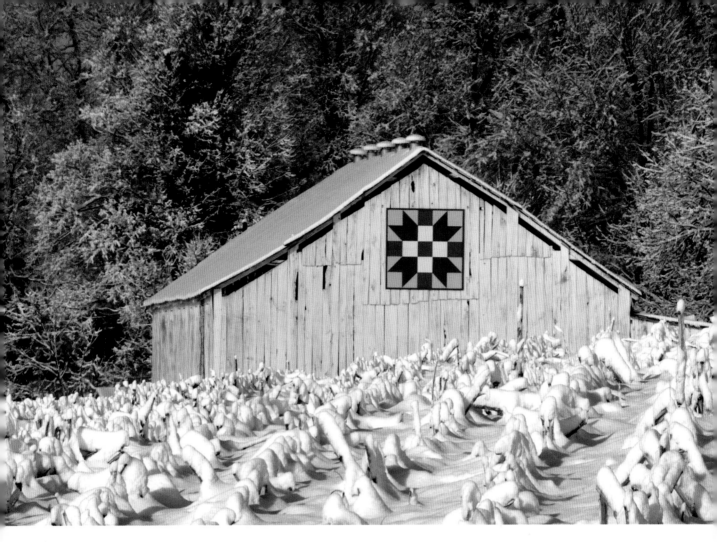

they were generous folks, so I was not surprised when Debbie told me that they had offered to help. Debbie and her friend Mary DeBold visited Madison County, and were soon ready to start a quilt trail of their own.

Debbie wasn't sure how the project would be received. "There is already so much to see, in Woodford County with the thoroughbred farms and horse barns, but once you get into the rural areas, we do have a rich farming tradition," she said. There are beautiful farms and also antique shops, wineries, and a distillery. Others in the community agreed, and Debbie gained support from the Kentucky Arts Council, the City of Versailles, and Woodford County Habitat for Humanity.

The inaugural quilt for Woodford County was Sisters, installed at Pastures Farm, which was established by the Dunlap family in 1782 when Kentucky was still a territory. It was one of the first tobacco farms in the area and the family grew the crop for over two hundred years. Debbie said, "Susan Dunlap was the first one to trust us to put a barn quilt on her barn. She is right in the part of the county

Sisters
Photo by Sally
Horowitz

241

kentucky

where the horse-racing tradition is strong. When you pass through, you see the thoroughbreds and bluegrass that are iconic for the area."

Susan Dunlap's great-aunt Margie had given her a family quilt in the Sisters pattern. Susan said, "The barn quilt gave me a chance to keep that quilt alive. I am so close to my sisters, Jayne and Jeri, so there were multiple generations involved." Soon after Debbie met with the Dunlaps, Susan's husband, Tavner, was diagnosed with lymphoma. The barn quilt raising was something he really looked forward to. The quilt block was installed on a cold fall day, but even so, Susan said, "It was so cheerful and wonderful and an example of public and private arts and humanities that came together in a beautiful way." To celebrate the occasion, Susan had cookies made by a bakery in New York City that were hand iced in the Sisters quilt pattern.

Tavner passed away nineteen months after his diagnosis, and Susan has moved from the farm to Louisville, so she was unable to take the barn quilt with her. One of her sisters had the quilt block made into a cloth quilt and they gave it to Susan the first Christmas that she was a widow. In return, Susan had Debbie Tichenor paint two-by-two-foot replicas of the barn quilt for each of her sisters, so that now they each have one. The first barn quilt in the county remains a local favorite, with its bright colors especially striking when surrounded by snow.

Down a road lined with stone-fenced pastures filled with cows and horses is the Berry Pickin' Days quilt block, created in honor of Pat Fleet's Great-grandmother Tate. Pat's family lived with her grandmother and great-grandmother when her father was in Germany on the front lines of World War II. "He left on my first birthday and was gone until I was almost four," she said. "I was so young that I don't remember much about my great-grandmother, but I remember her face because she was always with me. I remember playing under the ironing board and Great-grandmother sitting in the rocking chair quilting or crocheting." Pat shared a bittersweet story of the time in 1948 when her great-grandmother was in the hospital. Five-year-old Pat was not allowed inside, so she would sit on the lawn outside the hospital. "Mom and Grandma would raise the window and talk to me out there. One day they said I could go up to visit her, and that was the last time I saw her," Pat said.

Pat has carried her great-grandmother in her heart ever since, and when it came time to select a quilt pattern, she thought back to their time together. Her most cherished memories are of the days when she had her great-grandmother to herself, when her mom and grandmother went to pick berries. They would come home with purple stains on their dresses and aprons from those berries which her grandmother would then turn into jams and cobblers. Pat chose one of her great-grandmother's quilts as the model for her barn quilt, and since the quilt had no name, she called it Berry Pickin' Days in honor of those sweet memories.

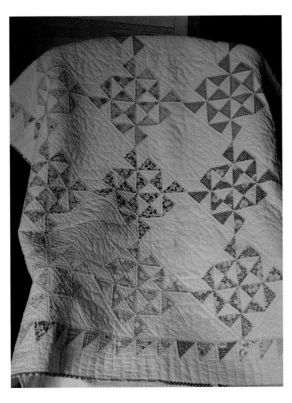

Berry Pickin' Days, cloth quilt
Photo by Debbie R. Tichenor, coordinator,
Woodford County Quilt Trail

Berry Pickin' Days
Photo by Debbie R. Tichenor, coordinator,
Woodford County Quilt Trail

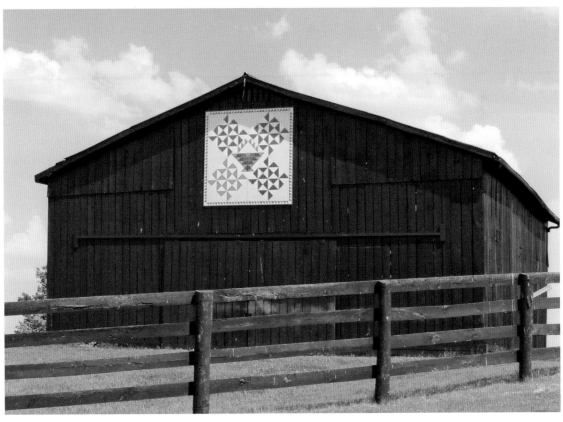

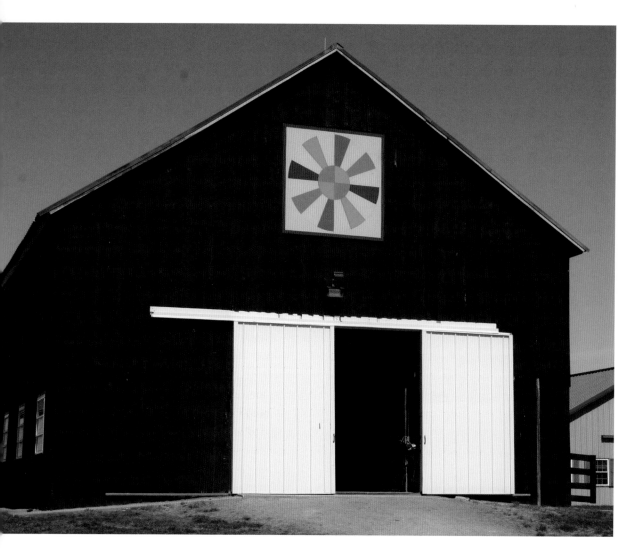

Circle of Life
*Photo by Debbie R.
Tichenor, coordinator,
Woodford County
Quilt Trail*

I have asked many a farmer why Kentucky barns are black and have never gotten a certain answer. Some said that the black color increases the heat inside for tobacco drying, and that made sense to me. But then I saw a black horse barn, so that explanation no longer worked. I do know that those black barns make the perfect backdrop for a barn quilt, the effect almost like a painting hung in a gallery frame, and Circle of Life on the barn at Life Adventure Center of the Bluegrass is a great example.

The John Cleveland Foundation operated the Cleveland Home for Orphaned Girls in Versailles, starting in 1875. The home grew into a place where girls who were not orphans but who needed a fresh start, whether redirection or refuge, came to live. More recently, the foundation decided to create a proactive organization rather than a treatment facility. In 2005 Life Adventure Center opened, located on a farm owned by the foundation that now spans 575 acres. The center's mission is

to "educate and empower youth and families to build self-esteem, respect, and responsibility, through a variety of outdoor adventure challenges."

Board president Steve Bush said that the programs at LAC "focus on families and underserved populations, with goals of enhancing growth, improving communication, and building resiliency." The four program areas are equine, challenge/team building, outdoor adventure, and environmental education.

A change in corporate logo led to the board's thinking of adding a barn quilt to the property, and Steve was given the charge of deciding on a pattern. Circle of Life jumped out as soon as he saw it, as it reflected Life Adventure Center and the circle that is a part of their practice. Many of the center's activities begin with the "joining of a circle" to engage and connect individual participants to a larger group for teambuilding.

The blue/green harmonious colors inside the circle are taken from the organization's logo and suggest the balance resulting from team interaction. The pairs of four colored spokes radiating outward represent the four program areas. As a science teacher, Steve incorporated the four ancient elements in the choices of colors: red for fire, blue for water, brown for earth, and green for vegetation. The gray-blue background completes the picture, standing for sky and air.

For Debbie Tichenor, who started the quilt trail in Woodford County, the benefits have been many. She enjoyed working with Habitat volunteers Aaron Hamblin, Joe Buckley, and Starr Byarlay, who built the racks to hold the boards and showed up with tools ready for every hanging. Debbie shared with me a photo of Aaron with a huge protractor that he built to help create a star pattern, and she talked of the sadness shared by the community on his passing in 2013. She said, "These men have touched my life in many ways. I am so fortunate to have had the opportunity to learn some of their life lessons." Debbie added, "When I see the barn quilts they make me smile; if anyone is getting up in the morning going to work and it gives them a good feeling, we have fulfilled one of the missions of the quilt trail."

245

south carolina

S OUTH CAROLINA'S UPCOUNTRY is a study in contrasts. Stately antebellum homes in historic communities and tiny railroad towns coexist with modern resort developments where powerboats and jet skis zip across man-made lakes. Glen and I had visited a couple of times to kayak on Lake Jocassee, and had become friends with Martha File, who founded the quilt trail in South Carolina and shared our love of paddling.

Like the area it encompasses, the Upstate Heritage Quilt Trail embraces both the old and new, celebrating the quilters of previous generations alongside modern fabric artists. Each of the over one hundred quilt blocks on the trail is a replica of a cloth quilt, whether an heirloom from the nineteenth century or a contemporary work. Many were mounted on buildings in Seneca and Pickens, often painted with great detail. The committee takes great pride in the painstaking efforts that replicate the patterns found in the cloth quilts. I loved the Double Wedding Rings and Crazy Quilts, and each time Glen and I drove up to the lake, we set aside time to see a few more.

Two quilted treasures are kept at the Central Heritage Society, and painted replicas are mounted on the grounds, framing a garden bench. Society member Ann Sheriff said that the building is a historic home that is kept in its original state as much as possible, as a repository of the history not only of the town of Central but also of the farmers who came to the area to conduct business and to take their crops to the railroad.

Texas Star was quilted by Martha Fain Powell more than 150 years ago. It is said that Martha and her family brought the quilt from the Atlanta area when the

Flower Baskets and
Texas Star quilts
*Photo by Central
Heritage Society*

city was under siege by Sherman's forces. I had heard similar stories and often chalked them up to family legend, but Beverly Cureton, president of the Heritage Society, provided some compelling evidence. Other family possessions that were donated along with the quilt included several china saucers, some of which have charred edges from the fire that burned the Powell home.

The quilt was passed down to Martha's daughter, Eugenia, whose husband owned a general store in Central, and later donated to the Heritage Society, where it is on display among artifacts from the community's two-hundred-year history.

The Flower Baskets quilt was made by Josephine Barker Morgan, who lived in the area between Central and Six Mile from 1856 to 1935. Josephine's granddaughter, Lillian Framer Hall, made a gift of the quilt to the Heritage Society. I was intrigued as much by the names of the two towns as I was by the hand-stitched heirloom. Beverly Cureton said that Central got its name because the railroad town was half-way between Atlanta and Charlotte. Six Mile is the distance from that community to the fort that served as the trading post for the area in the 1800s.

On arriving at Lucy Harward's home, I immediately noticed the well-manicured, almost formal gardens spread throughout the property. On being complimented on the landscaping, Lucy laughed and explained that husband, Dale, is

248

Flower Baskets and
Texas Star
*Photo by Central
Heritage Society*

the gardener. "If you find dirt under my fingernails, I must have been eating choco-
late," she said. Lucy proved a delightful Southern hostess, with a bowl of purple
muscadine grapes and the larger, greenish globes called scuppernongs laid out on
the table next to a tree-shaded bench. I nibbled on each and sampled sweet scupper-
nong juice and agreed with Dale that a splash of ginger ale enhanced the taste nicely.

Dale had been a Methodist minister in Florida, and the two visited Pickens,
South Carolina, often to spend time with Lucy's family. Dale's compensation in-
cluded a parsonage, so the couple had moved from one home to another over the
course of several decades. The property in South Carolina was purchased in 1968
so that they would have someplace that they felt was home, where Dale could
plant his muscadine vines and pecan trees. Dale wanted to farm, and Lucy wanted
to see the mountains, and the spot they chose answered both requirements.

Lucy said that raising bees was good for the gardens and also a hobby that
both she and Dale enjoyed. Recently, though, the bees had brought unwanted
visitors to the Harwards' property. After many years of beekeeping without in-
cident, Dale found one morning that a bear had completely destroyed some of
the hives. Lucy called the Department of Natural Resources, who sent an agent
to install a trap. Somehow the bear retrieved the honeybuns and sardines in the

249

gunny sack inside without being caught. The remaining hives were moved to a friend's property, but when the hives returned to their original location, the bears returned as well.

Lucy had called the Department of Natural Resources so many times that when she identified herself, the DNR representative said, "Let me guess—you've got a bear in your bees." He reminded Lucy that killing a bear was illegal, right as Lucy heard the pump of her daddy's .410 gun. "Dale, don't shoot him," she called, as the BAM! resounded both in her ears and in those of the agent on the phone.

Dale wanted a barn quilt that reflected their life, so the design had to include flowers and bees. Lucy suggested Grandmother's Flower Garden, but the pattern's interlocked hexagonal petals just didn't look like flowers to Dale. Moving

following the barn quilt trail

the flowers and adding leaves created a pattern that suited him just fine, and Lucy added four traditional beehives, called skeps, in the corners. With a church and a schoolhouse to represent the couple's careers of preaching and teaching, just one final touch was needed for Harward's Hay Day Farm. After all, as Lucy said, "If you've got bees you've got to have bears. We just let them run around the schoolhouse."

Martha File suggested that I visit one more site where I would find a unique quilt block that she guaranteed would be worth the trip. Based on her hearty but rather vague recommendation, I drove into the foothills near Walhalla. A wide gravel road led into woods strewn with the reds and golds of fall. I passed a house —and then another—and thought perhaps one of them might be my destination. No quilt block was evident, though, so I continued onto the narrowing gravel into the nearly leafless trees. As I rounded a curve, a modern wooden and metal structure with a Log Cabin quilt square came into view and I knew that I had reached End of the Road Studios.

Robin Cooper Dubose greeted me, appropriately paint-spattered and quite enthusiastic. As I complimented her on the quilt design, she broke into a grin. "Did you try it?" she asked. Sensing my confusion, she walked to the quilt block and grabbed a corner; with a sharp tug, the piece came off in her hands. Robin began removing each piece and rotating them as she demonstrated how the Interactive Log Cabin got its name. As Robin pulled, turned, and replaced each block the diamond configuration was replaced by diagonal rows. I had seen thousands of quilt blocks by this point, but this one was astoundingly creative. The Log Cabin pattern changes depending on the way that the quilter arranges the light and dark sections in the blocks. For a cloth quilt, the artist would have to settle on a design before piecing the blocks together. Not so with Robin's creation.

Robin said that she loves the "accidental magic" of quilts, and that is what she set out to create in the barn quilt. The blues and greens were chosen to create an agricultural look that seems as if it belongs in the landscape.

Robin explained the connection between the cut-canvas collages that she creates and quilting: "I love fabric, color, texture, and pattern." When it comes to quilting, Robin enjoys cutting fabric but not the sewing. Robin serves as the visionary and designer and her mother-in-law, Judy, finishes the job. Robin showed me one of their collaborations—a quilt called Bed Bugs, made from men's shirts with a couple of bugs appliquéd on top.

The conversation shifted to quilts and quilting then to folk art and the place of untrained artists in the wider community. It had been a while since I had the chance to talk art and artists, and I enjoyed the chance to speak passionately on the subject. I left End of the Road Studios knowing that I would return, and I would bring Glen along so that he could have a turn with Robin's magical barn-quilt puzzle.

Interactive
Log Cabin

I was invited to speak at the library in Landrum, South Carolina, and took the opportunity to find out a bit about the quilt trail that was underway. My host, Ellen Henderson, invited me to lunch with the group of quilters who had started the local quilt trail. The idea resulted from a visit to a quilt show in Seneca, where the Upstate Quilt Trail flourished, and samples of their quilt blocks were on display. The Landrum Quilt Club thought of the quilt show that they hosted each year at a middle school; the school was generous in donating the use of the property, and the quilters each time gave a gift of thanks. A painted quilt seemed a perfect token for the upcoming show, and the Foothills Quilt Trail was born.

The volunteer painters of the Upstate Heritage Quilt Trail were willing to help out by painting the blocks, but they did want to stick with their tradition of a cloth quilt corresponding to each one they created. To meet the requirement, when each quilt square went up in Landrum, if no corresponding cloth quilt existed, one of the quilters in the group stitched a block in the same pattern to keep the tradition alive.

Ellen and I left the quilters behind to visit dentist Paul Walters. His office waiting area held a family waiting for one child to emerge and another to be called, but once Paul finished the procedure at hand, he was able to take a break and share a sweet story.

Paul grew up in Reevesville, in the Lowcountry of South Carolina, about two hundred miles southeast. The landscape is far different from the foothills where Paul now makes his home, but the traditions are similar. Paul spoke with fondness of Mrs. Estelle Crosby, or "Mamie Tell," an elderly neighbor who often cared for Paul and his sister. Mamie Tell did not have her own grandchildren, but Paul said, "She took me and my sister as hers." Mamie Tell often kept the children after school; Paul said, "If our parents ever missed us at home, we could always be found next door at her house as there was always candy or snacks to be had." One of Paul's favorites was peanut butter and honey on crackers. I had never tried the combination but it sounded pretty good.

Paul's favorite times were when Mamie Tell's church friends came over to quilt on the circa-1800s quilt frame that once belonged to her grandmother. Paul was especially taken by the beeswax with which the women would coat the quilting thread. He learned to sew but mostly enjoyed "plundering" in Mamie Tell's sewing box; it was there that he found the Bow Tie block that was the basis for his quilt. The block was one of several in the box, but it appealed to young Paul. "It was typical for Sunday school," he said, "a white shirt, a bow tie, and Buster Brown shoes." My mind immediately went to a 1960s photo of my brother, Ron, posed out front of our home, proudly wearing just such an outfit on an Easter morning.

Mamie made Paul the blue gingham Bow Tie quilt, which he eventually took to college and is now part of the collection that he and wife, Tina, have built over

the years. When he revealed that his Bow Tie quilt had survived dormitory life, I had to ask about its current condition. To our surprise and delight, Paul fetched the quilt from his office and spread it for us to see. Other than a couple of faint stains on the back, it looked perfect. The heirloom quilt was obviously treasured by the young man who now keeps it safe until ready to be handed down to a daughter or grandchild in the future.

A highlight to my visit to Landrum was the chance to meet a quilting legend. Georgia Bonesteel is well known to quilters, having starred in a PBS series, *Lap Quilting,* for decades. Georgia's quilting career began in New Orleans, where she pieced and sold evening bags from the leftover fabric corners from a men's tie factory. After moving to North Carolina in the 1970s, Georgia began creating full-sized quilts. "I loved the way that putting three layers together created shadow on the quilted surface," she said.

Georgia shared her enthusiasm for quilting when she conducted classes at a local community college. The public television series that grew from Georgia's teaching experience is still popular among quilters worldwide.

south carolina

Georgia had been a founding member of the quilting group in Landrum and participated in starting the quilt trail there. Her Moon over the Mountains block hangs on the library building and is a testament to her affection for the community. Georgia said she was "blown away" upon discovering the barn quilts in Burnsville, North Carolina. She believes that the quilt blocks "give a graphic stamp to our community that states we believe in structure and design, repetition. It shows everyone what we do as quilters."

More recently, Georgia had begun work to start a new quilt trail in Henderson County, North Carolina, where she makes her home. Glen and I detoured for a quick visit with Georgia on our way south and met her at the Beginnings Quilt Shop. One of the first quilt blocks in the newly formed trail hangs there, a bright blue-and-green pattern with a yellow sunburst that echoes the shop's logo. We took a short drive to the North Carolina State Theater's Flat Rock Playhouse, whose quilt block Georgia was most eager to show us.

Black and white is an unusual combination for a quilt, but I loved it immediately. The shapes seemed abstract, but Georgia said that there was a concept behind the design. She had come up with an idea and asked Martin Webster, an artist who had designed many of the quilt blocks in western North Carolina, to create the geometric pattern. "Oh, I get it!" Glen exclaimed, but all I saw were curves. Once Georgia said that the shapes represented Comedy and Tragedy, I could see the masks clearly. We all agreed that the pattern would make a lovely cloth quilt, and Georgia said that indeed she intended to make one sometime soon.

Glen and I left the legendary quilter and the mountains behind and headed south to the end of our journey. We no longer have a home in Georgia, but even a mobile-home park situated ten miles from our former house felt like we had settled in. We visited favorite restaurants, took care of business with doctors and banks, and caught up with friends. We celebrated the fact that our new life was on track. The quilt trail had given us an excuse to break away from our routine, from our ties to one place, from our love of possessions and collections, and we saw all of those things as improvements.

south carolina

the deep south

GLEN AND I had only a few weeks to spend in Atlanta and a lot to do. As soon as the RV was parked in Stone Mountain and plugged in, we dashed over to our favorite hole-in-the-wall Jamaican restaurant and burst in the door calling out, "Mom, we're home!" We were greeted with exuberant hugs by the proprietor, whose curried goat and plantains we had salivated for, as small-town restaurants seldom served Caribbean fare. I didn't cook much those weeks, as we had to get our fill of Indian, Thai, and German food, and of course our calendar was packed with dinners out with friends.

I had looked forward to warm weather, but an unusual November cold snap moved in. We had hoped to kayak with our club, something both Glen and I had dearly missed. Glen would eagerly have braved the cold, but no number of layers is sufficient to keep my toes from numbing when the air temperature is below forty. We bundled up inside and spent an evening watching movies instead of riding bikes. A crockpot full of chili and a good dose of Turner Classics made for time well spent. Cold and rain were the only two things that made RV life difficult for me, as the small space seemed so confining without access to outdoors.

I groused about the temperature but the cold wouldn't budge, so I chose a sunny afternoon for some barn quilting nearby. An hour or so away, the Southern Quilt Trail of about sixty quilt blocks extends from Powder Springs, just west of Atlanta, to Tallapoosa, near the Alabama line. The quilt trail here includes only a few barns, but that was good news on a bracingly cold day, as it meant less time outside for photography at each site. One of my favorites was a one-room schoolhouse just across from the Haralson County courthouse in Buchanan, where a

259

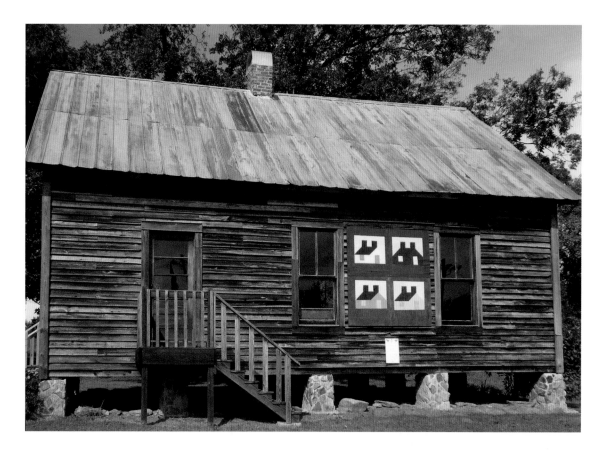

Schoolhouse

Schoolhouse quilt block hangs. Having been a teacher myself, I could not imagine working with kids of all ages inside the tiny structure.

The schoolhouse was built around 1870 in the Little Creek Community in Haralson County. According to Dr. Terrell McBrayer, who worked with the historical society on the restoration, an 1870 Georgia law provided funding for schools. The Little Creek School was most likely built the following year, along with a post office and other buildings. In 1932, the school was consolidated with three other area schools.

Each one-room schoolhouse was adapted in turn, either enlarged to accommodate additional students or adapted to a new function, but the Little Creek School remained in its original state. The building was put to use by the community as a voting place, a justice-of-the-peace court, and a location for church activities. As more modern buildings became available, the schoolhouse fell into disuse and was allowed to deteriorate.

In 2006, the Haralson County Historical Society took on the task of moving the structure to the county seat in Buchanan and restoring the schoolhouse. It was quite a challenge, as a lot of the wood had rotted away, and new construction was needed. "It was amazing how we got material to match those unpainted timbers,"

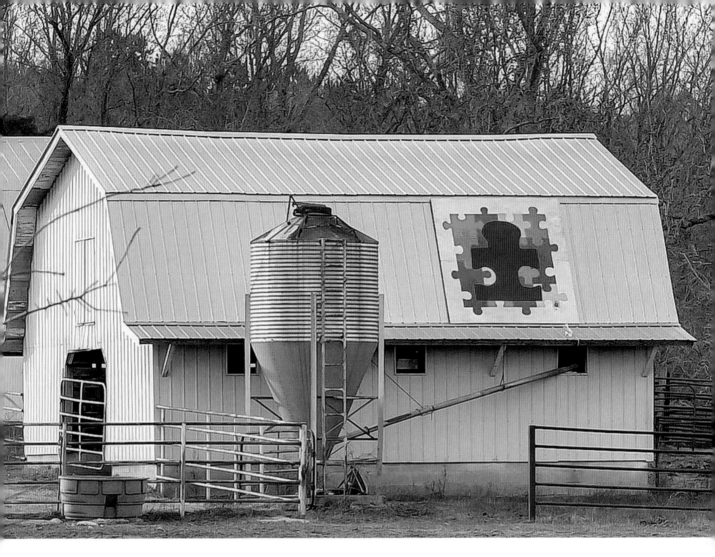

McBrayer said; the weathered boards were harvested from an older barn and out-buildings from another nearby farm.

The restoration took about two years, and the building is now ready for visitors who want to discover what life was like for Georgia's first public-school students.

Alabama

I had already documented the only quilt trail in Alabama, which honors the cele-brated quilters of Gee's Bend, and I had not located a more recent community project. But when I heard about Alabama mother Mandi Frye, who had painted a barn quilt in honor of her daughter, I was eager to find out more.

Mandi's "sweet joyful angel," Madison, was born in 2001 with a rare genetic condition called 2q37 deletion syndrome. She has faced many challenges, which

261

began with open heart surgery when she was only four months old. Her condition is also manifested in weak muscle tone, intellectual disability, and developmental delay. "She has been seen by so many doctors," her mother said.

At age six, Madison was diagnosed with autism, which is represented by her barn quilt. Mandi said, "The different colors and shapes represent the diversity of the people and families living with the condition. The brightness of the colors signals hope that through increased awareness of autism, and with appropriate education and treatments, people with autism will lead fuller, more complete lives," she said. Mandi believes that increased awareness is key. "A lot of people don't accept these kids because they don't know if they are acting out or what might be going on. I talk about Madison for acceptance; there are so many of these kids out there."

Mandi's mother was a skilled painter, but Mandi was afraid that her frequent hand tremors would prevent her from following suit. She found that when she picked up a paintbrush, the shaking stopped. Mandi began painting and opened a shop called The One Perfect Piece, after Madison, whom she describes: "I am who God made me and I am perfect." To Mandi, God is "the puzzle maker who, by trials and tribulations, shapes each of us to fit his puzzle."

"God gives special kids to special parents but I feel like I am the one that's blessed," Mandi said.

The quilt block hangs on the barn on the hay farm founded by Mandi's husband Mike's great-grandfather. The barn quilt is for Madison to see every day and for others to see and think of her. She is well known throughout the town, and those who drive by will now know, "This is Madison's place."

Mississippi

Regina Breland saw the brightly colored designs on Kentucky's tobacco barns and was soon taken with the barn quilt concept. After looking at the national map, she realized that her home state of Mississippi had no quilt trail. She said, "We are in the South where everybody has a quilt. It made me mad in a way." The idea was on Regina's "heart and mind" for about a year; she finally realized that she would have to be the one to start the quilt trail in her home state.

Of course the best way to introduce people to barn quilts was to have one to show them, so Regina painted a Folded Flag pattern for her family barn. The quilt block honors both the veterans in her family and those throughout the community who have served so proudly. "It was such a feeling of accomplishment," she said.

Armed with a copy of *Barn Quilts and the American Quilt Trail Movement*, Regina set out to show others exactly what she was talking about. Local and statewide news coverage increased awareness of the growing trail, and Regina hopes that the

Opposite:
Wedding Ring
Photo by Regina H. Breland

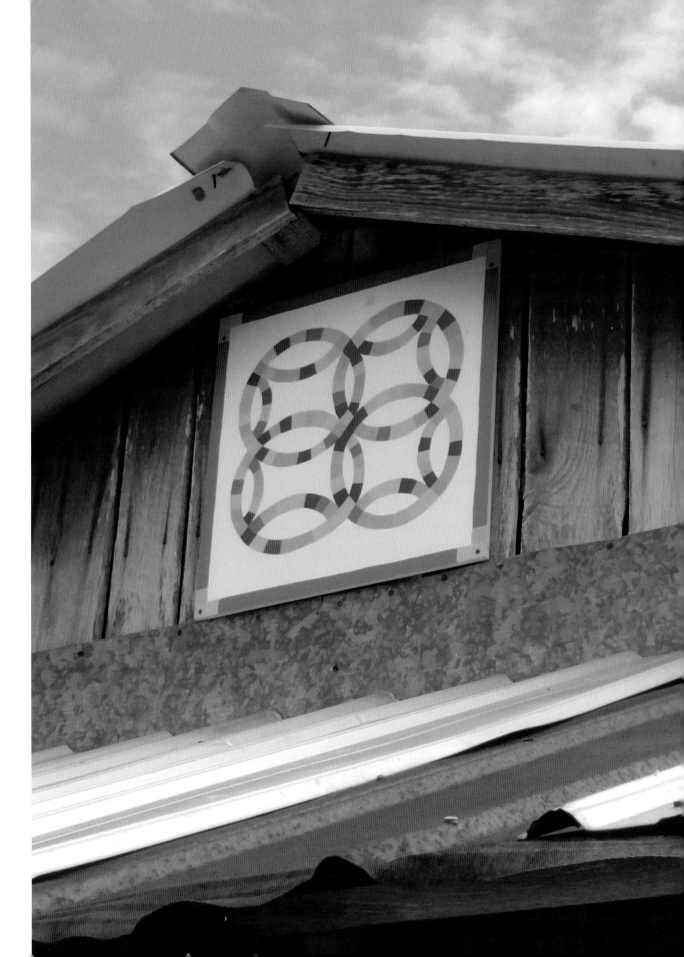

local project will eventually join up with others that are springing up elsewhere in the state. "I don't want it to be just me and my community," she said.

Joyce Welford said that her barn quilt was painted in honor of her granny, Oneida Welford, her mother-in-law. "Everybody called her Granny Welford," Joyce said, "and she was the best quilter of my life."

Joyce expressed great admiration for Granny, who raised eight children during difficult times. Oneida's husband, Jim, retired to the farm after bring wounded while in the army. Oneida became close to her husband's sisters, and the women gathered at their home place to quilt every Tuesday. The goal was to make a quilt for each grandchild but also to raise each other's spirits. "You couldn't go over there on a Tuesday because you couldn't get a word in," Joyce said. Each of Granny's nineteen grandchildren would eventually receive a quilt made by the Welford women.

Granny Welford loved and took care of everybody. When Joyce and Ollie were first married, Joyce was a bit intimidated because her husband was accustomed to the table full of food that his mother had cooked for her eight children. Granny solved the problem by cooking a bit extra each evening to supplement what Joyce had prepared. "He picked her biscuits over mine every time," Joyce said.

Joyce's daughter, Olivia, spent a lot of time with her grandmother and was the recipient of one of the family quilts. I couldn't help noticing the unusual names— Oneida, Ollie, Olivia. Clearly this was a family that appreciated tradition. When the family started thinking about which pattern to choose for the barn quilt, the Wedding Ring came to mind as the one Oneida had most often made and given as a gift to her grandchildren.

Oneida passed away, but her children still visit the family home. Ollie checks on the property daily, and his siblings sit on the porch, plant gardens, and celebrate the holidays there. Sisters who live out of state still come home to their mother's house, where a barn quilt now reminds them of Granny Welford.

Florida

Glen and I finished up the year in Florida, visiting my mom, kayaking on the Suwannee River, and soaking in the warmth. This was the time of year that RV dwellers celebrate, as the eighty-degree sunshine meant a park bathed in light and abuzz with activity. The chance to get outdoors meant greater opportunities to socialize and to discover how other RVers live. From door handles to lighting to the latest flat-screen televisions, we checked out dozens of "rigs," taking note of others' modifications, while those considering an RV office stopped by to check out Glen's custom-built setup.

We met dozens of people but still felt lonely, surrounded by acquaintances but without real friends, until we met Barb and Sid Zielke. Barb sensed our need

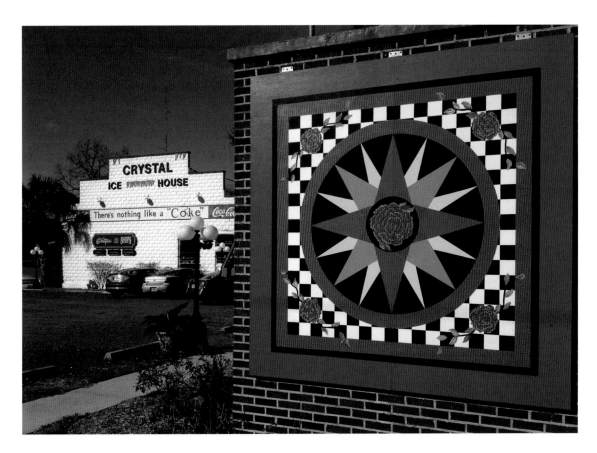

for belonging and introduced us to the ways of RV friendship. The couple, who had been living on the road for thirteen years, invited us to join them for dinner and card games, and soon we were taking turns playing host. An open door was an invitation for a visit, and before long, Barb's call of, "Hi Girlfriend; what's up, Boyfriend?" meant that fun was in store. Whether with a game of miniature golf or a trip into town, the couple infused our days with the laughter and easy friendship we had missed. More importantly, we kept in touch and managed to meet in Washington and then California in the coming months. Glen and I learned from Barb and Sid that creating a new network of friends who share our lifestyle was essential to a happy life on the road.

As the New Year began, my thoughts turned once again to barn quilts, and I was delighted to find that Florida had joined the quilt trail at last. Stephanie and Paul Metts proudly shared their story, which began when the two retired to a home on the Suwannee River in the farming community of Trenton, Florida. The area is known as Old Florida, without the shiny developments and crowds or tourists. Stephanie said, "It's pretty and pristine. It's not the beachy Florida but the natural Florida with springs and mossy trees." In short, Trenton is the Florida that we who are native to the state hold in our minds as home.

265

the deep south

On trips into town, Paul and Stephanie would pass by the Coca-Cola bottling building that had been vacant since 1975. Eventually they bought and restored the building and turned it into a quilt shop. The cold-storage building next door became part of the facility as well. The shop became a popular destination for quilters throughout the area. "Quilters come no matter how bad the gas prices are," Stephanie said.

Stephanie was glad to have the business but was troubled by the fact that Trenton didn't offer a reason for visitors to stay. "We had to send them away just to get something to eat," she said. Stephanie started the Suwannee Valley Quilt Festival in hopes of enlivening the town. "I just wanted to get people here," she said. About seven thousand people attend the annual event to see quilts hanging all over town, along with antique tractors and cars on display.

Local businesses reported increased sales the day of the festival, and Stephanie thought that a quilt trail might benefit the community in the same way. The Compass Rose quilt block, painted by artist Janet Moses, hangs at Stephanie's Suwannee Valley Quilt Shoppe and symbolizes guidance that might bring visitors to Trenton.

Other local communities recently signed on to extend the Florida Quilt Trail, including Madison County, in Florida's Panhandle. There a patriotic logo block represents Madison County's four cherished freedoms: the freedom of speech, the freedom of worship, the freedom from want, and the freedom from fear. Artist and steering committee member Janet Moses said, "We view this as a way to promote our heritage, history, arts, and culture for all to enjoy—a lovely ride, year-round through our community, will tell our story and share our local talent."

Janet contributed her artwork to the burgeoning quilt trail in the town of White Springs as well. The first two paintings were hung on the Adams Country Store, a two-story general store that dates to the 1800s. Janet's skillfully executed Double Wedding Ring is a replica of a quilt made by Nancy Morgan, a White Springs resident who received a Florida Folk Heritage Award for her quilting.

The eight-foot replica of a yo-yo quilt that Janet created was one of the few I had seen that appeared three-dimensional. The masterful work of art pays tribute to Queenie Udell, an African American woman who was known for the yo-yos that she created. Queenie was born in 1919 in Jefferson County, Florida, and moved to the area known as Black Bay in White Springs in the late 1940s. Her mother and grandmother used flour sacks and worn-out clothing to make their yo-yo quilts and taught Queenie the art when she was a young girl.

To make a yo-yo, Queenie would first cut a circle of cloth. When she had a few circles she would then gather the edges of each circle with thread. The gathered circle was pulled tight and flattened into the distinctive yo-yo with a little hole in the center where the gathers all came together. Queenie said, "People gives me scraps and I just sews 'um." She made her multicolored quilts in her spare time,

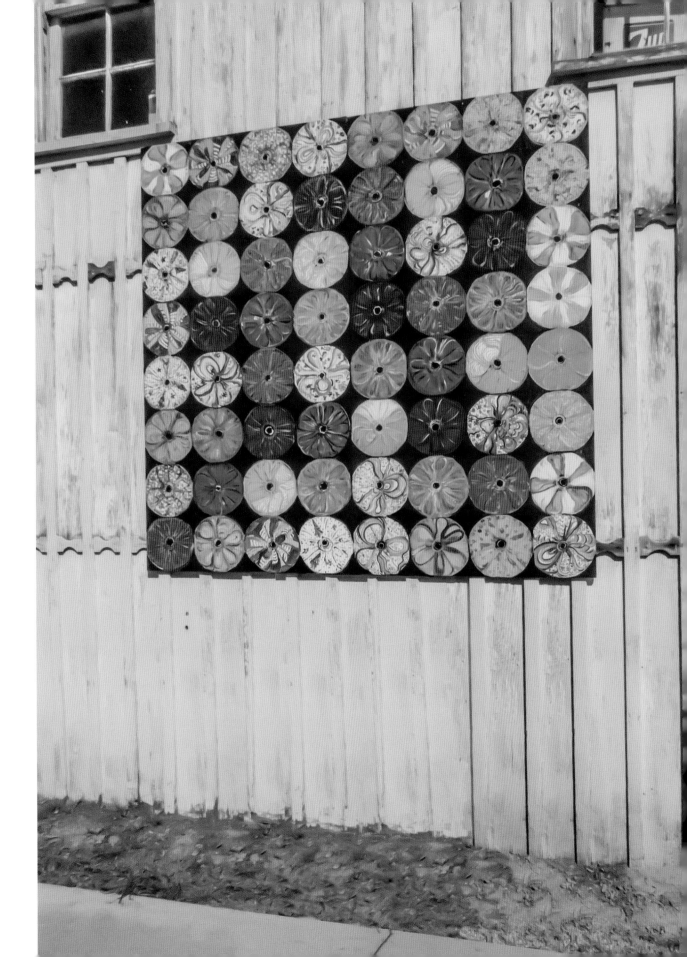

often working late into the evening gathering by hand the small circles of brightly patterned fabrics. After she had an assortment of yo-yos, Queenie would begin tacking them together in small blocks which were later assembled to make the size quilt she desired.

Merri McKenzie had come to White Springs as an artist-in-residence in the 1970s. There, she met renowned folklorist Peggy Bulger and contributed her knowledge of fiber arts to Bulger's field studies, which included visits with Queenie. Merri said that she had never seen yo-yos as small as the ones Queenie sewed, which were about the size of nickels. But almost as impressive was the way that the colors were laid out in the quilt. "She would not have been able to look at the quilt from a distance in her small shotgun house, but the way she used colors was very well planned. It's incredible what she was able to accomplish," Merri said.

For artist Janet Moses, replicating the quilt was quite a challenge, but in the end, she said, "I painted it with great joy knowing how much it would be loved and appreciated by all."

Ninety-six-year-old Queenie was pleased to hear that her work would be part of the quilt trail, and it was hoped she would be able to attend the dedication of the murals in February 2015. Two weeks prior to the event, Merri McKenzie shared the sad news of Queenie's passing but said that she was able to visit on the final day of Queenie's life: "It was a bittersweet visit as she could only communicate with her eyes but she saw her quilt which I laid over her and she listened while I told her about the White Springs Quilt Trail."

Mayor Helen White shared her thoughts: "Being draped in her quilt, surrounded by love and compassion, Queenie was able to release her spirit knowing that she was recognized and appreciated for a life well lived, and that her artistry will remain a part of her community's history."

I was not only pleased that the Quilt Trail had begun to flourish in my native state but also proud of the community spirit that adapted the project to the culture of the area.

There was greater news from Florida that winter. Glen and I were married at a Florida lakeside in December 2014, with just my mother, Annette, and her friend, Kelly Wise, in attendance. The announcement brought dozens of congratulations from across the country; we had made so many friends along the way. The clients at New View in Wisconsin sent a package filled with handmade greetings, to express their happiness and wishes for good luck in our marriage. Glen strung the colorful cards across the front of the coach, and we agreed that they were far superior to an ordinary "Just Married" banner.

I was told by many friends that we had been "as good as married" already. But for me, who finally tied the knot just a few weeks before being eligible for a senior

citizen's discount, being married was no mere formality. Marriage meant that I had succeeded in learning to love.

I had always thought love would happen all at once, like stepping through a magical door to a host of new feelings. Maybe it happens that way for some. For me, being loved was the necessary step to being able to love. Glen was not a door through which I stepped but rather a mirror. Someone had to be brave enough to go first, to let love shine in my direction until I saw it there and became a mirror myself. I cannot imagine it being anyone but Glen.

The story of the quilt trail, of the thousands of people across the country for whom those quilt blocks hold meaning is our story now, and one that we share with anyone who cares to listen. Our travels continue, with no plans for a permanent home on the horizon.

One day soon, we might just make it to Yellowstone.

the deep south

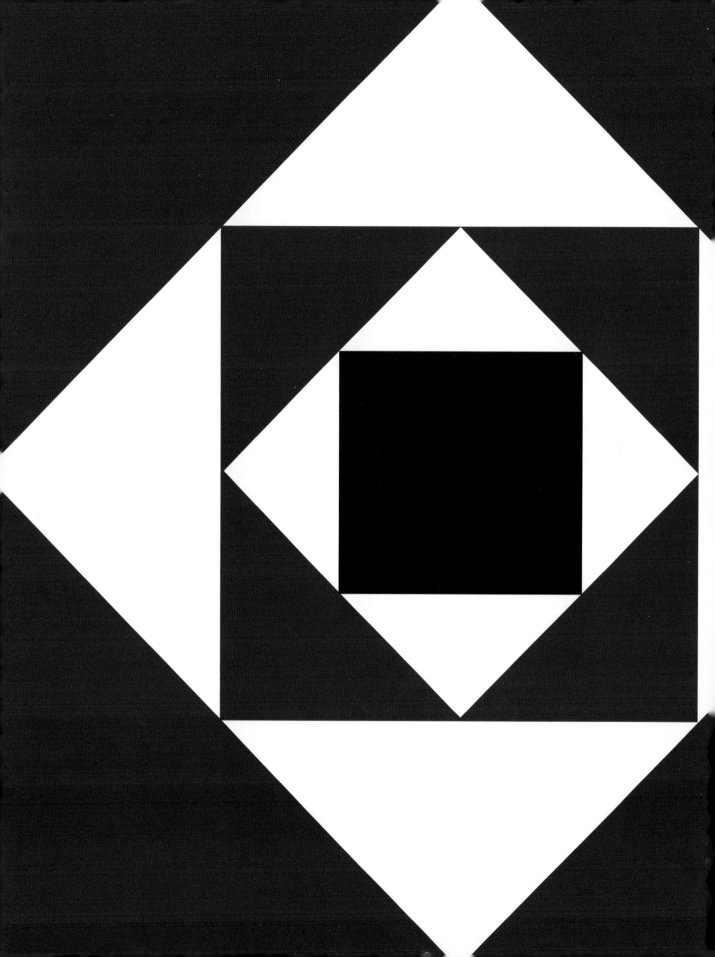

photo credits

I would like to thank the photographers who contributed to this book. Following is a list of their names and the pages upon which their photographs appear.

Regina H. Breland, 263

Kristin L. Bryant, 197

Central (South Carolina) Heritage Society, 248, 249

Kris Crawford, 201

Carla Cross, 155

Maria Shaw Dombrowski, 112

Carl E. Feather, 63

Sally Horowitz, 241

Bill Kilborn, 267

Jim Leuenberger, 186

Lisa's Photo Creations, 89

Steven Mercure, 91

Drema Morgan, 98, 99

Martha Nelson, 118

Josie Porter, 261

Renae Quandt/Kamler, 151

Bobbi Ryan, 45

Debbie R. Tichenor, 243, 244

Trenton's Suwannee Valley Quilt Festival, 265

Mary Ellen Wagner, 239

Linda Wiant, 4

index

Page numbers in boldface type refer to illustrations.

index

index